www.wadsworth.com

www.wadsworth.com is the World Wide Web site for Wadsworth and is your direct source to dozens of online resources.

At *www.wadsworth.com* you can find out about supplements, demonstration software, and student resources. You can also send email to many of our authors and preview new publications and exciting new technologies.

www.wadsworth.com
Changing the way the world learns®

DESIGN BASICS

David A. Lauer

Stephen Pentak
The Ohio State University

SIXTH EDITION

THOMSON ™

WADSWORTH — Australia • Canada • Mexico • Singapore • Spain
United Kingdom • United States

THOMSON
WADSWORTH

Publisher: Clark Baxter
Executive Editor: David Tatom
Acquisitions Editor: John R. Swanson
Development Editor: Sharon Adams Poore
Assistant Editor: Amy McGaughey
Editorial Assistant: Brianna Brinkley
Technology Project Manager: Melinda Newfarmer
Marketing Manager: Mark Orr
Marketing Assistant: Kristi Bostock
Advertising Project Manager: Vicky Wan
Project Manager, Editorial Production: Trudy Brown, Emily Smith

Print/Media Buyer: Kris Waller
Permissions Editor: Sarah Harkrader
Production Service and Compositor: Lachina Publishing Services
Text Designer: John Edeen
Photo Researcher: John Turner, Elsa Peterson Limited
Copy Editor: Lachina Publishing Services
Illustrator: Jamie Pentak
Cover Designer: Preston Thomas
Cover Image: Roy Lichtenstein
Cover Printer: The Lehigh Press, Inc.
Text Printer: Courier Corporation/Kendallville

For more information about our products, contact us at:
Thomson Learning Academic Resource Center
1-800-423-0563

For permission to use material from this text, contact us by:
Phone: 1-800-730-2214 **Fax:** 1-800-730-2215
Web: http://www.thomsonrights.com

Library of Congress Control Number: 2003112925

ISBN 0-534-62559-2

Wadsworth/Thomson Learning
10 Davis Drive
Belmont, CA 94002-3098
USA

Asia
Thomson Learning
5 Shenton Way #01-01
UIC Building
Singapore 068808

Australia/New Zealand
Thomson Learning
102 Dodds Street
Southbank, Victoria 3006
Australia

Canada
Nelson
1120 Birchmount Road
Toronto, Ontario M1K 5G4
Canada

Europe/Middle East/Africa
Thomson Learning
High Holborn House
50/51 Bedford Row
London WC1R 4LR
United Kingdom

Latin America
Thomson Learning
Seneca, 53
Colonia Polanco
11560 Mexico D.F.
Mexico

Spain/Portugal
Paraninfo
Calle Magallanes, 25
28015 Madrid, Spain

For Celia
D. A. L.

For Debbie
S. P.

CONTENTS

PREFACE

The sixth edition of *Design Basics* has a new appearance. Color is evident throughout the text. In previous editions color images were only found in Chapter 13. This change in the text is immediately obvious and refreshing: after all, we know a painting (for example) is a work of art conceived in color and it is a let-down to see a black and white reproduction. But, some design concepts are easier to see when color is taken out of the mix of sensations. Texture, for example, may be less obvious in a composition with a variety of intense colors. So, some images remain in black and white and the inclusion of color has been done with care.

The subject of this book is *design*, both the principals and the elements. The text is a work of design and is subject to the same critical eye as any example discussed within its covers. The examples shown and analyzed should be viewed with a critical eye. What other perspectives are possible? Can you find elements or principals *more* worthy of discussion? As you develop your own eye and your own work (whatever the medium), you will find yourself increasingly critical of the designed and composed world around you. A brief introduction to the critique process is now outlined in Chapter 1.

This edition of *Design Basics* is the first to so thoroughly exploit the web as a source for examples of artworks. This process may be "invisible" to the reader, but it is significant.

The authors found examples in museums and galleries but may have returned to those places via the web to search out alternative images. This has permitted us to find not only good examples but truly distinct examples to demonstrate the concepts. The reader can enjoy the same ability to wander the galleries by utilizing the bibliography and web links.

Each revision of this text is assisted by the insights of reviewers who are engaged in teaching and research. We are grateful for their insights.

Karen J. Clark, *The Art Institute of Portland*
David A. Cook, *Sterling College*
Peter Forbes, *Syracuse University*
Janet Hayes, *Gibbs College–Norwalk*
Dahn Hiuni, *Kutztown University*
Merrill Krabill, *Goshen College*
Alison Miyauchi, *Alberta College of Art and Design*
Karen-Sam Norgard, *University of Wisconsin–Whitewater*
Thomas F. Schantz, *Kutztown University*
Linda Lee Vanderkolk, *Purdue University*
Catherine C. E. Walker, *East Carolina University*
Sandra Williams, *University of Nebraska–Lincoln*

Supplements Available for Instructors and Students

Web Site

For the first time, *Design Basics* will have a student companion web site (**http://art.wadsworth.com/lauer06/**). The site includes critical thinking exercises, Internet activities, annotated web links, glossary and flashcards, chapter outlines, and project-oriented exercises. The project exercises will help students understand the material through traditional design and computer-based design activities.

WebTutor™ ToolBox

Preloaded with content and available free via PIN code when packaged with the text, WebTutor™ ToolBox pairs all the content of this text's companion Web Site with all the sophisticated course management functionality of a WebTutor™ product. You can assign materials (including online quizzes) and have the results flow automatically to your gradebook. WebTutor™ ToolBox is ready to use as soon as you log on— or you can customize its preloaded content by uploading images and other resources, adding Web links, or creating your own practice materials. Students only have access to student resources on the Web site.

ArtExperience: Fundamentals CD-ROM

This CD-ROM contains studio art demonstrations and numerous interactive exercises covering Visual Elements, Principles of Design, and Style, Form, and Content. Available for packaging with the text.

DESIGN PRINCIPLES

PART 1

Frank Modell. 1956. © *The New Yorker* Collection from
cartoonbank.com. All Rights Reserved.

DESIGN DEFINED

What do you think of when you hear the word "design"? Do you associate design with fashion, architecture, or automotive style? Design has a more universal meaning than the commercial applications that might first come to mind. A dictionary definition uses the synonym "plan": To **design** indeed means to plan, to organize. Design is inherent in the full range of art disciplines as well as in the fields mentioned here.

Visual Organization

Design is essentially the opposite of chance. In ordinary conversation, when we say "it happened by design" we mean something was planned—it did not occur just by accident. People in all occupations plan, but the artist or designer plans the arrangement of elements to form a visual pattern. Depending on the field, these elements will vary—from painted symbols to written words to scenic flats to bowls to furniture to windows and doors. But the result is always a visual organization. Art, like other careers and occupations, is concerned with seeking answers to problems. Art, however, seeks visual solutions in what is often called the design process.

The poster shown in **A** is an excellent example of a visual solution. How the letters are arranged is an essential part of communicating the idea. *Math Rules* **(B)** demonstrates the artist's ability to see a new possibility for numbers as shapes that can form a face. By contrast the report cover shown in **C** is a clever verbal solution (the report is published on recycled material), but the communication is *not* as dependent on the visual composition. All three of these are creative; however, the first two are more visual, whereas *This Annual Report Is Trash* works as a play on words.

Creative Problem Solving

As we have said, the design process involves seeking visual solutions to problems. The arts are called "creative" fields because there are no predetermined correct answers to the problems. Infinite variations in individual interpretations and applications are possible. Problems in art vary in specifics and complexity. Independent painters or sculptors usually create their own "problems" or avenues they wish to explore. The artist can choose as wide or narrow a scope as he or she wishes. The architect or graphic and industrial designer is usually given a problem, often with very specific options and

A

It's Time to Get Organized. 1986. Poster. John Kuchera. Art Director and Designer: Hutchins/Y&R.

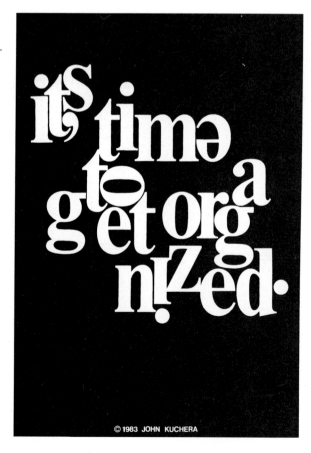

© 1983 JOHN KUCHERA

clearly defined limitations. Students in art classes also usually are in this category—they execute a series of assignments devised by the instructor that require rather specific solutions. However, all art or visual problems are similar in that a creative solution is desired.

The creative aspect of art also includes the often-heard phrase "there are no rules in art." This is true. In solving problems visually, there is no list of strict or absolute dos and don'ts to follow. Given the varied objectives of visual art throughout the ages, definite laws are impossible. However, "no rules" may seem to imply that all designs are equally valid and visually successful. This is not true. Artistic practices and criteria have been developed from successful works, of which an artist or designer should be aware. Thus, guidelines (not rules) exist that usually will assist in the creation of successful designs. These guidelines certainly do not mean the artist is limited to any specific solution.

Content and Form

Discussions of art often distinguish between two aspects, **content** and **form.** Content implies the subject matter, story, or information that the artwork seeks to communicate to the viewer. Form is the purely visual aspect, the manipulation of the various elements and principles of design. Content is what artists want to say; form is how they say it. Problems in art can concern one or both categories.

Sometimes the aim of a work of art is purely **aesthetic.** Take, for example, adornment—subject matter can be absent and the only "problem" one of creating visual pleasure. Purely abstract decoration has a very legitimate role in art. Frequently, however, problems in art have a purpose beyond mere visual satisfaction. Art is, and always has been, a means of visual communication.

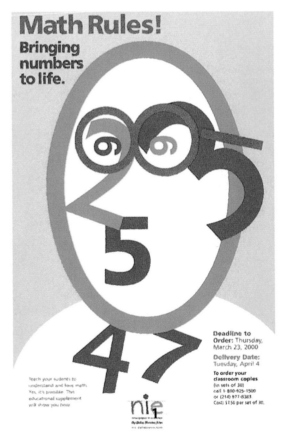

B
Math Rules. 2000. Poster promoting math-oriented educational supplements. Steve Chambers. Print. *Regional Design Annual,* Sept./Oct. 2000, page 140.

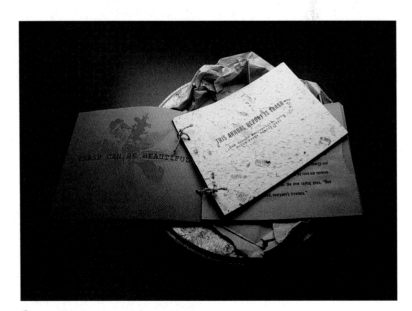

C
This Annual Report Is Trash. 1991. Design Firm: Pattee Design. Client: Des Moines Metropolitan Area Solid Waste Agency. Design Team: Steve Pattee, Kelly Sile. Copywriter: Mike Condon. Printer: Professional Offset Ptg. Papermaker: Jerusalem Paperworks.

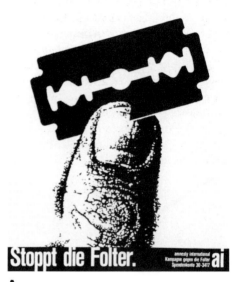

A

Stop Torture. 1985. Poster for Amnesty International. Art Director and Designer: Stephan Bundi. Atelier Bundi, Bern, Switzerland.

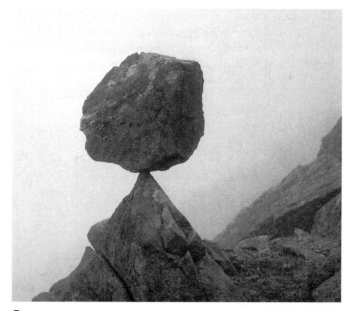

B

Andy Goldsworthy. *Balanced Rock* (Misty, Langdale, Cumbria, May 1977). *Andy Goldsworthy: A Collaboration with Nature,* Harry N. Abrams, Inc., Publishers, New York, 1990.

STEPS IN THE PROCESS

We have all heard the cliché "a picture is worth a thousand words." This is true. There is no way to calculate how much each of us has learned through pictures. Communication has always been an essential role for art. Indeed, before letters were invented, written communication consisted of simple pictorial symbols. Today, pictures can function as a sort of international language. A picture can be understood when written words may be unintelligible to the foreigner or the illiterate. We do not need to understand German to grasp immediately that the message of the poster in **A** is pain, suffering, and torture.

Art as Communication

In art, as in communication, the artist or designer is saying something to the viewer. Here the successful solution not only is visually effective but also communicates an idea. Any of the elements of art can be used in communication. Purely abstract lines, color, and shapes can very effectively express ideas or feelings. Many times communication is achieved through symbols, pictorial images that suggest to the viewer the theme or message. The ingenuity of creative imagination exercised in selecting these images can be important in the finished work's success.

In art, as in communication, images are frequently combined with written words. The advertisements we see every day usually use both elements, coordinated to reinforce the design's purpose.

Countless pictures demonstrate that words are not necessary for communication: Here two examples suggest the idea of balance. In the photograph *Balanced Rock* **(B)** no words are needed to communicate the idea. In **C** the visual and intellectual are combined. We read the word, but the uppercase "E" also provides a visual balance to the capital "B" and the dropped "A" is used as a visual fulcrum.

The Creative Process

These successful design solutions are due, of course, to good ideas. Students often wonder, "How do I get an idea?" Actually almost everyone shares this dilemma from time to time. Even the professional artist can stare at an empty canvas, the successful writer at a blank page. An idea in art can take many forms, varying from a specific visual effect to an intellectual communication of a definite message. Ideas encompass both the areas of content and form.

It is doubtful that anyone can truly explain why or how an answer to something we've been puzzling over appears out of the blue. Our ideas can occur when we are in the shower, mowing the lawn, or in countless other seemingly unlikely situations. But we need not be concerned here with sudden solutions. They will continue to occur, but what happens when

we have a deadline? What can we consciously do to stimulate the creative process? What sort of activities can promote the likelihood that a solution to a problem will present itself?

Many people today are concerned with such questions. A number of worthwhile books and articles have been devoted to the study of the creative process, featuring numerous technical terms to describe aspects of this admittedly complex subject. But we suggest three very simple activities with very simple names:

Thinking
Looking
Doing

These activities are not sequential steps and certainly are not independent procedures. They overlap and may be performed almost simultaneously or by jumping back and forth from one to another. Individuals vary; people are not programmed machines in which rigid step-by-step procedures lead inevitably to answers; people's feelings and intuitions may assist in making decisions. Problems vary so that a specific assignment may immediately suggest an initial emphasis on one of these suggestions. But all three procedures can stimulate the artistic problem-solving process.

BALANCE

C
The layout of the letters conveys the idea by suggesting the word's meaning.

GETTING STARTED

The well-known French artist Georges Braque wrote in his *Cahiers* (notebooks) that "one must not think up a picture." His point is valid; a painting is often a long process that should not be forced or created by formulas to order. However, each day countless designers must indeed "think up" solutions to design problems. Thinking is an essential part of this solution. When confronted by a problem in any aspect of life, the usual first step is to think about it. Thinking is applicable also to art and visual problems. It is involved in all aspects of the creative process. Every step in creating a design involves choices, and the selections are determined by thinking. Chance or accident is also an element in art. But art cannot be created mindlessly, although some twentieth-century art movements have attempted to eliminate rational thought as a factor in creating art and to stress intuitive or subconscious thought. But even then it is thinking that decides whether the spontaneously created result is worthwhile or acceptable. To say that thinking is somehow outside the artistic process is truly illogical.

Thinking about the Problem

Knowing what you are doing must precede your doing it. So thinking starts with understanding the problem at hand:

Precisely what is to be achieved? (What specific visual or intellectual effect is desired?)
Are there visual stylistic requirements (illustrative, abstract, nonobjective, and so on)?
What physical limitations (size, color, media, and so on) are imposed?
When is the solution needed?

These questions may all seem self-evident, but effort spent on solutions outside the range of these specifications will not be productive. So-called failures can occur simply because the problem was not fully understood at the very beginning.

Thinking about the Solution

Thinking can be especially important in art that has a specific theme or message. How can the concept be communicated in visual terms? A first step is to think logically of which images or pictures could represent this theme and to list them or, better yet, sketch them quickly, since a visual answer is what you're seeking. Let's take a specific example: What could visually represent the idea of art or design? Some obvious **symbols** are shown in the designs on these pages, and you will easily think of more. You might expand the idea by discussing it with others. They may offer suggestions you have not considered. Professional designers often are assisted by reports from market surveys that reveal the ideas of vast numbers of people.

Sketch your ideas to see immediately the visual potential. At this point you do not necessarily decide on one idea. But it's better to narrow a broad list to a few ideas worthy of development. Choosing a visual symbol is only the first step. How will you use your choice? The examples shown use only very obvious symbols for art, but in original and unexpected ways:

A fragment of a pencil becomes the subject of a monumental sculpture. **(A)**
Wasted talent is symbolized by a distorted and useless pencil. **(B)**

These designs are imaginative and eye-catching. The symbol was just the first step. *How* that symbol was used provided the unique and successful solution.

Thinking about the Audience

Selecting a particular symbol may depend on limitations of size, medium, color, and so on. Even thinking of future viewers may be an influence. To whom is this visual message addressed? What reaction do you want from this audience? What effect or feeling do you wish to create? To symbolize "art" as a bearded figure in a spattered smock and beret could be humorously effective in some situations yet silly or trivial in others. Undoubtedly, neither of these designs would be appropriate for a serious treatise on aesthetics.

A

Claes Oldenburg. *Proposal for a Colossal Monument in Downtown New York City: Sharpened Pencil Stub with Broken-off Tip of the Woolworth Building.* 1993. Etching with aquatint, 32³/₄ × 22″, edition of 60. Published by Aldo Crommelynck, New York and Paris. Distributed by Pace Editions, Inc. Photo: Ellen Page Wilson. Collection Claes Oldenburg and Coosje van Bruggen.

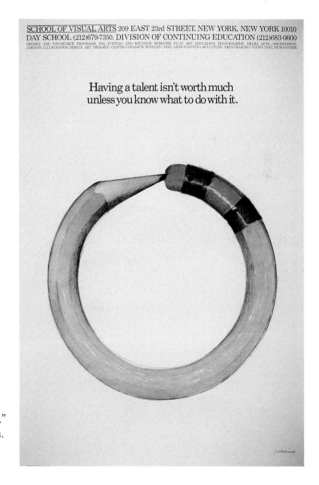

B

"Having a talent isn't worth much unless you know what to do with it." Poster for the School of Visual Arts. 1978. Designer: Tony Palladino. Courtesy of School of Visual Arts.

FORM AND CONTENT

What shall be presented, and how will it be presented? The thinking stage of the design process is often a contest to define this relationship of *form* and *content*. The contest may play itself out in additions and subtractions as a painting is revised or in the drafts and sketches of an evolving design concept. The solution may be found intuitively or be influenced by cultural values, previous art, or the expectations of clients.

Selecting Content

Raymond Loewy's revised logo for the Greyhound Bus Company is an example of content being clearly communicated by the appropriate image or form. The existing logo in 1933 **(A)** looked fat to Loewy, and the chief executive at Greyhound agreed. His revised version **(B)** (based on a thoroughbred greyhound) conveys the concept of speed, and the company adopted the new logo.

Selecting Form

The form an artist selects can also work in unexpected ways to express content. Edgar Heap of Birds presents just such a contradiction of our expectations for printed words. The word "Sooners" (the name given to the early white settlers of Okla-homa) is presented backward in the billboard shown in **C.** This is an immediate signal that something is wrong, whether or not we know the specific history.

What happens when the same form is used to convey opposing content? A billboard showing a model wearing a De Beers diamond **(D)** is replaced by activists to depict a woman from the Bushman group **(E).** The protest image plays off the familiar advertisement to send an unexpected message: "The Bushmen aren't forever."

Form and content issues would certainly be easier to summarize in a monocultural society. Specific symbols may lose meaning when they cross national, ethnic, or religious borders. Given these obstacles to understanding, it is a powerful testimony to the meaning inherent in form when artworks communicate successfully across time and distance.

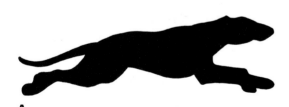

A
Raymond Loewy. Original logo for Greyhound Bus Co.

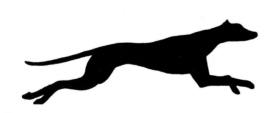

B
Raymond Loewy. Redesigned logo, 1933.

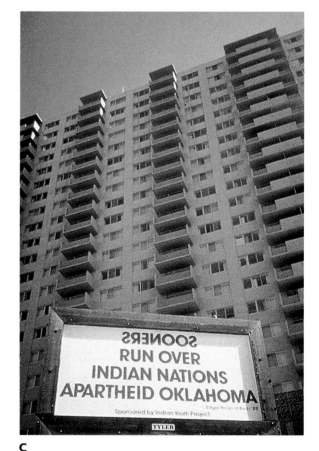

C
Hachivi Edgar Heap of Birds. *Apartheid Oklahoma.* 1989. Billboard, 5 × 10′ (13 × 25 m).

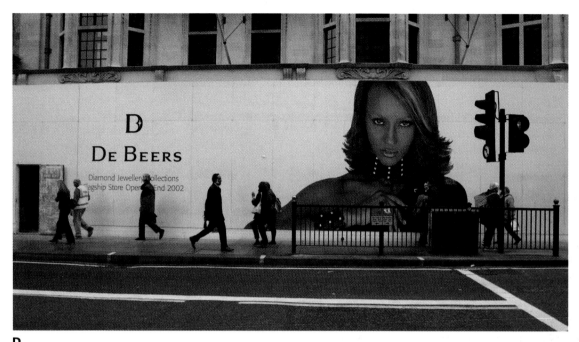

D
"A diamond is forever." De Beers diamond advertisement. Photo by Jonathan Player.
The New York Times. Thursday, November 21, 2002, page W1.

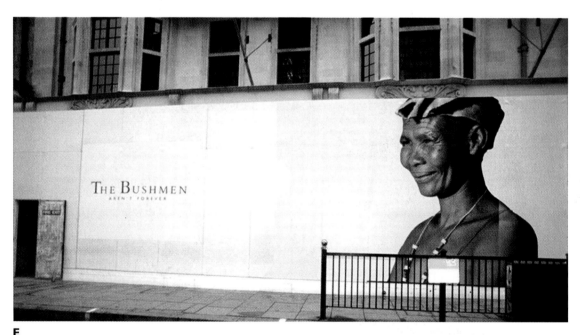

E
"The bushmen aren't forever." De Beers billboard covered by activists. Photo by Tim Mitchell/Survival.
The New York Times, Thursday, November 21, 2002, page W1.

FORM AND FUNCTION

Meaning and utility are least ambiguous when the relationship between form and content is clear and uncluttered. This is true of both images and objects. When such clarity is achieved, we say that form follows function. In this case form is determined by content and function is a priority. This relationship is often easiest to see and acknowledge in utilitarian design, such as the furniture design of the American Shaker movement. The interior presented in **A** reveals a simple, straightforward attitude toward furniture and space design. All the furnishings are functional and free from extraneous decoration. The ladder back of the chair exhibits a second utility when it is hung on the rail. Everything in this space communicates the Shaker value of simplicity.

The *Bookworm* bookshelf shown in **B** is also functional but in a playful and surprising way. This object's form is not dictated by a strict form-follows-function design approach.

This design solution is simple, like Shaker design, but the form expresses a sense of visual delight and humor as well.

Peter Eisenman's Wexner Center for the Arts at The Ohio State University **(C)** is a **site specific** architectural design solution, which takes into account the history of the setting and the context of the surrounding campus plan. The solution for the form of this arts center was influenced by these factors. Eisenman's design includes brick tower structures reminiscent of a former armory building that had been a campus landmark on this site. These new towers act as a visual reminder of the past integrated into an institution that has a mission to respond to art of the present. In this case the form of the architecture attempts to respond to several functional requirements:

house and exhibit contemporary art,
fit into a given setting,
respect the history of the site, and
convey a sense of dynamic future possibilities.

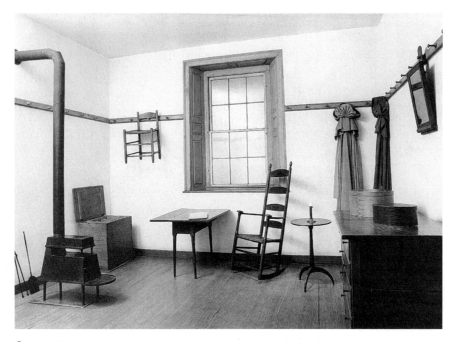

A
Shaker interior. American Museum in Britain, Bath U.K.

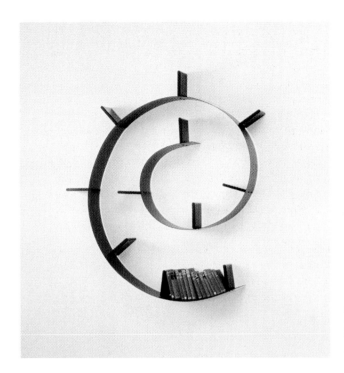

B
Bookworm Shelf. Ron Arad.
Thermoplastic technopolymer,
7.5″ H × 126″ W × 8″ D.

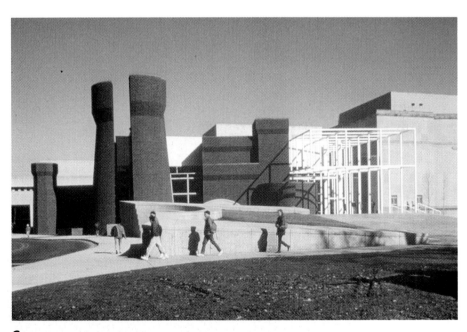

C
Peter Eisenman, Eisenman/Trott Architects, Inc. Wexner Center for the Arts,
The Ohio State University, Columbus, 1989.

SOURCES: NATURE

Looking is probably the primary education of any artist. This process includes observing both nature and human artifacts, including art, design, and commonplace objects. Most artists are stimulated by the visual world around them and learn of possibilities for expression by examining other art. Studying art from all periods, regions, and cultures introduces you to a wealth of visual creations, better equipping you to discover your own solutions.

For better or worse we do not create our design solutions in an information vacuum. We have the benefit of an abundance of visual information coming at us through a variety of media, from books to television. On the plus side, we are treated to images one would previously have had to travel to see. On the minus side, it is easy to overlook that we are often seeing a limited (or altered) aspect of the original artwork by the time we see it in reproduction.

Source versus Subject

Sources in nature and culture are clearly identifiable in the works of some artists, while less obvious in the works of others—perhaps only revealed when we see drawings or preparatory work. In any case a distinction should be made between source and subject. The source is a stimulus for an image or idea. For example, a bone can be the source for a work of sculpture. The **subject,** as mentioned previously, is tied to the content of the work or to the artist's ideas and way of seeing.

A

Henry Moore. *Standing Figure: Knife Edge.* 1961. Bronze, height 9′ 4″ (2.84 m). Reproduced by permission of The Henry Moore Foundation.

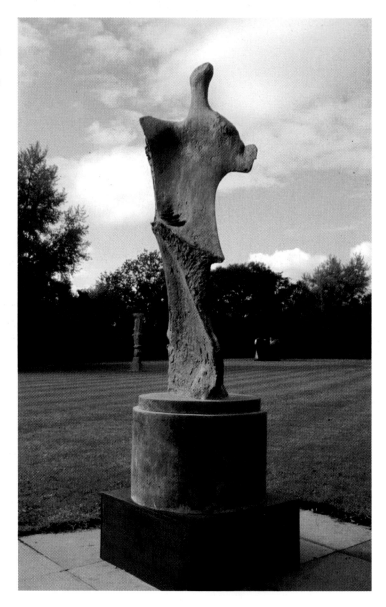

B
Henry Moore's collection of bones.
Reproduced by permission of
The Henry Moore Foundation.

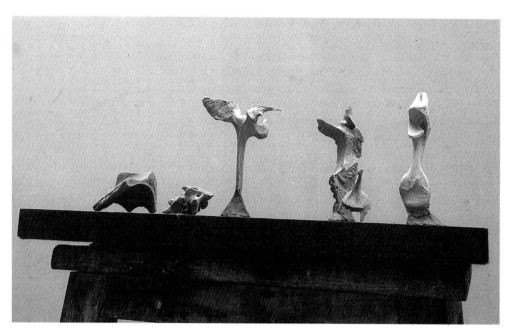

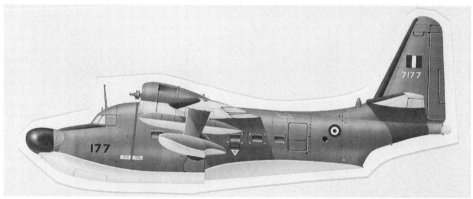

C
Grumman HU–16 Albatross, post-WWII
"utility and rescue amphibian." Bill Gunston,
consultant editor, *The Encyclopedia of World
Air Power,* Aerospace Publishing Limited,
1980, page 165.

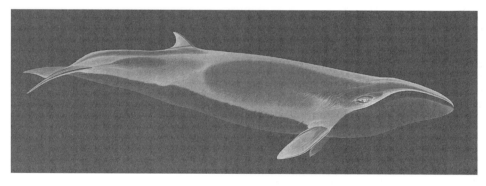

D
Martin Camm, illustrator. Pygmy Right
Whale, *Caperea marginata.* S. hemisphere,
18–21$^{1}/_{2}'$. (5.5–6.5 m). In Cawardine,
Mark, and Martin Camm. *Whales, Dolphins,
and Porpoises* (London: Dorling Kindersley,
1995), p. 48.

The sculptor Henry Moore noted that he had a tendency
to pick up shells at the beach that resembled his current work
in progress. In that way he recognized in nature a resemblance
to forms he was already exploring in the studio. His sculpture
of a mother embracing a child, for example, resembled the
protective wrapping form of a broken shell he found. In turn
the forms from nature he collected came to suggest possibilities
for new figurative pieces. Moore's *Standing Figure* **(A)** bears a
resemblance to various bones in his collection **(B),** but it is not
a copy of any of them.

Sometimes the relationship between a model seen in nature
and a design it inspires may not be as directly revealed as it
is in the case of Henry Moore's sculpture. We can probably
assume that the designers of the seaplane shown in **C** did not
copy the form or light-dark pattern of the whale **(D).** Similar
problems led to similar solutions, however. Both are stream-
lined for easy movement through the water. It is safe to
assume that the engineers and designers did look at models
from nature, and this influenced their solution.

SOURCES: HISTORY AND CULTURE

We expect artists and designers to be visually sensitive people who see things in the world that others might overlook and who look with special interest at the history of art and design.

Jennifer Bartlett's series entitled *In the Garden* consists of dozens of works in a variety of media, including drawings such as **A** and mixed media studies such as **B.** The source of imagery is clearly a garden pool. The subject is the many ways of seeing the garden and thinking about painting. A variety of styles is presented in this series, which reflects both the process of looking at the original source and looking at art from various periods.

Visual Training and Retraining

The art of looking is not entirely innocent. Long before the training in seeing we get in art and design classes, we are trained by our exposure to mass media. Television, film, internet, and print images provide examples that can influence our self-image and our personal relationships. The distinction between "news" and "docudrama" is often a blurry one, and viewers are often absorbed into the "reality" of a movie.

At times it seems that visual training demands a retraining of looking on slower, more conscious terms. "Look again" and "see the relationships" are often heard in a beginning drawing class. Part of this looking process involves examining works of art and considering the images of mass media that shape our culture. Many artists actively address these issues in their art by using familiar images or "quoting" past artworks. While this may seem like an esoteric exercise to the beginning student, an awareness of the power of familiar images is fundamental to understanding visual communication.

Certain so-called high art images manage to become commonly known, or **vernacular,** through frequent reproduction. In the case of a painting like *Washington Crossing the Delaware,* the image is almost as universally recognized as a religious icon once was. There is a long tradition of artists paying homage to the masters, and we can understand how an artist might study this or other paintings in an attempt to learn techniques.

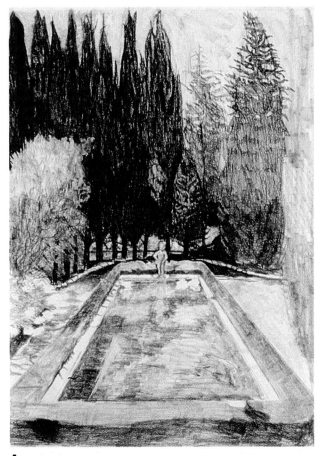

A

Jennifer Bartlett. *In the Garden Drawing #64*. 1980. Pencil on paper, 26 × 19¹/₂″ (66 × 49.5 cm). Courtesy Jennifer Bartlett, New York.

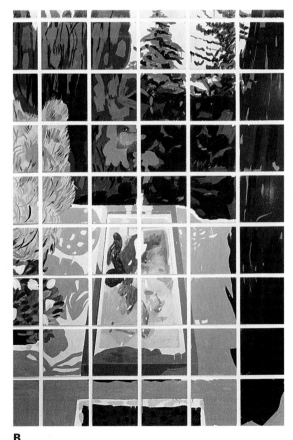

B

Jennifer Bartlett. *Study for In the Garden* (detail: 54 of 270 squares). 1980. Pencil, ink. gouache on paper, 24 × 36″ (61 × 91 cm). Commission, Institute for Scientific Information, Philadelphia. Collection of the artist, New York.

C
Robert Colescott. *George Washington Carver Crossing the Delaware.* 1975. Acrylic on canvas, 54 × 108″. Phyllis Kind Gallery, New York.

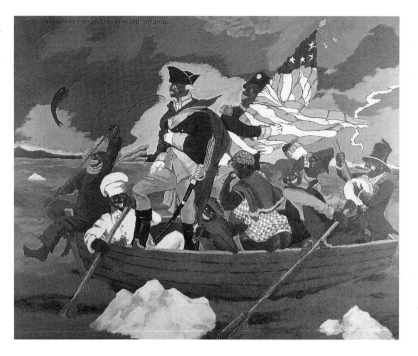

D
James Rosenquist. *Pushbutton.* 1960. Magazine advertisement with tape, pencil, paper, and colored paper mounted on paper, 11$^1/_2$ × 13$^1/_2$″ (29 × 34 cm). Collection of the artist.

E
James Rosenquist. *Pushbutton.* 1961. Oil on canvas, diptych: 82$^3/_4$ × 105$^1/_2$″ (2.1 × 2.68 m). The Museum of Contemporary Art, Los Angeles.

However, *George Washington Carver Crossing the Delaware* **(C)**, by the African American artist Robert Colescott, strikes a different relationship to the well-known painting we recognize as a source. Colescott plays with the familiarity of this patriotic image and startles us with a presentation of negative black stereotypes. One American stereotype is overlaid on top of another, leading the viewer to confront preconceptions about both.

James Rosenquist looks at billboards and advertising images, which form a significant part of our visual environment. He uses the process of **collage** to combine such images **(D)** as a process of discovery and preparation for his painting **(E)**. Looking, then, can be influenced by commercial images, which are as real an aspect of our lives as the elements of nature.

Looking is a complex blend of conscious searching and visual recollections. This searching includes looking at art, nature, and the vernacular images from the world around us, as well as formal research into new or unfamiliar subjects. What we hope to find are the elements that shape our own visual language.

THINKING WITH MATERIALS

Doing starts with visual experimentation. For most artists and designers this is thinking with the materials. Trial and error, intuition, or deliberate application of a system is set into motion. At this point an idea starts to take form, whether in a sketch or in final materials. The artist Eva Hesse got right to the point with her observation on materials:

Two points of view—
1. Materials are lifeless until given shape by a creator.
2. Materials by their own potential created their end.

The work of Eva Hesse is known for embracing apparent contradictions. The studio view **(A)** presents a number of her sculptural works that embody both of the preceding points of view. Hesse gave shape to materials such as papier-mâché, cloth, and wood. There are also elements, such as the hanging, looping, and connecting ropes and cords that reflect the inherent potential of the materials.

Photographs of the sculptor David Smith at work **(B)** show the playful side of doing. We can see the degree to which he allowed the materials to create their own end. Just as a child might delight in building blocks becoming a castle, Smith let the forms of cardboard boxes define the proportions of sculpture he would later complete in steel **(C).** Smith stacked the boxes on a windowsill and taped them to the window as he assembled each study. The influence of the window as a support shows through in the predominantly two-dimensional composition of the final pieces.

Doing and Redoing

When designers leave a record of their drawings, we are able in effect to see them doing their work. This is the case with the construction drawings for Loewy's logo design for Shell **(D).** The four steps depicted lay out the defining geometry of the scallop shell, and the first step shows that a circle provides the underlying form. These four drawings provide the map to the final version **(E),** but undoubtedly other possibilities were explored before this one was settled on. Today, drawings such as these would probably be done on a computer, which can greatly speed up the viewing of alternative possibilities.

The doing step in the design process obviously involves continuous looking and thinking, yet more than one artist, writer, or composer has observed that doing takes over with a life of its own. An artwork takes shape through you, and as it does you may find yourself wondering where the time went or what you were thinking of when a work session ends. This experience is exhilarating but includes the elements of risk and failure.

A wonderful film of the painter Philip Guston at work ends with him covering over his picture with white to begin again. Guston accepted such a setback along the way as normal and even necessary. His experience told him that revision would allow an idea to grow beyond an obvious or familiar starting point.

A
Eva Hesse. *Studio.* 1966.
Installation photograph by
Gretchen Lambert. Courtesy
Robert Miller Gallery.

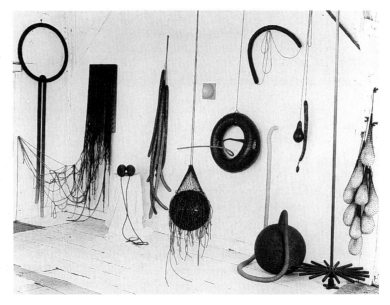

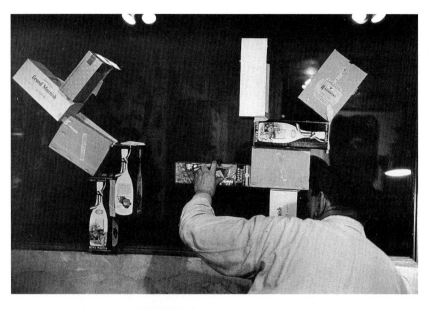

B
David Smith assembling liquor boxes
as models for his sculptures.

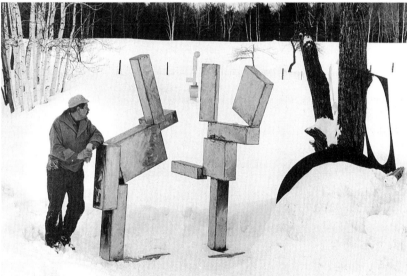

C
David Smith with completed sculptures
Cubi IV and *Cubi V.*

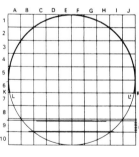
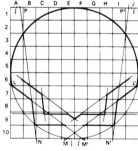
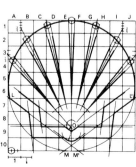
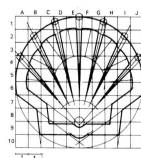

D
Raymond Loewy. Steps in
the development of a new
Shell logo, 1971.

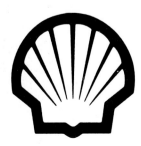

E
Raymond Loewy. Revision
of Shell logo, 1971.

CONSTRUCTIVE CRITICISM

Critique is an integral component of studio education for art students and can take several forms. You could have direct dialogue with a professor in front of a work in progress, or your entire class could review a completed work **(A** and **B).** Critique can also be a self-critique and take the form of a journal entry. The goal of a critique is increased understanding through examination of the project's successes and shortcomings. A variety of creative people, from artists to composers to authors, generally affirm that criticism is best left for *after* the design or composition is completed. A free and flexible approach to any studio work can be stifled by too much criticism too soon.

The components of a constructive critique can vary, but a critique is most valid when linked to the criteria for the art-work, design, or studio assignment. If a drawing's objective is to present an unusual or unexpected view of an object, then it is appropriate to critique the perspective, size, emphasis, and contrast of the drawing—those elements that contribute to communicating the point of view. Such a critique could also include cultural or historic precedents for how such an object might be depicted. A drawing of an apple that has been sliced in half and is seen from above would offer an unusual point of view. An apple presented alongside a serpent would present a second point of view charged with religious meaning for Jews and Christians. Both approaches would be more than a simple representation and would offer contrasting points of view. Nevertheless, both drawings may be subject to a critique of their composition.

A Model for Critique

A constructive model for critique would include the following:

> **Description:** A verbal account of *what* is there.
> **Analysis:** A discussion of *how* things are presented with an emphasis on relationships (for example, "bigger than," "brighter than," "to the left of").
> **Interpretation:** A sense of the meaning, implications, or effect of the piece.

A simple description of a drawing that includes a snake and an apple might lead us to conclude that the drawing is an illustration for a biology text. Further description, analysis, and interpretation could lead us to understand other meanings and the emphasis of the drawing. And, in the case of a critique, thoughtful description, analysis, and interpretation might help the artist (or the viewer) see other, more dynamic possibilities for the drawing.

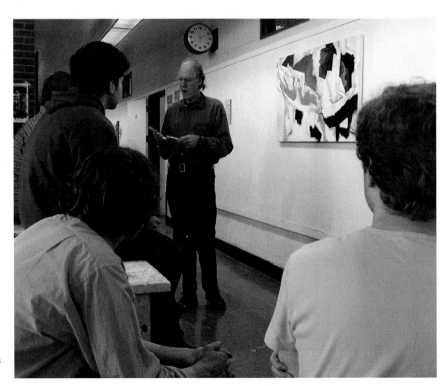

A
A professor critiques
a work in progress.

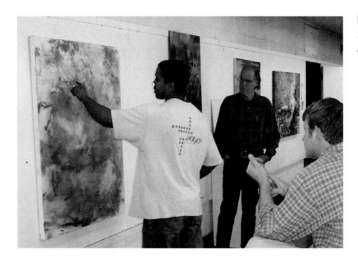

B
Students review and critique
each other's work.

C
Mark Tansey. *A Short History of Modernism.* Oil on canvas, three panels: 58 × 120″ overall.
Collection Steve and Maura Shapiro. Courtesy Gagosian Gallery, New York, with permission
from the estate of Mark Tansey.

The many sections devoted to principles and elements of art and design in this text are each a potential component for critique. In fact the author's observation about an image could be complemented by further critical analysis. For example, the text may point out how color brings emphasis to a composition, and further discussion could reveal other aspects such as size, placement, and cultural context.

The critique process is an introduction to the critical context in which artists and designers work. Mature artworks are subject to critical review, and professional designers submit to the review of clients and members of their design teams.

Future theory and criticism is pushed along by new designs and artworks.

On a lighter note, the critique process can include the range of responses suggested by Mark Tansey's painting shown in **C.**

You may feel your work has been subjected to an aggressive cleansing process.
You may feel you are butting your head against the wall.
And don't forget that what someone takes from an image or design is a product of what they bring to it!

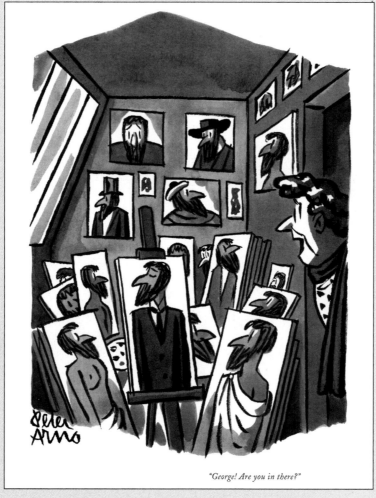

"George! Are you in there?"

Peter Arno. 1970. © *The New Yorker* Collection from cartoonbank.com.
All Rights Reserved.

HARMONY

Unity, the presentation of an integrated image, is perhaps as close to a rule as art can approach. Unity means that a congruity or agreement exists among the elements in a design; they look as though they belong together, as though some visual connection beyond mere chance has caused them to come together. Another term for the same idea is **harmony.** If the various elements are not harmonious, if they appear separate or unrelated, your pattern falls apart and lacks unity.

The image in **A** illustrates the idea of a high degree of unity. When we look at the elements in this design, we immediately see that they are all somewhat similar. This harmony, or unity, is not merely from our recognizing all of the objects are paint cans. Unity is achieved through the repetition of the oval shapes of the cans. Linear elements such as the diagonal shadows and paint sticks are also repeated. The subtle grays of the metal cans unify a composition accented by a few bright colors. Such a unity can exist with either **representational** imagery or abstract forms.

The wrenches in **B** vary with surprising elegance from large to small, simple to complex, and straight to curved. However, a fundamental unity based on a similar shape would be apparent to us even if these were unfamiliar objects.

Seen simply as cutout shapes, the variety of silhouettes in **C** would be apparent. Alex Katz balances this variation with the unity of the repeated portrait of his wife, Ada. This approach of theme and variation is the essence of the concept of unity.

Where Does Unity Come From?

Unity of design is planned and controlled by an artist. Sometimes it stems naturally from the elements chosen, as in these examples. But more often it reflects the skill of the designer to create a unified pattern from varied elements. Another term for "design" is the **composition,** which implies the same feeling of organization. Just as a composition in a writing class is not merely a haphazard collection of words and punctuation marks, so too a visual composition is not a careless scattering of random items around a format.

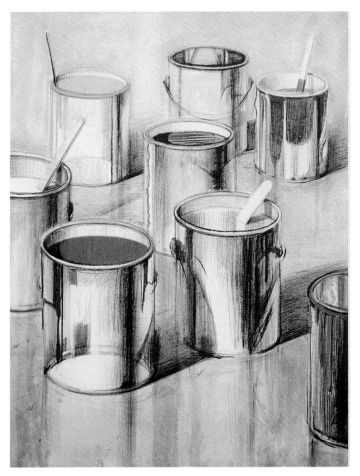

A
Wayne Thiebaud. *Paint Cans.* 1990. Lithograph, hand worked proof, 75.7 × 58.8 cm. DeYoung Museum (gift of the Thiebaud Family, 1995.99.12).

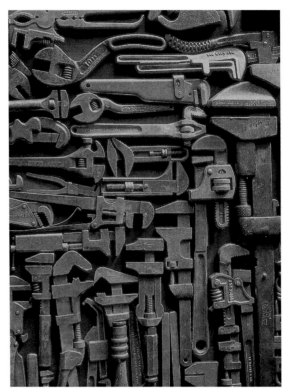

B
Despite differences in appearance, all the objects have characteristics in common. Adjustable-wrench collage illustration (pg. 59) for article on Elmo Rinehart's collection of historic tools. *Smithsonian Magazine,* February 1991.

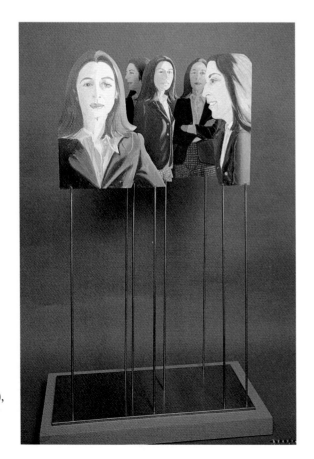

C
Alex Katz. *Black Jacket.* 1972. Oil on aluminum (cutout), $62^5/8 \times 36^1/4''$ (159 × 92 cm). Des Moines Art Center (gift in honor of Mrs. E. T. Meredith, Permanent Collection, 1978.7).

VISUAL UNITY

An important aspect of visual unity is that the whole must be predominant over the parts: You must first see the whole pattern before you notice the individual elements. Each item may have a meaning and certainly add to the total effect, but if the viewer sees merely a collection of bits and pieces, then visual unity doesn't exist.

This concept differentiates a design from the typical scrapbook page. In a scrapbook each item is meant to be observed and studied individually, to be enjoyed and then forgotten as your eye moves on to the next souvenir. The result may be interesting but is not a unified design.

Exploring Visual Unity

The **collage** in **A** is a design. It is similar to a scrapbook in that it contains many diverse images, but we are aware first of the pattern the elements make together, and then we begin to enjoy the items separately.

Do not confuse intellectual unity with visual unity. Visual unity denotes some harmony or agreement between the items that is apparent to the eye. To say that a scrapbook page is unified because all the items have a common theme (your family, your wedding, your vacation at the beach) is unity of idea—that is, a conceptual unity not observable by the eye. A unifying idea will not necessarily produce a unified pattern. The fact that all the elements in **A** deal with African American history is interesting but irrelevant to the visual organization.

The unity in **B** does not derive from recognizing all the items in the design as plant specimens. The visual unity stems from the repetition of spiral forms and curved linear features. Then the variety of thick and thin, darkness, and arrangement add interest.

The need for visual unity does not deny that very often there is also an intellectual pleasure in design. Many times the task of a designer is to convey an idea or theme. Now the visual unity function is important along with an intellectual reading of the design. One example can show this dual appreciation. The poster in **C** is for a series of noontime concerts in downtown Seattle. The unity (and idea) is immediately seen in a design of lined-up lunch bags. Each bag contains an element of the varied programs. Then we realize the bag shapes themselves become like buildings on city blocks with tiny trees to express the "downtown" theme.

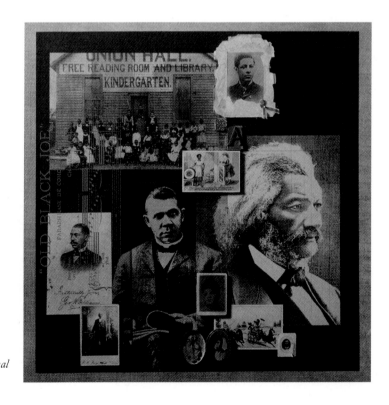

A
Fred Otnes, designer. Collage for *National Geographic* magazine. January 1988.

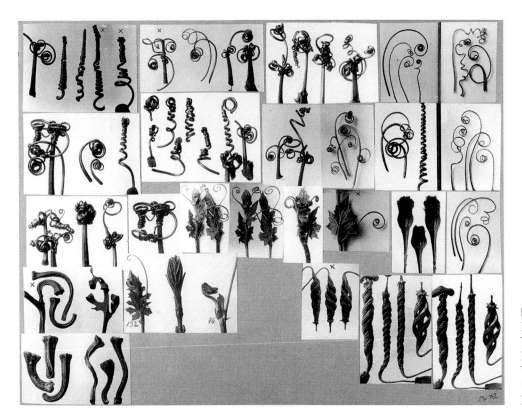

B
Karl Blossfeldt. *Pumpkin Tendrils.*
Works of Karl Blossfeldt by Karl
Blossfeldt Archive. Ann and Jürgen
Wilde, eds., *Karl Blossfeldt: Working
Collages.* MIT Press, Cambridge,
MA, 2001, page 54.

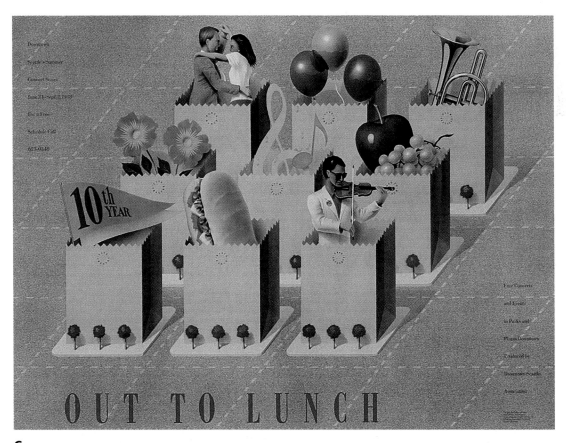

C
Poster for "Out to Lunch" concert series in downtown Seattle. Designers: Pat Hansen,
Jesse Doquilo. Illustrator: Steve Coppin. © Hansen Design Company, Seattle.

A
We instantly see two groups of shapes.

B
The white diagonal is as obvious as the two groups of rectangles.

C
Grouping similar shapes makes us see a plus sign in the center.

D
The circles seem to form "lines," and we see an M-shape.

VISUAL PERCEPTION

The designer's job in creating a visual unity is made easier by the fact that the viewer is actually looking for some sort of organization, something to relate the various elements. The viewer does not want to see confusion or unrelated chaos. The designer must provide some clues, but the viewer is already attempting to find some coherent pattern and unity. Indeed, when such a pattern cannot be found, chances are the viewer will simply ignore the image.

This is one of the conclusions that studies in the area of perception have shown. Since early in the twentieth century, psychologists have done a great deal of research on visual perception, attempting to discover just how the eye and brain function together. Much of this research is, of course, very technical and scientific, but it is useful for the artist or designer

to understand some of the basic findings. The most widely known of these perception studies is called the **gestalt** theory of visual psychology.

How We Look for Unity

Consider a few elementary concepts that only begin to suggest the range of studies in perception. Researchers have concluded that viewers tend to group objects that are close to each other into a larger unit. Our first impression of **A** is not merely some random squares but two groups of smaller elements.

Negative (or empty) **spaces** will likewise appear organized. In **B** viewers immediately see the many elements as two groups. However, with all the shapes ending on two common boundaries, the impression of the slanted white diagonal shape is as strong as the various rectangles.

Also, our brain will tend to relate and group objects of a similar shape. Hence, in **C** a cross or plus sign is more obvious than the allover pattern of small shapes. In **D** the pattern is not merely many circles of various sizes. Instead our eye will close the spaces between similar circles to form a design of "lines." These diagonal lines organize themselves to give the impression of an "M" shape.

The elements that make up the Richard Prince painting shown in **E** are easily identified as three ellipses and a circle in a white field. The close proximity of the four black shapes forms a constellation, and the smaller parts give way to the organization of the larger pattern. In this case it is possible to see this configuration as a startled clownlike face. This reading is assisted by the title (*My Funny Valentine*) but also reveals how easily we project a "face" onto a pattern.

The impulse to form unity or a visual whole out of a collection of parts can also work on an architectural scale. The Beaubourg **(F)** is a contemporary art center in Paris. Conduits and structural features that are usually hidden form the outer shell of the building. This potentially chaotic assortment of pipes and scaffolding is given visual unity by the constant repetition of vertical ducts, square structural framing, and circular openings. This building's distinct appearance stands in contrast to other buildings in the area, further strengthening its visual identity. Our brain looks for similar elements, and when we recognize them we see a cohesive design rather than unorganized chaos.

E
Richard Prince. *My Funny Valentine.* 2001. Acrylic on silk screen frame, 86¹/₂ × 68¹/₂″. Courtesy Barbara Gladstone Gallery, New York.

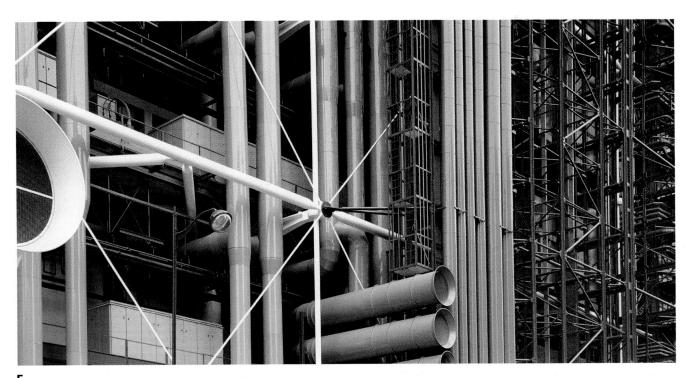

F
Piano & Rogers; Ova Arup & Partners. Centre National d'Art et de Culture Georges Pompidou (Beaubourg) Paris, 1971–77.

A
If they are isolated from one another, elements appear unrelated.

B
Placing items close together makes us see them first as a group.

PROXIMITY

An easy way to gain unity—to make separate elements look as if they belong together—is by **proximity,** simply putting the elements close together. The four elements in **A** appear isolated, as floating bits with no relationship to each other. By putting them close together, as in **B,** we begin to see them as a total, related pattern. Proximity is a common unifying factor. Through proximity we recognize constellations in the skies and, in fact, are able to read. Change the proximity scheme that makes letters into words and reading becomes next to impossible.

Proximity in Composition

Thomas Eakins's painting **(C)** of bathers at a swimming hole shows the idea of proximity in composition. The lighter elements of the swimmers' bodies contrast with the generally darker background. However, these light elements are not placed aimlessly around the composition but, by proximity, are arranged carefully to unite visually. Four of the figures form the apex of an equilateral triangle at the center of the painting. This triangle provides a stable unifying effect.

Elizabeth Osborne's watercolor painting **(D)** is an interesting collection of still-life objects that are grouped in clusters, such as a gently curving line of lemons and oranges. Notice how these small clusters connect, forming the larger constellation of the whole composition. The elements are visually tied together by proximity. Our eyes move smoothly from one item to the next.

Proximity is the simplest way to achieve unity, and many artworks employ this technique. Without proximity (with largely isolated elements), the artist must put greater stress on other methods to unify an image.

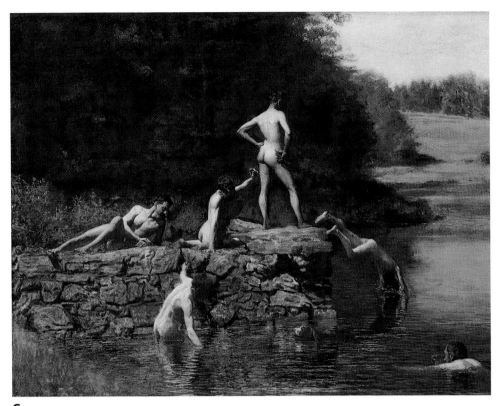

C
Thomas Eakins. *Swimming.* 1885. Oil on canvas, 27 3/8 × 36 3/8″. Collection: Amon Carter Museum, Forth Worth, Texas.

D
Elizabeth Osborne. *Still Life with Red Bowl.* 1979. Watercolor on paper, 30 × 40″ (76 × 102 cm). Private collection. Photo courtesy of Locks Gallery, Philadelphia.

REPETITION

A valuable and widely used device for achieving visual unity is **repetition.** As the term implies, something simply repeats in various parts of the design to relate the parts to each other. The element that repeats may be almost anything: a color, a shape, a texture, a direction, or an angle. In the painting by Sophie Taeuber-Arp **(A),** the composition is based on one shape: a circle with two circular "bites" removed. This shape is repeated in different sizes and positions. The result is a composition that is unified but not predictable.

Tom Friedman's sculpture **(B)** also shows unity by repetition. The obvious aspect is the repetition of the cut pencil fragments. The unity created by these many repeated parts is strengthened by the continuous line and cohesive mass of the assembled form.

Repetition can be a unifying factor in a representational painting. In Degas's *The Millinery Shop* **(C),** notice how often the artist repeats a circle motif. Just as in **A,** circles are a repeating element of visual unity, but now the circles represent objects such as hats, flowers, bows, the woman's head, bosom, skirt, and so forth. The painting is a whole design of circles broken by a few verticals (the hat stand, the ribbons, the back draperies) and a triangle or two (the table, the woman's bent arm, and the front hat's ribbons). When we look beyond the subject matter in art, we begin to recognize the artist's use of repetition to create a sense of unity.

See also: *Rhythm,* pages 104–115.

A
Sophie Taeuber-Arp. *Composition with Circles Shaped by Curves.* 1935. Gouache on paper, 13⅞ × 10⅝″ (35 × 27 cm). Kunstmuseum Bern (gift of Mrs. Marguerite Arp-Hagenbach).

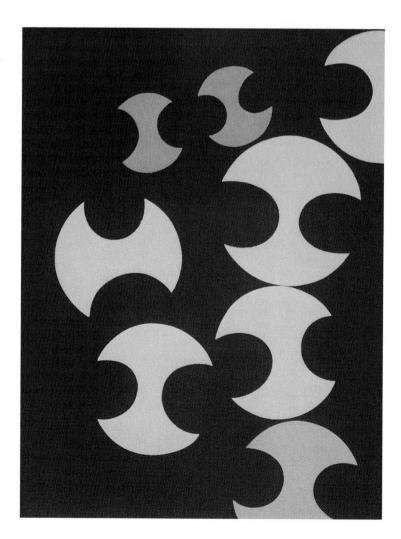

B
Tom Friedman. *Untitled.* 1995. Pencils cut at
45-degree angles and glued in a continuous
loop, 11 × 14 × 11″. *Affinities: Chuck Close
and Tom Friedman* (Exhibition Catalog).
The Art Institute of Chicago, 1996.
Collection of Zoe and Joel Dictrow.

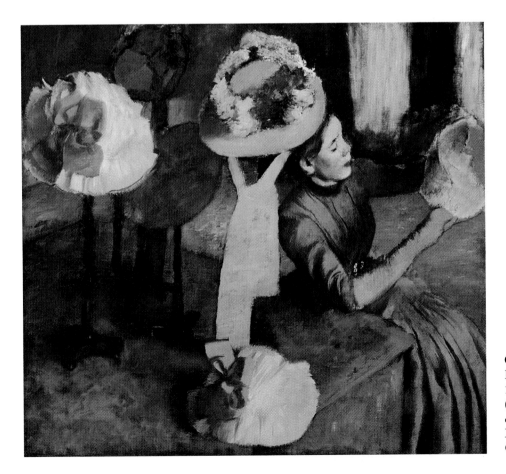

C
Edgar Degas. *The Millinery Shop.*
1884–1890. Oil on canvas, 39 1/8 × 43 3/8″
(100 × 110.7 cm). Photograph courtesy
of The Art Institute of Chicago (Mr. and
Mrs. Lewis Larned Coburn Memorial
Collection, 1933.428).

CONTINUATION

A third way to achieve unity is by **continuation,** a more subtle device than proximity or repetition, which are fairly obvious. Continuation, naturally, means that something "continues"—usually a line, an edge, or a direction from one form to another. The viewer's eye is carried smoothly from one element to the next.

The design in **A** is unified by the closeness and the character of the elements. In **B,** though, the shapes seem even more of a unit because they are arranged in such a way that one's vision flows easily from one element to the next. The shapes no longer float casually. They are now organized into a definite, set pattern.

Continuation Can Be Subtle or Deliberate

The edge of the sleeping girl's head and her outstretched arm connect to the curving line of the sofa, forming one line of continuity in *The Living Room* **(C).** Other subtle lines of continuation visually unite the many shapes and colors of what might otherwise be a chaotic composition.

A deliberate or more obvious form of continuation is a striking aspect in many of Jan Groover's photographs. In one series of photographs, she would catch passing trucks as an edge of the truck would visually align with a distant roofline or a foreground pole. This alignment would connect these disparate elements for an instant, resulting in a unified image. In **D** Groover employs a more subtle form of continuation, which results in a fluid eye movement around the picture. One shape leads to the next, and alignments are part of this flow.

Three-Dimensional Design

Continuation is not only an aspect of two-dimensional composition. Three-dimensional forms such as the automobile shown in **E** can utilize this design principle. In this case the line of the windshield continues in a downward angle as a line across the fender. A sweeping curve along the top of the fender also connects the headlight and a crease leading to the door handle.

A
Proximity and similarity unify a design.

B
The unity of the same elements is intensified.

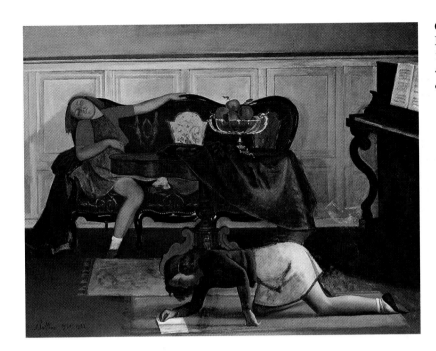

C
Balthus (Balthasar Klossowski de Rola).
The Living Room. 1941–1943. Oil on canvas,
$44^1/_2 \times 57^3/_4''$. The Minneapolis Institute
of Arts.

D
Jan Grover. *Untitled.* 1987. Gelatin-silver
print, $11^{15}/_{16} \times 14^{15}/_{16}''$ (30×38 cm).
Janet Borden, Inc.

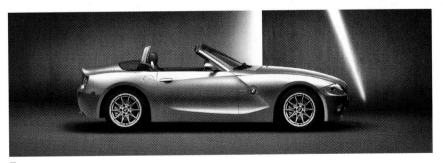

E
2003 BMW Z4 Roadster. Courtesy BMW of North America, LLC.

CONTINUITY

As we have learned, continuation is the planned arrangement of various forms so that their edges are lined up—hence forms are "continuous" from one element to another within a design.

Serial Design

The artist has almost unlimited choices in how to apply the concept of continuation in a single design. The task changes, however, when there are multiple units. The artist's job now is not only to unify one design, but to create several designs that somehow seem to relate to each other. In other words, all the designs must seem part of a "series." In a series the same unifying theme continues in successive designs. This is not an unusual job for a designer. Countless books, catalogs, magazines, pamphlets, and so on all require this designing skill.

Using a Grid

Continuity is the term often used to denote the visual relationship between two or more individual designs. An aid often used in such serial designs is the grid. The artist begins by designing a **grid,** a network of horizontal and vertical intersecting lines that divide the page and create a framework of areas, such as in **A.** Then this same "skeleton" is used on all succeeding pages for a consistency of spacing and design results throughout all the units. To divide any format into areas or modules permits, of course, innumerable possibilities, so there is no predetermined pattern or solution. In creating the original grid, there are often numerous technical considerations that would determine the solution. But the basic idea is easily understood.

Using the same grid (or space division) on each successive page might suggest that sameness, and hence boring regularity, would result from repetition. This, however, is not necessarily true. A great deal of variety is possible within any framework, as the varied page layouts in **B** and **C** show.

Grid Design on the Internet and in Corporate Identity

As the computer has gained importance in graphic design, formats based on the grid have become even more common and can be seen in web site designs on the Internet. The grid alone is no guarantee of a successful or dynamic composition, however, as can be seen in the range of quality in home page designs.

Sometimes a company will use the same grid on all its publications in order to create a corporate identity through shared visual unity. We are all familiar with examples of this strategy. Sometimes a company, over a period of weeks or months, runs a series of advertisements that have an identical layout. The illustrations and copy change, but the basic space division stays the same. Often a single glimpse of the page identifies the advertiser in our minds because we are already so familiar with the overall format.

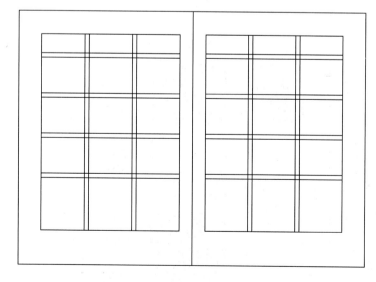

A
A grid determines page margins and divides the format into areas used on successive layouts.

Opposite:

B
A grid need not lead to boring regularity in page design.

C
Wide variety is possible within the basic framework.

ARCHITECTURE

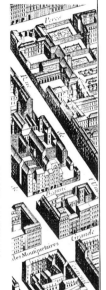

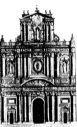

MUSIC

THE GRID

The word "design" implies the idea that the various components of a visual image are organized into a cohesive pattern. A design must have visual unity.

Using the Grid Effectively

The checkerboard pattern in **A** has complete unity. We can easily see the constant repetition of shape and the obvious continuation of lined-up edges. Unhappily, the result is also quite boring. The design in **B** has the same repetitive division of space, but it doesn't seem quite as dull. There are now some changes (or variations) that make this design a bit more interesting to the eye. In **C** the variations have been enlarged so we can almost forget the dull checkerboard in **A,** but the same underlying elements of unity are still present. This is the basis of the principle of unity with variety. There is an obvious, underlying feeling of unity, yet variations enliven the pattern.

Shapes may repeat, but perhaps in different sizes; colors may repeat, but perhaps in different values.

In the collage by Rauschenberg **(D),** an underlying feeling of a checkerboard is again the basic space division. The feeling now is more casual and fluid. In an irregular way, the elements vary in size and color. There is not the rigid lining up of edges as seen in **A.** Our attention first is directed to the contrasting variety of historical art images. But the basic planned structure is also clear and provides a framework.

The watercolor depiction of animal designs shown in **E** is organized in a grid but does not resemble a checkerboard. Each design is unique but is unified by similar style and the compositional structure of the grid.

A point to remember is that, with a great variety of elements, a simple layout idea can give needed unity and be very effective.

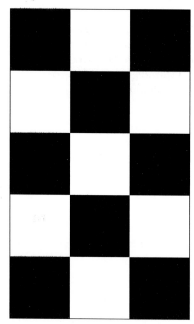

A
A checkerboard shows perfect unity.

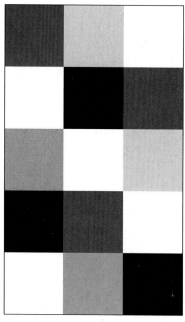

B
Some variations in the basic pattern increase interest.

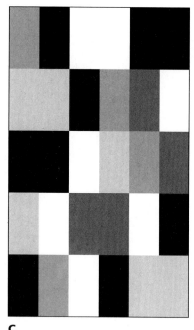

C
More variation possibilities are endless.

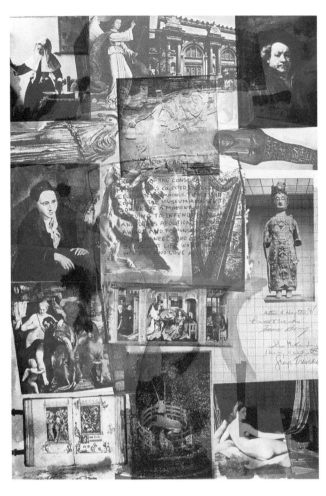

D

Robert Rauschenberg. *Centennial Certificate.* 1969.
Color lithograph, 35⁷/₈ × 25″ (91 × 64 cm).
The Metropolitan Museum of Art, New York
(Florence and Joseph Singer Collection,
1969.630).

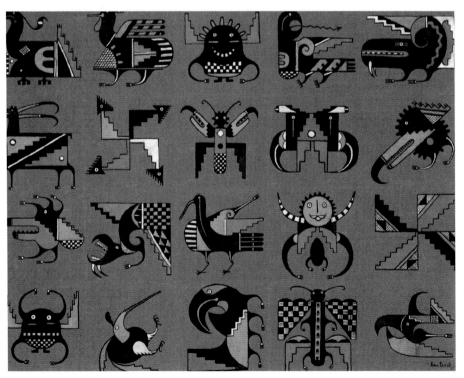

E

Awa Tsireh. *Animal Designs.* ca. 1917–1920.
Watercolor on paper sheet, 20¹/₁₆ × 26¹/₈″
(50.9 × 66.2 cm). Smithsonian American Art
Museum, Corbin-Henderson Collection
(gift of Alice H. Rossin).

VARIED REPETITION

Is the principle of unity with variety a conscious, planned ingredient supplied by the artist or designer, or is it something that a confident designer produces automatically? There is no real answer. The only certainty is that the principle can be seen in art from every period, culture, and geographic area.

Variety Adds Visual Interest

The sculpture in **A** is composed of three separate forms. Unity is evident in the similar twisting and curved shapes. Variety is achieved by position (standing or reclining), size, and difference in proportion of the curved features.

The use of unity with variety displayed in the collection of photographs **(B)** suggests a more rigid approach. The individual subject of industrial buildings might not catch our attention, but the variety displayed in the grid format immediately invites comparison and contrast. The idea of related variations seems to satisfy a basic human need for visual interest that can be arrived at without theoretical discussions of aesthetics.

A conscious (or obvious) use of unity with variety does not necessarily lessen our pleasure as viewers. A very obvious use of the principle is not a drawback. Valerie Clarke's work in **C** immediately shows unity. Thirteen photographs of the same size are lined up. The background white wall repeats, and the line of the bench continues from one photograph to another. We then concentrate on the various poses of the women artists and the surprise of one empty frame. This obvious use of unity with variety was certainly carefully planned. But the result puts the emphasis where it was intended—on the figures.

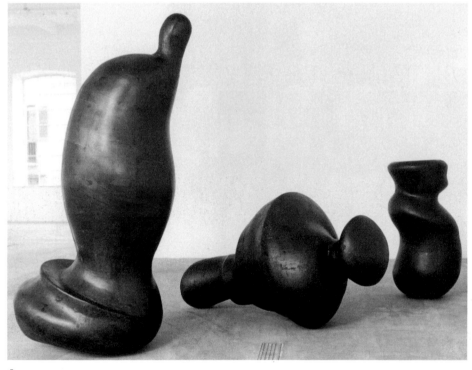

A
Tony Cragg. *Rational Beings.* 1995. Styrofoam sheets, carbon fiber mesh, mixed media, 9³/₄ × 4¹/₂ × 5′. Marian Goodman Gallery, New York.

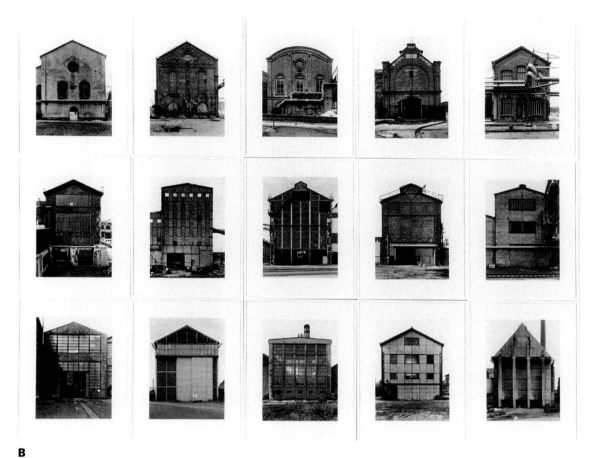

B

Bernd and Hilla Becher. *Industrial Facades.* 1970–92. Fifteen black-and-white photographs, overall: 68³/₄ × 95″ (installed as a group). Albright-Knox Art Gallery, Buffalo, New York (Sarah Norton Goodyear Fund, 1995).

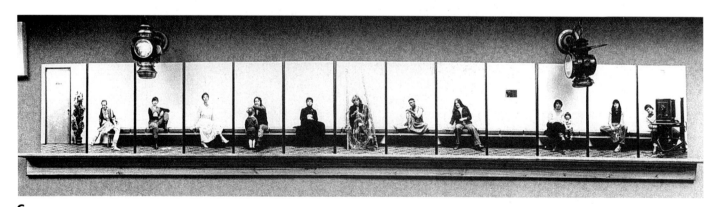

C

Valerie Clarke. *The Waiting Room.* 1984. Thirteen photographic panels, 25″ × 15′ (64 cm × 4.6 m). Installation, The Women's Center, University of Michigan–Flint.

EMPHASIS ON UNITY

In the application of any art principle, wide flexibility is possible within the general framework of the guideline. So it is in unity with variety. To say a design must contain both the ordered quality of unity and the lively quality of variety does not limit or inhibit the artist. The principle can encompass a wide variety of extremely different visual images and can even be contradicted for expressive purposes.

Unity through Repetition

These pages show successful examples in which the unifying element of repetition is emphasized. Variety is present, but admittedly in a subtle, understated way. The Diane Arbus photograph shown in **A** intrigues us in the same way we are fascinated in life when we meet identical twins. Such perfect repetition is unexpected, so we proceed to search for the tiny differences and variety we know exist in nature and, hence, in art.

We know at a glance that all the plants depicted in **B** are irises. As with other Japanese screens from this period, the composition is strongly unified by repetition of natural forms. But this is not wallpaper. No two leaves or flowers are identical, and the eye is rewarded with subtle variation on a constant theme.

The visual unity gained by repetition is immediately apparent, in fact almost overwhelmingly so, in **C.** Here is an example of a rigid unity quite unlike the graceful unity of the Japanese screen. The thirty-two identical life-size figures seated at the table with palms down on the flat surface and eyes cast downward are unsettling in their unity through repetition. The effect is similar to an irrational bad dream. Unity without variety can evoke our worst feelings about assembly lines and institutions.

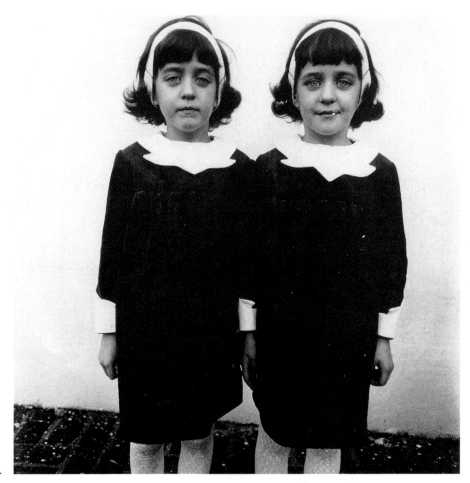

A
Diane Arbus. *Identical Twins, Roselle, NJ, 1967.* 1967. Photograph. Photo courtesy Robert Miller Gallery, New York.

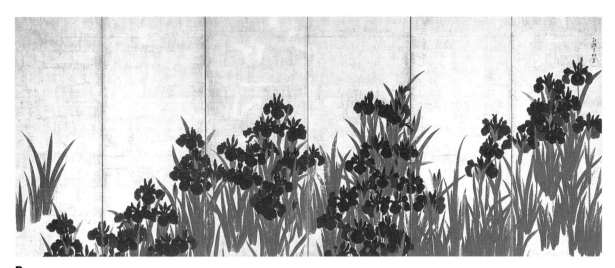

B
Ogata Korin. *Irises.* Edo period, c. 1705. Screen. Nezu Art Museum, Tokyo.

C
Katharina Fritsch. *Tischgesellschaft (Company at Table).* 1988. Thirty-two life-size polyester figures, wooden table and benches, partially painted; printed and bleached cotton, 4' 7¹/₈" × 52' 6" × 5' 8⁷/₈" (1.4 × 16 × 1.75 m). On permanent loan from the Collection of Dresdner Bank Frankfurt am Main to the Museum für Moderne Kunst, Frankfurt am Main.

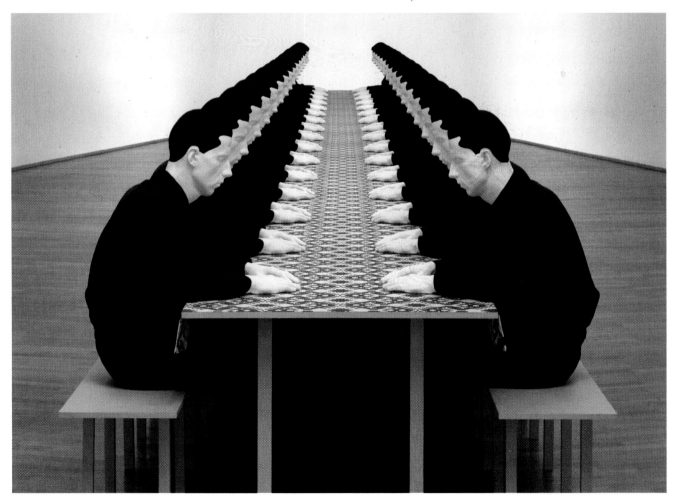

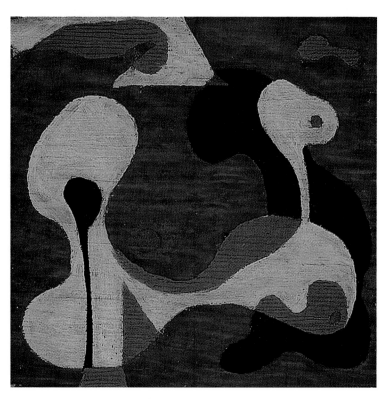

Ray Eames. Painting. Gouache on varnished plywood. Courtesy Eames Office.

EMPHASIS ON VARIETY

Two artists argue over a painting:

> "This painting is great because of the unity of similar shapes," says the first.
> "You're crazy! It is the variety and contrasts that make it great!" says the second.

And both might be right.

Life is not always orderly or rational. To express this aspect of life, many artists have chosen to underplay the unifying components of their work and let the elements appear at least superficially uncontrolled and free of any formal design restraints. The examples here show works in which the element of variety is strong.

Variety in Shapes, Sizes, Colors, Patterns

The painting shown in **(A)** demonstrates unity by an emphasis on curved shapes. Variety is achieved through a simple range of colors, sizes, negative shapes, and placement. A bland unity is avoided since no two shapes are exactly alike. The variety possible in a limited vocabulary is emphasized.

Tony Cragg's piece shown in **B** is apparently a precarious arrangement of balanced glass vessels of different sizes and shapes. Such a collection might start with a playful impulse like a house of cards. "Playful" is a term often applied to such a design, and it should not be interpreted as a disparaging adjective. Play by nature is fun, casual, and offers the unexpected. In art we often find it balanced by a corresponding discipline elsewhere. In this case the varied forms and arrangements are brought together by Cragg's use of color as a unifying element.

An aggressive near ugliness pervades the chaotic jumble of battered texts in George Herms's **assemblage** sculpture **(C)**. A first impression might be of materials out of control and barely hanging together. One can find, however, an intellectual unity of purpose in the imagery and visible text. A visual unity is also at work in the strong cross-like structure and a limited range of colors dominated by brown, black, and white.

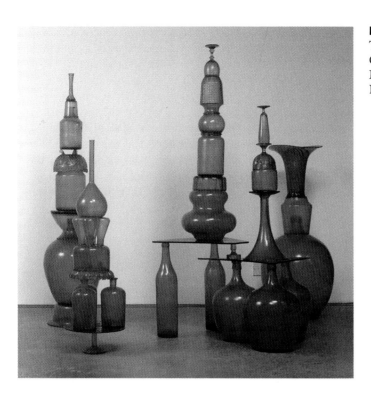

B
Tony Cragg. *Bromide Figures.* 1992.
Glass, 133 × 172 × 135 cm.
Marian Goodman Gallery,
New York.

C
George Herms. *The Librarian.* 1960.
Assemblage: wood box, papers, brass
bell, books, painted stool, 4′ 9″ × 5′ 3″
× 21″ (1.4 m × 1.6 m × 53 cm).
Norton Simon Museum, Pasadena
(gift of Molly Barnes, 1969).

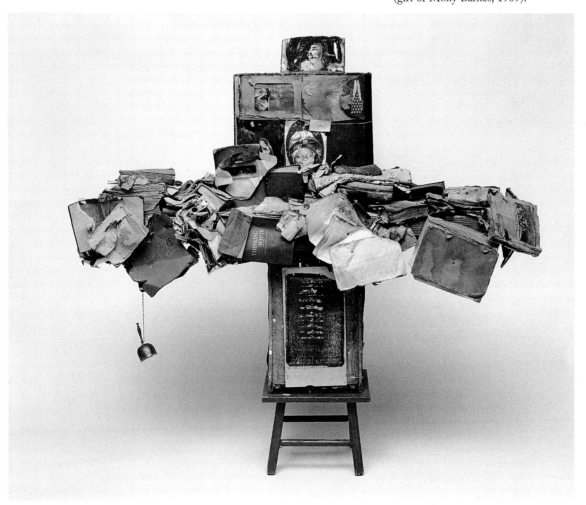

CHAOS AND CONTROL

Without some aspect of unity, an image or design becomes chaotic and quickly "unreadable." Without some elements of variety, an image is lifeless and dull and becomes uninteresting. Neither utter confusion nor utter regularity is satisfying.

The photograph of a commercial strip shown in **A** reveals a conflicting jumble of **graphic** images, each vying for our attention. In this case information overload cancels out the novelty or variety of any single sign and leaves us confused with the chaotic results.

The photo in **B** reveals the bland unity of a housing sub-division. There is an attempt at variety in the facades, but the backs of the homes are identical. After a number of years,

personal variations may show in paint color, landscaping, and sometimes eccentric renovations. Such expressions can bring about conflict between conformity and individuality.

The model for the Frank Gehry-designed Guggenheim Museum at Bilbao **(C)** offers a dramatic but coherent emphasis on variety. The various sweeping curves provide a contrast to the other straight and angular architectural features. Within the curves are a variety of directions, sizes, and shapes. In this case a variety of architectural forms was made possible by the use of computer design software developed for airplane design. Here you can see the power of variety to offer contrast within a unified whole.

A
Signs create a visual clutter along old Route 66 in Kingman, Arizona.

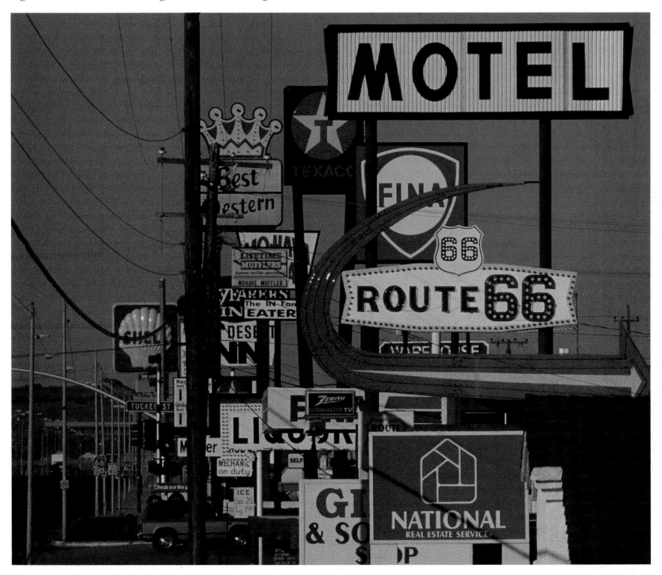

B
The bland unity of a housing subdivision.

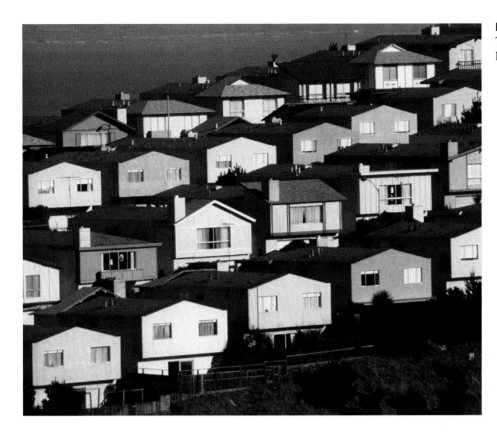

C
Frank Gehry. Model of Guggenheim Museum. Bilbao, Spain.

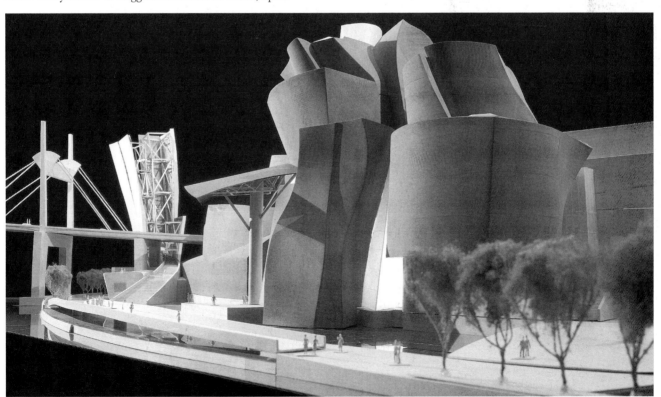

"*Oh, look! I think I see a little bunny.*"

Whitney Darrow Jr., 1946. © *The New Yorker* Collection from cartoonbank.com.
All Rights Reserved.

CHAPTER **3**

ATTRACTING ATTENTION

There are very few artists or designers who do not want people to look at their work. In past centuries, when pictures were rare, almost any image was guaranteed attention. Today, with photography and an abundance of books, magazines, newspapers, signs, and so on, all of us are confronted daily with hundreds of pictures. We take this abundance for granted, but it makes the artist's job more difficult. Without an audience's attention, any message, any artistic or aesthetic values, are lost.

How does a designer catch a viewer's attention? How does the artist provide a pattern that attracts the eye? Nothing will guarantee success, but one device that can help is a point of emphasis or **focal point.** This emphasized element initially can attract attention and encourage the viewer to look closer.

Using Focal Point for Emphasis

Every aspect of the composition in **A** emphasizes the grapefruit at center stage. The grapefruit shape is large, centered, light and yellow (compared with darker gray surroundings), and even the lines of the sections point to the center. All of these elements bring our focus to the main character or subject. This is the concept of a focal point.

Even in purely abstract or nonobjective patterns, a focal point will attract the viewer's eye and give some contrast and visual emphasis. The painting by Stuart Davis **(B)** is a pattern of simple, bold forms in bright, flat colors. The more complicated curving black shape near the center provides a change and becomes the focal point.

The photograph in **C** is a view of an ordinary street scene. The large pine tree might go unnoticed in a stroll through the neighborhood. Several things contribute to the emphasis on this tree in the photograph: placement near the center, large size, irregular shape, and dark value against the light sky.

There can be more than one focal point. Sometimes an artwork contains secondary points of emphasis that have less attention value than the focal point. These are called accents. However, the designer must be careful. Several focal points of equal emphasis can turn the design into a three-ring circus in which the viewer does not know where to look first. Interest is replaced by confusion: When everything is emphasized, nothing is emphasized.

A
Susan Jane Walp. *Grapefruit with Black Ribbons,* 2000. Oil on linen, 8 × 8 1/4″. Tibor de Nagy Gallery, New York.

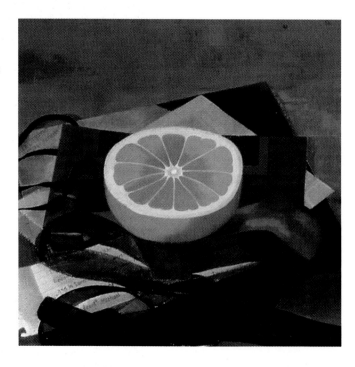

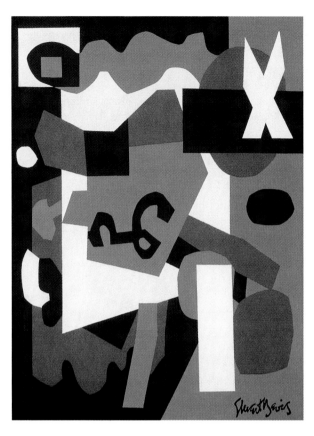

B
Stuart Davis. *Ready-to-Wear*. 1955. Oil on canvas,
56 × 42″ (142.9 × 106.7 cm). The Art Institute of
Chicago (gift of Mr. and Mrs. Sigmund Kunstadter
and Goodman Fund, 1956.137).

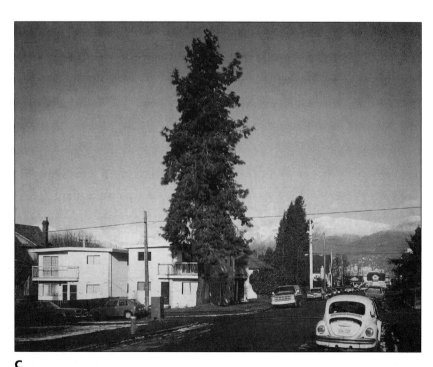

C
Jeff Wall. *The Pine on the Corner*. 1990. 3′ 10³/4″ × 3′ 10¹/4″ (1.19 × 1.48 m).
Edition of 3. Marian Goodman Gallery, New York.

EMPHASIS BY CONTRAST

Very often in art the pictorial emphasis is clear, and in simple compositions (such as a portrait) the focal point is obvious. But the more complicated the pattern, the more necessary or helpful a focal point may become in organizing the design.

Creating a Focal Point through Contrast

As a general rule, a focal point results when one element differs from the others. Whatever interrupts an overall feeling or pattern automatically attracts the eye by this difference. The possibilities are almost endless:

When most of the elements are dark, a light form breaks the pattern and becomes a focal point.

When most of the elements are muted or soft-edged, a bold contrasting pattern will become a focal point **(A)**.

In an overall design of distorted expressionistic forms, the sudden introduction of a naturalistic image **(B)** will draw the eye for its very different style.

Text or graphic symbols will be a focal point (in this case the number *16*) **(C)**.

When the majority of shapes are rectilinear and angular parallelograms, round shapes stand out **(D)**.

This list could go on and on; many other possibilities will occur to you. Sometimes this idea is called emphasis by contrast. The element that contrasts with, rather than continues, the prevailing design scheme becomes the focal point.

Color is an element often used to achieve emphasis by contrast. A change in color or a change in brightness can immediately attract our attention.

See also: *Devices to Show Depth: Size,* page 180; *Value as Emphasis,* page 228; *Color as Emphasis,* page 252.

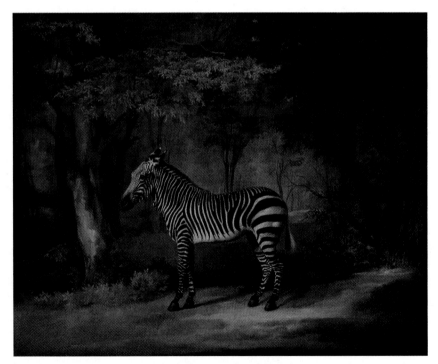

A

George Stubbs. *Zebra.* 1763. Oil on canvas, 40$^{1/2}$ × 50$^{1/4}$″.
Yale Center for British Art, Paul Mellon Collection.

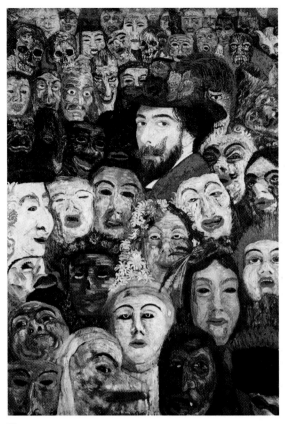

B
James Ensor. *Self-Portrait Surrounded by Masks.* 1899.
Oil, 47¹/₂ × 31¹/₂″ (121 × 80 cm). Sammlung Cleomir
Jussiant, Antwerp.

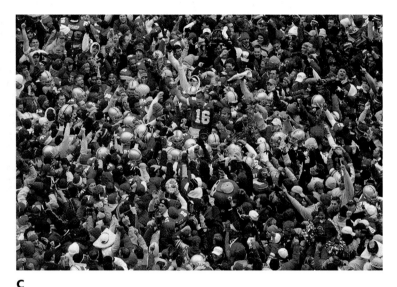

C
Karl Kuntz (photographer). *Columbus Dispatch.*
Sunday, November 24, 2002.

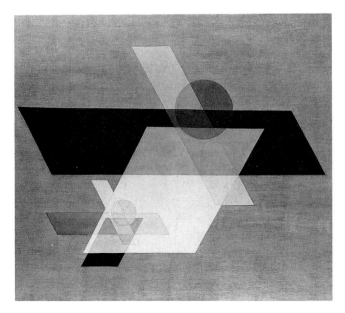

D
László Moholy-Nagy. *A II.* 1924. Oil on canvas,
45⁵/₈ × 53⁵/₈″ (1.16 × 1.36 m). Solomon R.
Guggenheim Museum, New York.

A
Call for entries for AIGA/New York show, "Take Your Best Shot." Designer: Michael Beirut, Vignelli Associates, New York.

EMPHASIS BY ISOLATION

A variation on the device of emphasis by contrast is the useful technique of emphasis by isolation. There is no way we can look at the design in **A** and not focus our attention on that element at the bottom. It is absolutely identical with all the elements above. But simply by being set off by itself, it grabs our attention. This is contrast, of course, but it is contrast of placement, not form. In such a case, the element, as here, need not be any different from the other elements in the work.

Creating a Focal Point through Isolation

In the painting by Eakins **(B)** the doctor at left repeats the light **value** of the other figures in the operating arena. All of the figures in this oval stand out in contrast to the darker figures in the background. Isolation gives extra emphasis to this doctor at the left.

Sanctuary **(C)** is a rather haunting painting and could even be said to have isolation as its subject. A reclining figure lies adjacent to and almost part of a wall. Together they form a unit isolated within a large space. In the space to the right of the wall sit two severe chairs, also set apart from the figure. Tension is created between two isolated focal points.

In neither of these examples is the focal point directly in the center of the composition. This placement could appear too obvious and contrived. However, it is wise to remember that a focal point placed too close to an edge will tend to pull the viewer's eye right out of the picture. Notice in Eakins's painting **(B)** how the curve of the oval on the left side and the doctor looking toward the action at right keep the isolated figure from directing our gaze out of the picture. In **C** a repetition of the large light squares of window space connect the two sides of the picture and the two focal points.

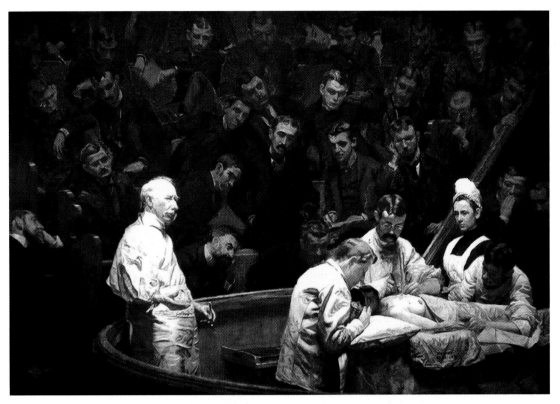

B
Thomas Eakins. *The Agnew Clinic.* 1889. Oil on canvas, 6′ 2¹/₂″ × 10′ 10¹/₂″ (1.9 × 3.3 m).
University of Pennsylvania Art Collection, Philadelphia.

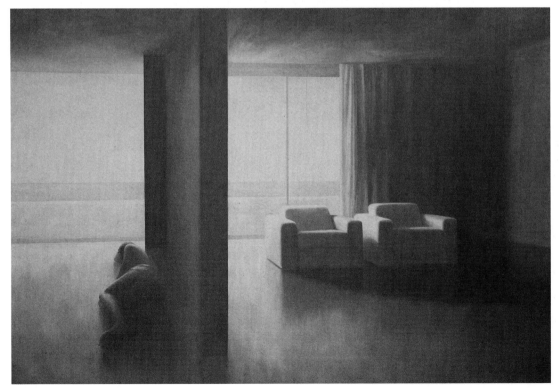

C
Scott Siedman. *Sanctuary.* 1985. Acrylic on canvas, 6 × 9′ (1.83 × 2.74 m).
Courtesy of the artist.

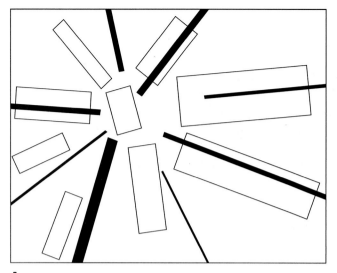

A

Our eyes are drawn to the central element of this design by all the elements radiating from it.

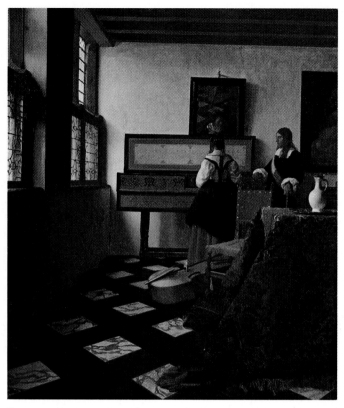

B

Jan Vermeer. *A Lady at the Virginals with a Gentleman (The Music Lesson).* 1662–64. Oil on canvas, 29 × 25". The Royal Collection, London.

EMPHASIS BY PLACEMENT

The placement of elements in a design may function in another way to create emphasis. If many elements point to one item, our attention is directed there, and a focal point results. A radial design is a perfect example of this device. Just as all forms radiate from the convergent focus, so they also repeatedly lead our eyes back to this central element. As **A** illustrates, this central element may be like other forms in the design; the emphasis results from the placement, not from any difference in character of the form itself.

Creating a Focal Point through Placement

Radial designs are more common in architecture or the craft areas than in two-dimensional art. In pictures perspective lines can lead to a point of emphasis and the result can be a radial

design. In Vermeer's painting **(B)** the girl is the focal point, and the perspective lines of the interior all direct our eyes back to the figure. It is a mark of the subtlety and complexity of Vermeer's work that the painting is not simply constructed to point to the main figure but also unfolds other areas of interest and keeps our attention and interest.

The placement of the most famous apple of all time is also near the center of **C**. This is a busy, crowded painting, and the passing of the apple takes place at the intersection of the tree trunk and the lines formed by the arms of Adam and Eve. The composition has an equal balance to the left and right of this focal point and the key element is emphasized.

Both **B** and **C** succeed because the focal point for each does not have to compete with other elements for prominence.

See also: *Symmetrical Balance,* page 86; *Radial Balance,* page 100.

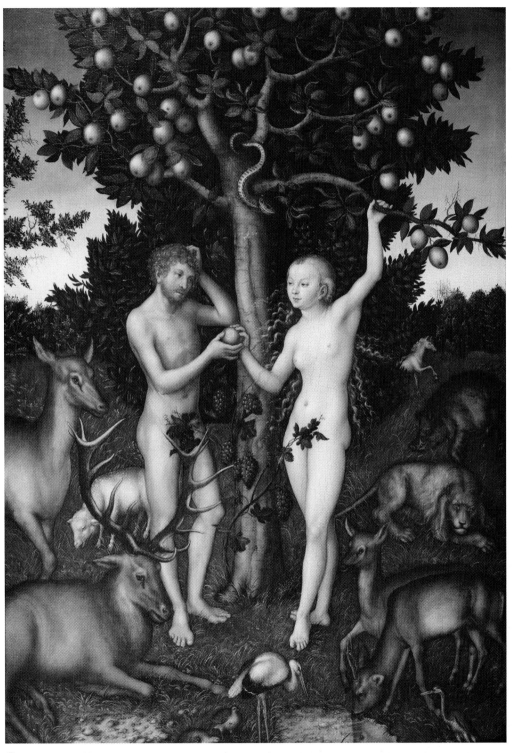

C
Lucas Cranach the Elder. *Adam and Eve.* 1526. Oil on panel, 46⅛ × 31¾″ (117 × 80 cm).
Courtauld Gallery, Courtauld Institute, London.

A
Cover of *Seattle Weekly* newspaper. November 18, 1992. Designer: Fred Andrews, Quickfish Media, Inc. Photographer: David Lee, Warner Bros.

ONE ELEMENT

A specific theme may, at times, call for a dominant, even visually overwhelming focal point. The use of a strong visual emphasis on one element is not unusual.

In the graphic design of newspaper advertisements, billboards, magazine covers, and so on, we often see an obvious emphasis on one element. This can be necessary to attract the viewer's eye and present the theme (or product) in the few seconds most people look casually at such material. The very large-scale "X" in **A** is also a bright orange against the black-and-white background photograph. It is an immediate focal point, attracts our attention to the page, and also conveys an idea of the theme of the article.

Maintaining Unity with a Focal Point

A focal point, however strong, should remain related to and a part of the overall design. The "X" in **A** is visually dominating, yet is related to other elements in placement and character.

Contrast the effect in **A** with that in **B**. In **B** the focal point is obvious again. But here the rectangular shape at the center is very different from the network of lines forming the rest of the design. To a lesser extent the same observation might apply to the painting by Bonnard **(C)**. The isolated black oval tray in the center foreground is clearly a focal point. In this case it seems too dominant; this sudden dark spot seems out of keeping with the subtle value and color changes in the rest of the painting.

In general, the principle of unity and the creation of a harmonious pattern with related elements is more important than the injection of a focal point if this point would jeopardize the design's unity. In Juan Gris's still life **(D)**, the massed group of linear circles defining the bunch of grapes is a focal point. But the values of this element are repeated in several other places. Circular forms are seen elsewhere as well—the bottle top and glass bottom repeat the same small linear circle motif. The established focal point is not a completely unrelated element.

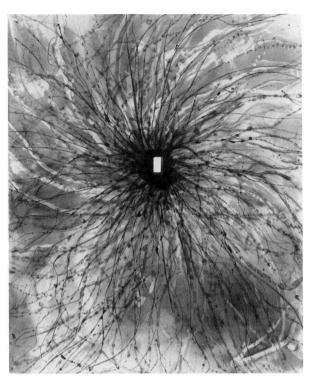

B
Anish Kapoor. *Door.* 1991. Spit bite aquatint,
28 × 24″ on 36 × 30³/4″ sheet. Edition 20.
Printed by Lawrence Hamlin.

C
Pierre Bonnard. *Coffee.* c. 1915. Oil on canvas, 28³/4 × 41⁷/8″
(73 × 106.4 cm). Tate Gallery, London. Reproduced by
courtesy of the Trustees.

D
Juan Gris. *The Grape (Bottle, Glass and Fruit Dish).*
1921. Oil on canvas, 24 × 20″ (61 × 50 cm).
Kunstmuseum Basel (Emmanuel Hoffman
Foundation, Permanent Loan to the Oeffentliche
Kunstsammlung Basel).

EMPHASIZING THE WHOLE OVER THE PARTS

A definite focal point is not a necessity in creating a successful design. It is a tool that artists may or may not use, depending on their aims. An artist may wish to emphasize the entire surface of a composition over any individual elements. Lee Krasner's painting **(A)** is an example. Similar shapes and textures are repeated throughout the painting. These shapes and textures form loose rows and columns and a kind of grid. The artist creates an ambiguous visual environment that is puzzling. Dark and light areas repeat over the surface in an even distribution, and no one area stands out. The painting has no real starting point or visual climax.

The painting by Alan Crockett shown in **B** is less dense than **A,** and by comparison it seems open and airy. Although it is not as grid-like as the Krasner painting, it does disperse the viewer's attention across the entire composition. In this case a similarity of marks and a variety of line directions throughout the painting emphasize the whole over the parts. The variety of colors against a white ground keeps our eye moving from mark to mark.

The still photograph of Bill Viola's video installation *The World of Appearances* **(C)** exhibits no emphasis or focal point. This artwork develops slowly as a video in extreme slow motion. At one time a figure becomes a strong focal point. Later, after a dramatic splash, the image of water settles into a surface of ripples and waves with no distinct focus. Tension is followed by activity and that is followed by a quieter contemplative play of light and color. In an installation such as this, the viewer can replace a depicted figure as the focal point.

See also: *Crystallographic Balance,* page 102.

A
Lee Krasner. *Untitled.* 1949. Oil on composition board, 48 × 37″ (122 × 94 cm). The Museum of Modern Art, New York (gift of Alfonso A. Ossorio).

B
Alan Crockett. *Funny Farm.* 1997. Oil, wax on linen, 38 × 23″.

C
Bill Viola. *The World of Appearances.* 2003. Video installation
at James Cohan Gallery, New York.

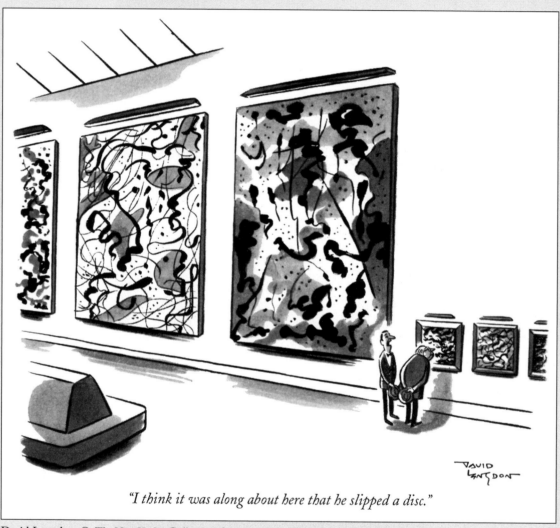

"I think it was along about here that he slipped a disc."

A

Richard Roth. *Untitled.* 1983. Installation:
11′ diameter (3.4 m) sphere with red stool.
© 1993 Richard Roth.

SCALE AND PROPORTION

"Scale" and "proportion" are related terms in that both basically refer to size. Scale is essentially another word for size. "Large scale" is a way of saying big, and "small scale" means small. Big and small, however, are relative. What is big? Big is meaningless unless we have some standard of reference. A big dog means nothing if we do not know the size of an average dog. This is what distinguishes the two terms. **Proportion** refers to relative size—size measured against other elements or against some mental norm or standard.

The small stool and the clues given by the architecture of the space provide a scale reference for judging the size of the sphere in **A.** Because a sphere has no inherent scale reference, we depend on the context to judge its size. In **A** the sphere is almost oppressively large in proportion to the setting. Imagine the same sphere outdoors seen from an airplane. It might have the same visual impact as a period on this page.

We often think of the word "proportion" in connection with mathematical systems of numerical ratios. It is true that historically many such systems have been developed. Artists have attempted to define the most pleasing size relationships in items as diverse as the width and length of sides of a rectangle to parts of the human body.

Using Scale and Proportion for Emphasis

Scale and proportion are closely tied to emphasis and focal point. The lemon and strawberry depicted in Glen Holland's painting **(B)** are at a one-to-one (1:1) scale, so the painting is obviously small. However, the proportion of these subjects to the rest of the painting and the unusual point of view lend a monumental feeling to these humble subjects.

In past centuries visual scale was often related to thematic importance. The size of figures was based on their symbolic importance in the subject being presented. This use of scale is called **hieratic scaling.** Saint Lawrence is unnaturally large compared with the other figures in the fifteenth-century painting in **C.** The artist thus immediately establishes not only an obvious focal point but indicates the relative importance of Saint Lawrence to the other figures.

See also: *Devices to Show Depth: Size,* page 180.

B
Glen Holland. *Sweet & Sour.* 1998. Oil on wood, actual size. Fischbach Gallery, New York.

C
Fra Filippo Lippi. *Saint Lawrence Enthroned with Saints and Donors.* Altarpiece from the church of the Villa Alessandri, Vincigliata Fiesole. c. late 1440s. Tempera on wood, gold ground. Overall, with added strips: 47.75 × 45.5″ (121.3 × 115.6 cm). The Metropolitan Museum of Art, New York (Rogers Fund, 1935).

HUMAN SCALE REFERENCE

One way to think of artistic scale is to consider the scale of the work itself—its size in relation to other art, in relation to its surroundings, or in relation to human size. Unhappily, book illustrations cannot show art in its original size or scale. Unusual or unexpected scale is arresting and attention-getting. Sheer size does impress us.

When we are confronted by **frescoes** such as the Sistine chapel ceiling, our first reaction is simply awe at the enormous scope of the work. Later we study and admire details, but first we are overwhelmed by the magnitude. The reverse effect is illustrated in **A.** It comes as a shock to realize that this portrait is a mere 1⁵/₈″ in diameter. The exquisite detail and delicate precision at this scale is impressive. Our first thought has to be of the fantastic difficulty of achieving this effect in so tiny a format.

The Power of Unusual Scale

If large or small size springs naturally from the function, theme, or purpose of a work, an unusual scale is justified.

We are acquainted with many such cases. The gigantic pyramids made a political statement of the Pharaoh's eternal power. The elegant miniatures of the religious Book of Hours **(B)** served as inspirational illustrations for the private devotionals of medieval nobility. The small scale is appropriate to private reflection.

The Chinese medallion in **C** compresses a world of details—figures, landscape, and architecture—into a 3¹/₂″ diameter circle. An immensity of information is rendered on an intimate scale.

The scale of **D** illustrates the opposite approach. Kent Twitchell's enormous wall painting dwarfs even today's large billboards. The car photographed in the foreground gives a feeling of the work's tremendous size. Naturalistic images blown up to such monumental scale cannot be ignored, and they alter the urban environment.

A
Nicholas Hilliard. *Self-Portrait.* 1577.
Watercolor on vellum. Diameter: 1⁵/₈″ (4 cm).
© The Board of Trustees of the Victoria and Albert Museum, London.

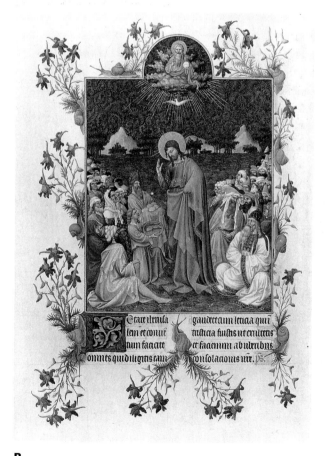

B
Limbourg Brothers. *Multiplication of the Loaves and Fishes,* from the *Book of Hours (Les Très Riches Heures)* of the Duke of Berry. 1416. Manuscript illumination, 6¹/₄ × 4³/₈″ (16 × 11 cm). Musée Condé, Chantilly.

C
Medallion. Ming Dynasty, late 16th–early 17th century. Ivory, bone, and horn.
Front: carved in high relief with scene of the return by moonlight of a party from a
"spring outing." Ivory. Diameter: 3³/₈″ (8.6 cm). The Metropolitan Museum of Art,
New York.

D
Kent Twitchell. Mural for L.A. Marathon. 1988–90. Hwy. I-405. San Diego Freeway.

A
Nazca earth drawing. Spider. Approximately 150′ long.

CONTEXT

Earthworks are unique in the grandeur of their scale. The Nazca earth drawing **(A)** is pre-Columbian in origin. Its original function or meaning has been lost and is the subject of much speculation. With a length of 150 feet it can really only be seen properly from the air! A sense of scale can be determined by the tire tracks around the perimeter of the spider.

Claes Oldenburg has made use of a leap of scale in his *Typewriter Eraser* **(B).** As with the work of other **pop artists,** this piece calls attention to an everyday object not previously considered worthy of aesthetic consideration. Oldenburg transforms the object by elevating it to a monumental scale. A magnification such as this allows us to see the form with fresh eyes, and, as a result, we might discover new associations, such as the graceful strands of the brush, which project upward like a fountain. It can also be argued that Oldenburg makes monuments appropriate to a consumer culture.

The mural for Gajol (a licorice ad) shown in **C** takes up the whole side of a building. Its visual impact is due in part to the simplicity of the design over such a large surface. One small circle becomes a bit of licorice, while another in a triangle becomes an eye. These smaller elements give meaning to what would otherwise be simply an unusual and very large curving shape. The proportion of smaller to larger elements gives definition to this large-scale advertisement.

Consider Location

Here again the idea of proportion can be relevant. Works of art are often selected (or created) for specific locations, and their size in proportion to the setting is a prime consideration. A small religious painting appropriate in scale for a side chapel could be visually lost on the altar of a vast cathedral.

B
Claes Oldenburg and Coosje van Bruggen.
Typewriter Eraser, Scale X. 1999. Stainless
steel and cement. Approximately 20′ tall.
National Gallery of Art, Sculpture Garden,
Washington, D.C. (gift of The Morris and
Gwendolyn Cafritz Foundation, 1998.150.1).

C
Per Arnoldi. Mural for Gajol Licorice. Denmark.

A

Changes in scale within a design also change the total effect.

INTERNAL PROPORTIONS

The second way to discuss artistic scale is to consider the size and scale of elements within the design or pattern. The scale here, of course, is relative to the overall area of the format—a big element in one painting might be small in a larger work. Again, we often use the term "proportion" to describe the size relationships between various parts of a unit. To say an element in a composition is "out of proportion" carries a negative feeling, and it is true that such a visual effect is often startling or unsettling. However, it is possible that this reaction is precisely what some artists desire.

The three examples in **A** contain the same elements. But in each design the scale of the items is different, thus altering the proportional relationships between the parts. This variation results in very different visual effects in the same way that altering the proportion of ingredients in a recipe changes the final dish. Which design is best or which we prefer can be argued. The answer would depend on what effect we wish to create.

Using Scale to Effect

Look at the difference scale can make in a painting. The images in **B** and **C** both deal with the same topic: the well-known story of Christ's last supper with His disciples before the crucifixion. In Ghirlandaio's painting **(B)** all the figures are quite small. They are placed within a large, airy, and open space. The regular placement of the figures at the table and the geometric, repeating elements of the architecture give a feeling of calm and quiet order. *The Last Supper* by Nolde **(C)** is, indeed, in a different style of painting, but a major difference in the two works is the use of scale within the picture. Nolde's figures are large scale, crammed together in a constricting space. The result is crowded and claustrophobic. Nolde focuses our attention on the intense emotions of the event. The harsh drawing, agitated brushwork, and distortion of the figures enforce the feeling. Both artists relate the same story, but they have very different goals. The choice of scale is a major factor in achieving each artist's intention.

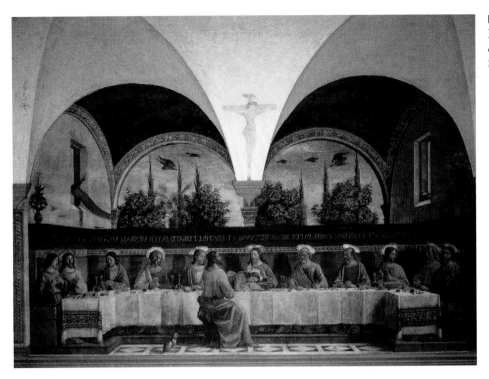

B
Domenico Ghirlandaio. *Last Supper.*
c. 1480. Fresco, 25′ 7″ (8 m) wide.
San Marco, Florence.

C
Emil Nolde. *The Last Supper.* 1909.
Oil on canvas, 34⅝ × 42½″
(88 × 108 cm). Statens Museum
for Kunst, Copenhagen.

A
Mark Fennessey. *Insects IV.* 1965–66.
Wash, 29 × 20″ (73.6 × 50.7 cm).
Yale University Art Gallery (transfer
from the Yale Art School).

CONTRAST OF SCALE

Unexpected or Exaggerated Scale

An artist may purposely use scale to attract our attention
in different ways. For example, we notice the unexpected or
exaggerated, as when small objects are magnified or large ones
are reduced. The wash drawing in **A** is startling, here seen
enlarged to page-filling size. Just the extreme change in scale
attracts our attention. The opposite approach is shown in **B.**
Here the purposeful use of the very tiny figures contrasts with
a vast space-evoking anxiety.

Unexpected scale is often used in advertising. As visual
attention must be directed to a product, we regularly see
layouts with a large package, cookie, automobile grille, or
cereal flake, for example. A sudden scale change surprises us
and gets our attention.

Large and Small Scale Together

The use of large or small scale is often employed in painting
or design. However, a more common practice is to combine the
two for a dramatic contrast. In the Degas painting **(C)** a very
large-scale lady at the right looks out of her box seat at the
theater. On the stage in the background, the figures gradually
diminish in size as distance increases. The woman's fan, far
larger than a group of dancers, provides scale contrast and
visual interest.

B
Gilbert Li. *Social Insecurity.* 2001.
Design Firm: Up Inc. (Toronto,
Canada). Client: Alphabet City, Inc.
$7^3/_8 \times 10^7/_8''$, 342 pages.

C
Edgar Degas. *Dancer with a Bouquet of
Flowers.* c. 1878–1880. Oil on canvas,
$15^7/_8 \times 19^7/_8''$ (40 × 50 cm). Museum
of Art, Rhode Island School of Design,
Providence, RI (gift of Mrs. Murray S.
Danforth).

SURREALISM AND FANTASY

The deliberate changing of natural scale is not unusual in painting. In religious paintings many artists have arbitrarily increased the size of the Christ or Virgin Mary figure to emphasize philosophic and religious importance.

Some artists, however, use scale changes intentionally to intrigue or mystify us rather than to clarify the focal point. **Surrealism** is an art form based on paradox, on images that cannot be explained in rational terms. Artists who work in this manner present the irrational world of the dream or nightmare—recognizable elements in impossible situations. The painting by Magritte **(A)** shows one such **enigma,** with much of the mystery stemming from a confusion of scale. We identify the various elements easily enough, but they are all the wrong size and strange in proportion to each other. Does the painting show an impossibly large comb, shaving brush, bar of soap, and other items, or are these normal-sized items placed in a dollhouse? Neither explanation makes rational sense.

A scale change can be an element of fantasy like the small door that Alice can't fit through until she shrinks in *Alice in Wonderland.* The city skyline shown in **(B)** is almost convincing but also more than just a bit "off." In fact, it is the *New York–New York* Hotel in Las Vegas. The cars in the photograph betray the actual size of this Vegas fantasy.

Charles Ray's *Family Romance* **(C)** radically demonstrates the impact of a side-by-side scale change. In this case the adult figures are reduced in scale, and the children are presented at closer to actual scale. This comparison reveals the difference in bodily proportions for adults and children.

Magritte would say that such artworks provoke a "crises of the object." They cause us to pause and reconsider how we know things.

A

René Magritte. *Personal Values(Les Valeurs Personnelles).* 1952. Oil on canvas, 31¹/₂ × 39³/₈″ (80.01 × 100.01 cm). Private collection, Belgium.

B
New York–New York Hotel & Casino.
Las Vegas, Nevada.

C
Charles Ray. *Family Romance.* 1993.
Mixed media, edition of 3, 54 × 96 × 24″
(137 × 244 × 61 cm). Regen Projects,
Los Angeles.

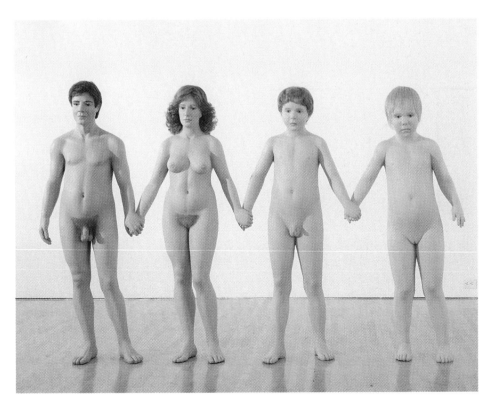

NOTIONS OF THE IDEAL

Proportion is linked to ratio. That is to say, we judge the proportions of something to be correct if the ratio of one element to another is correct. For example, the ratio of a baby's head to its body is in proportion for an infant but would strike us as out of proportion for an adult. In a life drawing class, you might learn that an adult is about seven-and-a-half heads tall. Formulas for the ideal figure have at times had the authority of a rule or canon. Contemporary art or design seldom seems based on such canons, but you may have noticed the apparent standard of "ten heads tall" in the exaggerated proportions of fashion illustration.

The ancient Greeks had a desire to discover ideal proportions, and these took the form of mathematical ratios. They found the perfect body to be seven heads tall and even idealized the proportions of the parts of the body. In a similar fashion they sought perfect proportions in rectangles employed in architectural design. Among these rectangles the one most often cited as perfect is the **golden rectangle.** While this is certainly a **subjective** judgment, the golden rectangle has influenced art and design throughout the centuries. The fact that this proportion is found in growth patterns in nature and lends itself to a modular repetition has given it some authority in the history of design.

Finding the Golden Rectangle

The proportions of the golden rectangle can be expressed in the ratio of the parts to the whole. This ratio (called the ratio of the **golden mean**) is width is to length as length is to length plus width (w:l as l:l + w). This rectangle can be created by rotating the diagonal of a half-square, as shown in **A.** Both the entire rectangle created and the smaller rectangle attached to the original square are golden rectangles in their proportions.

The ratio of the golden mean can be found in the Fibonacci Sequence, a counting series where each new number is the sum of the previous two: 1, 1, 2, 3, 5, 8, 13, 21, 34, and so on. The irrational number 21/34 is approximately .618 and is represented by the Greek letter ϕ.

We see this 3:5 ratio expressed in music (harmonies of thirds, fifths, and octaves), and we find it in growth patterns in nature. With research you can find numerous examples of these proportions in nature, the human body, and design.

In art the 3:5 proportion is well suited to figure (vertical) **(B)** and landscape (horizontal) **(C)** paintings.

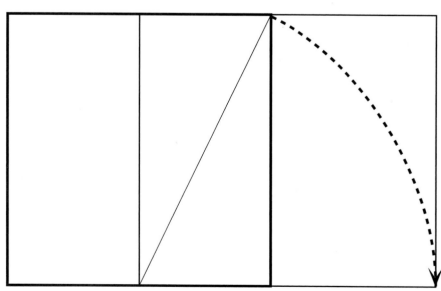

A
A golden rectangle can be created by rotating the diagonal of the half-square.

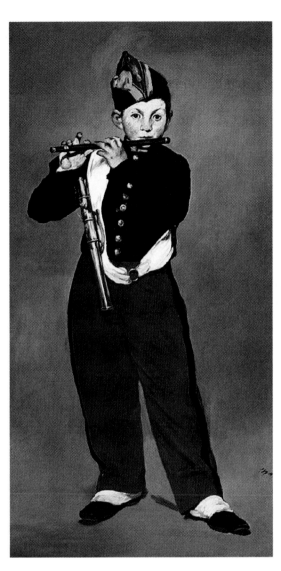

B
Édouard Manet. *The Fifer.* 1866. Oil on canvas, 63 × 38⁵/₈″ (160 × 98 cm). Signed lower right: Manet. Musée d'Orsay, Paris (bequest of Count Isaac de Camondo, 1911, RF 1992).

C
George Inness. *View of the Tiber near Perugia.* 1872–1874. Oil on canvas, 38⁹/₁₆ × 63⁹/₁₆″ (98 × 161.5 cm). National Gallery of Art, Washington, D.C. Ailsa Mellon Bruce Fund, 1973.16.1.

ROOT RECTANGLES

There are other rectangles that, like the golden rectangle, are derived from the square. These are called root rectangles and have proportions such as 1:√2, 1:√3, and 1√5. It is interesting to explore the dynamics of these shapes and find their expression in art and design.

Rotation of the diagonal of the half-square describes a half-circle and creates a new rectangle with a square at the center flanked by two golden rectangles. This rectangle can be seen in the **facade** of the Parthenon, shown in **A.** The center square contains the four center columns.

Root Five Rectangles

This rectangle, a derivative of the golden rectangle, is called a root five (√5) rectangle because its proportions are 1:√5. Masaccio's *The Tribute Money* **(B)** exploits the properties of this rectangle in depicting a three-part narrative with grace and subtlety. In the center area (the square), the tax collector demands the tribute money from Christ, who instructs Peter to get the money from the fish's mouth. On the left Peter kneels to get the money, and on the right he pays the tax collector.

Exploring Roots in Art and Design

The inherent geometry of rectangles such as the golden rectangle and root five rectangle not only provide an agreeable proportion, the diagonals and other interior structural lines often conform to significant features in a composition as is evident in **B.** These proportions do not provide a formula for design success, however. As with other visual principles, the attributes of the golden mean offer an option for design exploration, and this continues to interest many contemporary designers, architects, and artists.

The altered appearance of the "street rod" shown in **C** may seem an odd bird after looking at a Greek temple and Masaccio's fresco, and it was probably not designed with the golden mean in mind. What it does reveal is the power of altered proportions to get our attention and cause us to notice a form. In this case any notion of normal proportion is abandoned and replaced with a personal vision of what looks right. The roofline of this street rod is immediately recognizable as altered in proportion from our expected image of a car. In fact it bears a striking resemblance to the diagrams in **A** and **B.**

A

Parthenon, East Facade, Athens. The root five rectangle and golden rectangle are part of the geometry of the facade.

B

The geometry of root five and golden rectangles divides this three-part painting at significant locations. Masaccio. *The Tribute Money.* c. 1427. Fresco, 8′ 4″ × 19′ 8″ (2.54 × 5.99 m). Santa Maria del Carmine, Florence.

C

Modified 1932 Ford ("Deuce") Street Rod. Thom Taylor, designer. Source: Timothy Remus, *Ford '32 Deuce Hot Rods and Hiboys: The Classic American Street Rod 1950s–1990s*, Motorbooks International Publishers and Wholesalers.

David Lauer

A
Henri Rivière. *Funeral under Umbrellas.*
c. 1895. Etching, 8¹/₂ × 9″ (21.5 × 17.7 cm).
Paris, Bibliotheque Nationale, Cabinet
Des Estampes.

Funeral under Umbrellas **(A)** is a striking picture. What makes it unusual concerns the principle of **balance** or distribution of visual weight within a composition. Here all the figures and visual attention seem concentrated on the right-hand side. The left-hand side is basically empty. The diagonal sweep of the funeral procession is subtly balanced by the driving rain that follows the other diagonal. The effect seems natural and unposed. The result looks like many of the photographs we might see in newspapers or magazines.

A sense of balance is innate; as children we develop a sense of balance in our bodies and observe balance in the world around us. Lack of balance, or imbalance, disturbs us. We observe momentary imbalance such as bodies engaged in active sports that quickly right themselves or fall. We carefully avoid dangerously leaning trees, rocks, furniture, and ladders.

But even where no physical danger is present, as in a design or painting, we still feel more comfortable with a balanced pattern. Religious paintings often utilize balance to emphasize stability and order **(B)**.

Pictorial Balance

In assessing pictorial balance, we always assume a center vertical **axis** and usually expect to see some kind of equal weight (visual weight) distribution on either side. This axis functions as the fulcrum on a scale or seesaw, and the two sides should achieve a sense of **equilibrium.** When this equilibrium is not present, as in **C,** a certain vague uneasiness or dissatisfaction results. We feel a need to rearrange the elements in the same way that we automatically straighten a tilted picture on the wall.

B
Domenico Veneziano. *Santa Lucia dei Magnoli Altarpiece.* c. 1445. Tempera on wood, 209 × 216 cm. Galleria degli Uffizi.

C
An unbalanced design leaves the viewer with a vague uneasiness.

HORIZONTAL AND VERTICAL PLACEMENT

Balance—some equal distribution of visual weight—is a universal aim of composition. The vast majority of pictures we see have been consciously balanced by the artist. However, this does not mean there is no place in art for purposeful **imbalance**. An artist may, because of a particular theme or topic, expressly desire that a picture raise uneasy, disquieting responses in the viewer. In this instance imbalance can be a useful tool.

Using Imbalance to Create Tension

Philip Guston's *Transition* **(A)** is weighted to the right-hand side of the painting. Even the hands of the clock seem to point to the mass of enigmatic forms. The off-balance shift in weight seems in keeping with the title: A body off balance tends to be in transition until balance is reached.

In speaking of pictorial balance, we are almost always referring to horizontal balance, the right and left sides of the image. But artists consider vertical balance as well. An imag- ined horizontal axis divides a work top and bottom. Again, a certain general equilibrium is usually desirable. However, because of our sense of gravity, we are accustomed to seeing more weight toward the bottom, with a resulting stability and calmness **(B).** The farther up in the format the main distribution of weight or visual interest occurs, the more unstable and dynamic the image becomes.

The effect of a high center of visual interest can be seen in Paul Klee's whimsical *Tightrope Walker* **(C);** the instability of the image expresses the theme perfectly. The linear patterns build up vertically until we reach the teetering figure near the top. The artist can manipulate the vertical balance freely to fit a particular theme or purpose.

The figure in **D** is placed near the painting's center, however, most of the interest is focused in the left half of the image. This imbalance is subtly countered by the crossing diagonals. The downward sweep of the mountain and stream are balanced by the upward thrust of the tree. In this case diagonals influence the balance of horizontal and vertical elements.

A

Philip Guston. *Transition.* 1975. Oil on canvas, 66 × 80 1/2″ (167.6 × 204.5 cm). National Museum of American Art. Smithsonian Institution, Washington, D.C. Bequest of Musa Guston.

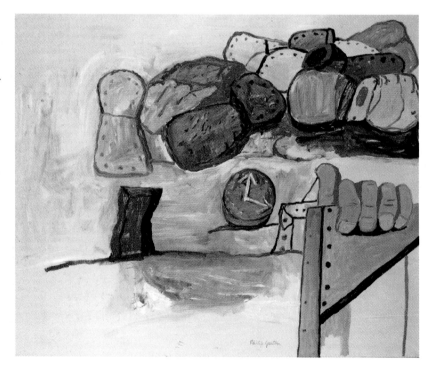

B

Keith Jacobshagen. *In the Platte River Valley.* 1983. Oil on canvas, 30 × 56¼″. Sheldon Memorial
Art Gallery and Sculpture Garden, University of Nebraska-Lincoln (gift of Wallis, Jaime, Sheri, and
Kay in memory of their parents, Joan Farrar Swanson and James Hovland Swanson, 1984.U-3729).

C

Paul Klee. *Tightrope Walker,* plate 4 from the
portfolio *Mappe der Gegenwart (Map of the
Future).* 1923. Color lithograph, 17³/₁₆ × 10⁵/₈″
(43.6 × 27 cm). The Museum of Modern Art,
New York (given anonymously).

D

Katsushika Hokusai. *Bay and Mt. Fuji.* Japan, Edo Period c. 1839.
Scroll: Ink and color on silk, 36.2 × 51.0 cm, Freer Gallery of Art
(gift of Charles Lang Freer/98.110). Smithsonian Institution.

A

Man's shirt (front view), Chikat, Alaska. c. 1890–1900. Woven from goat's hair on a cedarbark base, 44³/₄″ (114 cm) long. National Museum of the American Indian. Smithsonian Institution (#20961).

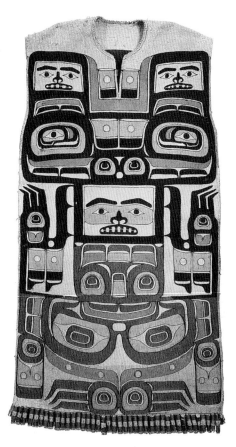

ARCHITECTURAL EXAMPLES

The simplest type of balance, both to create and to recognize, is called symmetrical balance. In symmetrical balance, like shapes are repeated in the same positions on either side of a vertical axis. This type of symmetry is also called **bilateral symmetry.** One side, in effect, becomes the mirror image of the other side. Symmetrical balance has a seemingly basic appeal for us, which can be ascribed to the awareness of our bodies' essential symmetry. In the case of the shirt shown in **A,** the symmetry is clearly in response to this symmetry of the body.

Formal Balance

Conscious symmetrical repetition, while clearly creating perfect balance, can be undeniably static, so that the term "formal balance" is used to describe the same idea. There is nothing wrong with quiet formality. In fact, this characteristic is often desired in some art, notably in architecture. Countless examples of architecture with symmetrical balance can be found throughout the world, dating from most periods of art history. The continuous popularity of symmetrical design is not hard to understand. The **formal** quality in symmetry imparts an immediate feeling of permanence, strength, and stability. Such qualities are important in public buildings to suggest the dignity and power of a government. So statehouses,

city halls, palaces, courthouses, and other government monuments often exploit the properties of symmetrical balance.

The state capitol in Albany, New York **(B),** has a repetitive pattern, and the result is a sedate, calm, and dignified facade. Such an effect is often termed **classical,** alluding to the many ancient Greek and Roman buildings in which symmetrical design imparted the same feeling of clarity and rational order. This symmetry is continued in the newer buildings that frame this entrance to the capitol. This ordered balance provides an anchor to the rest of the plaza (beyond this photograph), which is not symmetrical in design.

Symmetry Unifies

Symmetrical balance does not, by itself, preordain any specific visual result. Both **B** and **C** are examples of symmetrical architecture, but here the similarity ends. The simplicity of the capitol complex with the orderly progression of repeated shapes and a calm, regular rhythm of dark and light is certainly not present in the church interior **(C).** The latter is a busy, exciting, ornate space with only the symmetrical organization molding the masses of niches, columns, and statuary into a unified and coherent visual pattern. Symmetry is often associated with altars and religious artworks where stability and order reinforce enduring values.

B
New York State Capitol Building, Albany, NY (South Facade).
H. H. Richardson, Architect (with Leopold Eidlitz), 1876–83.

C
Balthasar Neumann. Würzburg,
Residenz Court Church Interior.
1732–44. Stuccoes by Bossi.
Frescoes by Byss.

A

Ed Ruscha. *Step on No Pets.* 2002.
Acrylic on canvas, 64⅛ × 72⅛″.
Gagosian Gallery, New York.

EXAMPLES FROM VARIOUS ART FORMS

Symmetrical balance is rarer in painting than in architecture. In fact, relatively few paintings would fit a strict definition of symmetry.

Using Symmetry of Nature

Sometimes the subject matter of a painting makes symmetrical balance an appropriate compositional device. Ed Ruscha turns a mountain landscape **(A)** into a symmetrical shape like a Rorschach test. Superimposed over this image is a palindrome, the verbal equivalent of bilateral symmetry.

Todd DeVriese's *Roses/Harmony* **(B)** exploits a geometric symmetry and the symmetry of natural forms such as ferns. This balanced distribution of shapes and repeating patterns creates the sense of harmony suggested in the title.

Using Symmetry for Emphasis

Both **A** and **B** show one distinct advantage to symmetrical compositions: the immediate creation and emphasis of a focal point. With the two sides being so much alike, there is an obvious visual importance to whatever element is placed on the center axis.

Margaret Wharton transforms a wooden chair into a *Mocking Bird* **(C)** through a process of slicing and reassembling. In this case we can, once again, trace the origins of the sculpture's symmetry back to the human figure. The symmetry of the chair derives from the human body for which it is designed. Wharton's cut and reassembled version takes on the winged symmetry of a birdlike form. In this case symmetry results in a whimsical, lighthearted artwork, rather than a solemn image.

B
Todd DeVriese. *Roses/Harmony.* 1996.
Collage, photocopy/vellum, glass print,
32 × 44″. The Ohio State University
Department of Art.

C
Margaret Wharton. *Mocking Bird.* 1981. Partially
stained wooden chair, epoxy glue, paint, and wooden
dowels, 60 × 60 × 13″ (152 × 152 × 33 cm).
Courtesy of the artist and Jean Albano Gallery,
Chicago.

A

Nan Goldin. *Siobhan with a cigarette, Berlin.* 1984. Photograph.

INTRODUCTION

The second type of balance is called **asymmetrical balance.** In this case balance is achieved with dissimilar objects that have equal visual weight or equal eye attraction. Remember the children's riddle, "Which weighs more, a pound of feathers or a pound of lead?" Of course, they both weigh a pound, but the amount and mass of each vary radically. This, then, is the essence of asymmetrical balance.

Informal Balance

In Nan Goldin's photograph **(A)** the figure gazes out at us from the right side of the picture. But the composition is not off balance. Left of center is the hand and cigarette, which balance the face as a natural point of interest. Balance is maintained as the two sides of the picture each provide a visual emphasis.

Goldin's photograph shows one advantage of asymmetrical balance. It is more casual than a formal symmetrical portrait in feeling. Another term for asymmetrical balance is, appropriately, **informal balance.** The human face is a strong target for our attention. Presented in absolute symmetry the result can be a static or boring portrait. Goldin's use of a more informal balance is in keeping with the delicate sense of balance in the lives of real people.

Symmetry can appear artificial, as our visual experiences in life are rarely symmetrically arranged. Some buildings and interiors are so designed, but even here, unless we stand quietly at dead center our views are always asymmetrical.

Carefully Planning Asymmetry

Asymmetry appears casual and less planned, although obviously this characteristic is misleading. Asymmetrical balance is actually more intricate and complicated to use than symmetrical balance. Merely repeating similar elements in a mirror image on either side of the center is not a difficult design task. But attempting to balance dissimilar items involves more complex considerations and more subtle factors.

The contrast possible in asymmetrical balance can be seen in **B.** This office building is a combination of curved and angular forms. A reassuring repetition of square windows provides a counterpoint to the more unsettling play of angles and arcs that characterize the stair ramp. Balance is achieved with very dissimilar elements.

The sculpture by Ham Steinbach **(C)** shows how "two" can balance "three" in an asymmetric arrangement. Two black pitchers sit on a red shelf adjacent to three red Bold 3 detergent boxes on a black shelf. This asymmetric pairing invites us to find the visual rhymes and contrasts that exist across the dividing line. The visual interest in comparing the unequal sides results in a balanced composition, and the number of elements feels correct.

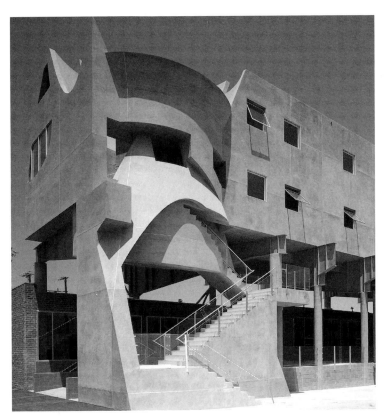

A
Samitaur Office Building. Culver City, CA. Architect: Eric Owen Moss.

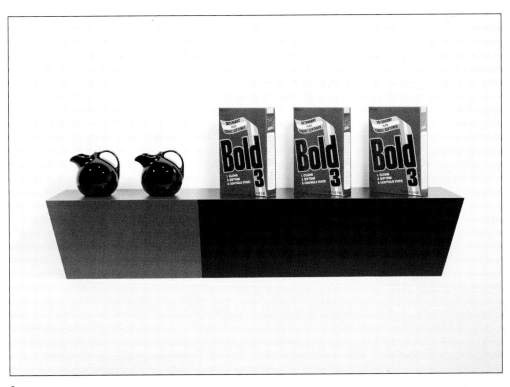

A
Ham Steinbach. *supremely black.* 1985. Plastic laminated wood shelf, ceramic pitchers, cardboard detergent boxes, 29 × 66 × 13″ (74 × 168 × 33 cm). Sonnabend Gallery and Jay Gorney Modern Art, New York.

BALANCE BY VALUE AND COLOR

Value

Asymmetrical balance is based on equal eye attraction—dissimilar objects are equally interesting to the eye. One element that attracts our attention is **value** difference, a contrast of light and dark. As **A** illustrates, black against white gives a stronger contrast than gray against white; therefore, a smaller amount of black is needed to visually balance a larger amount of gray.

The photograph of the cathedral at York **(B)** reverses the values but shows the same balance technique. The left side of the composition shows many details of the angled wall of the church nave. However, the receding arches, piers, columns, and so on are shown in subtle gradations of gray, all very close and related in value. In contrast, on the right side is the large black **silhouette** of a foreground column and the small window area of bright white. These two sharp visual accents of white and black are on the right and balance the many essentially gray elements on the left.

Color

The painting by John Singer Sargent in **C** groups a cluster of figures and guitars on the left. The right side of the painting is dominated by the light patch of the dancer's dress. Like value contrast, color itself can be a balancing element, and the patch of red at the left edge of the painting illustrates this. Studies have proven that our eyes are attracted to color. Given a choice, we will always look at a colored image rather than at one in black and white. A small area of bright color can balance a much larger area of a duller, more neutral color. Our eyes, drawn by the color, see the smaller element to be as interesting and as "heavy" visually as the larger element.

Balance by value or color is a great tool, allowing a great difference of shapes on either side of the center axis and still achieving equal eye attraction.

See also: *Color and Balance*, page 254.

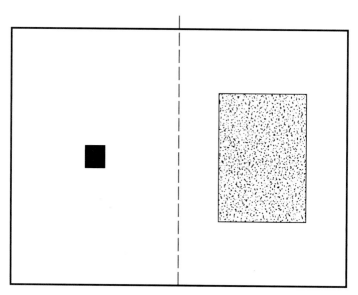

A
A darker, smaller element is visually equal to a lighter, larger one.

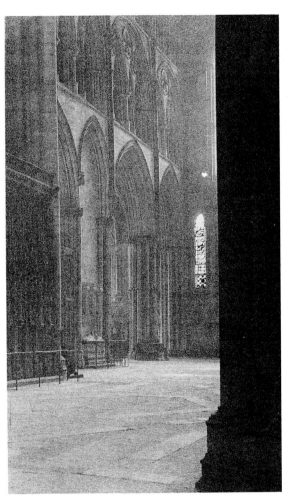

B
Frederic H. Evans. *York Minister, Into the South Transept.* c. 1900. Platinum print mounted on a sheet of brown paper upon a natural Japanese paper upon a larger sheet of gray paper, $8^{1/4} \times 4^{3/4}''$ (20.0 × 12.1 cm). The Metropolitan Museum of Art, New York (Alfred Stieglitz Collection, 33.43.368).

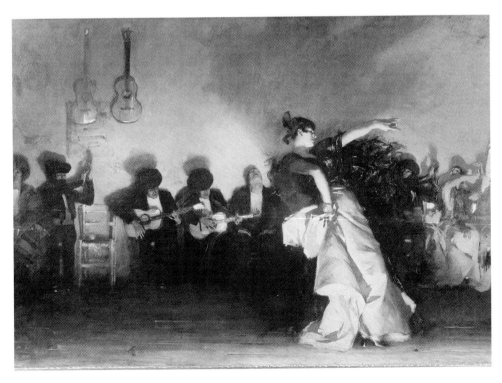

C
John Singer Sargent. *El Jaleo.* 1882. Oil on canvas, $91^{1/2} \times 139^{7/8}''$ (232.4 × 355.6 cm). Isabella Stewart Gardner Museum, Boston.

BALANCE BY TEXTURE AND PATTERN

The diagram in **A** illustrates balance by shape. Here the two elements are exactly the same value and texture. The only difference is their shape. The smaller form attracts the eye because of its more complicated contours. Though small, it is more interesting than the much larger, but duller, rectangle.

Texture Adds Interest

Any visual **texture** with a variegated dark and light pattern holds more interest for the eye than does a smooth, unrelieved surface. The drawing in **B** presents this idea: The smaller, rough-textured area balances the larger, basically untextured area (smoothness is, in a sense, a texture).

Using Texture and Pattern for Balance

The balance of the elements in the Japanese woodcut **(C)** shows how a large, simple form can be balanced by an intricate pattern or texture. The large, simple triangular mass of the mountain is positioned to the right. The left side is balanced by the pattern of clouds and sky, and a texture that suggests a forest of trees. Pattern and texture balance the strength of the large red mountain shape.

The still-life painting by Henri Fantin-Latour **(D)** offers a surprising composition. A pitcher sits on top of a broad expanse of white linen, and this focal point is balanced by the intricate pattern of foliage on the right.

Texture in Commercial Design

Printed text consisting of letters and words in effect creates a visual texture. The information is in symbols that we can read, but the visual effect is nothing more than a gray-patterned shape. Depending on the typeface and the layout, this gray area varies in darkness, density, and character, but it is visually textured. Very often in advertisements or editorial page layouts, an area of "textured" printed matter will balance photographs or graphics. The pages of this text are similarly composed.

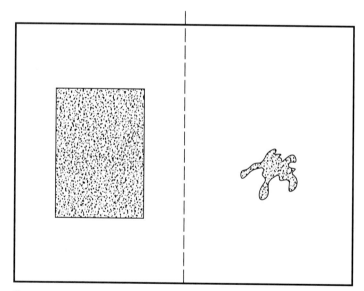

A
A small, complicated shape is balanced by a larger, more stable shape.

B
A small, textured shape can balance a larger, untextured one.

C
Katsushika Hokusai. *South Wind, Clear Dawn* from *Thirty-Six Views of Mount Fuji.* c. 1820–1830. Color woodcut, 10 × 14⁷/₈″ (25 × 28 cm). The Metropolitan Museum of Art, New York (bequest of Henry L. Phillips, 1939; JP 2960).

D
Henri Fantin-Latour. *Still Life: Corner of a Table.* 1873. Oil on canvas, 37⁵/₁₆ × 49³/₁₆″ (96.4 × 125 cm). The Art Institute of Chicago (Ada Turnbull Hertle Fund, 1951.226).

A

A large shape placed near the middle of a design can be balanced by a smaller shape placed toward the outer edge.

B

Aubrey Beardsley. *Garçons de Café.* 1894. Line block drawing originally published in *The Yellow Book,* vol. II, July.

BALANCE BY POSITION AND EYE DIRECTION

A well-known principle in physics says that two items of unequal weight can be brought to equilibrium by moving the heavier inward toward the fulcrum. In design this means that a large item placed closer to the center can be balanced by a smaller item placed out toward the edge. The two seesaw diagrams in **A** illustrate this idea of balance by position.

Achieving Casual Balance

Balance by position often lends an unusual, unexpected quality to the composition. The effect not only appears casual and unplanned but also can make the composition seem, at first glance, to be in imbalance. This casual impression can be seen in the illustration by Aubrey Beardsley **(B).** The three "garçons" are grouped to the left-hand portion of the com- position. Notice how much of these figures are actually the white aprons, which serve to lighten the weight of the figure grouping. Two tables, one stacked with plates on the right-hand edge of the picture, provide sufficient balancing lines and shapes to this informal group.

Connecting the Eyes

At first glance, the *Annunciation* fresco by Fra Angelico **(C)** seems heavily weighted to the left side of the composition. The angel has prominent wings with bright color and darker values. The figure of Mary, on the other hand, is pale, almost dissolving into the background. This imbalance is offset by subtle eye direction. We connect the figures through the line of their gaze and the arches sweeping across the top of the painting.

While not usually the only technique of balance employed by artists, eye direction is a commonly used device. Eye direction is carefully plotted, not only for balance but also for general compositional unity.

C
Fra Angelico. *Annunciation.* 1439–1443. Fresco, 73$\frac{1}{2}$ × 61$\frac{3}{4}$″ (187 × 157 cm).
Museo di San Marco, Florence.

ANALYSIS SUMMARY

In looking at works of art, you will realize that isolating one technique of asymmetrical balance as we have done is a bit misleading because the vast majority of works employ several of the methods simultaneously. For the sake of clarity, these methods are discussed separately, but the principles often overlap and are frequently used together. Let us look at just a few examples that make use of several of the factors involved in asymmetrical balance.

Combining Asymmetrical Techniques

The title of Martin Puryear's sculpture shown in **A** is appropriate for the asymmetric balance that is achieved. *Lever No. 3* presents a quirky and unexpected form with a small circular loop cast off from a more massive body. This loop sits like a head atop a long neck and visually balances the weight of the grounded body. The effect is like that of the smaller weight at the end of a long lever arm, but our visual interest is drawn to the space inside the loop more powerfully than if it were simply a solid circle. This added complexity helps offset the much larger bulk of the right side.

The figure in the Japanese print shown in **B** holds out a lantern in a manner that is surprisingly reminiscent of Puryear's sculpture. This picture, however, contains more elements. Notice how shape, value, position, and eye direction are all involved in balancing the composition.

Garry Winogrand's photograph **(C)** appears to be essentially symmetrical with elements balanced to the left and right of the center. In fact it is the *asymmetrical* aspects of the composition that keep us engaged:

> The white car on the left blends into the light sand, while the blue picnic stand on the right echoes the sky.
> The open door and figure on the left balance two figures on the right.
> The clouds are distributed equally left and right but the shapes vary.

The Winogrand photograph seems remarkably symmetrical for an unposed, spontaneous moment. The picture is, in fact, a play between the asymmetrical balance of lively casual elements and a symmetry that evokes a staged or artificial quality.

A

Martin Puryear. *Lever No. 3.* 1989. Wood, carved and painted, 84¹/₂ × 162 × 13″ (214.6 × 411.5 × 33 cm). National Gallery of Art, Washington, D.C. (gift of the Collectors Committee, 1989.71.1).

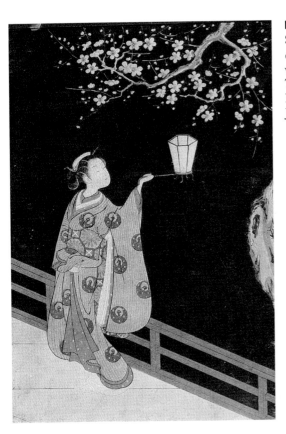

B
Suzuki Harunobu. *Girl with Lantern on Balcony at Night.* c. 1768. Color woodcut, $12^{3}/_{4} \times 8^{1}/_{4}''$ (32×21 cm). The Metropolitan Museum of Art, New York (Fletcher Fund, 1929; JP 150).

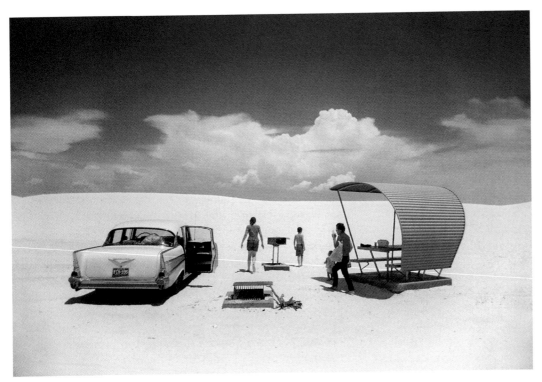

C
Garry Winogrand. *White Sands National Monument.* 1964. Courtesy of Estate of Garry Winogrand, Center for Creative Photography, University of Arizona.

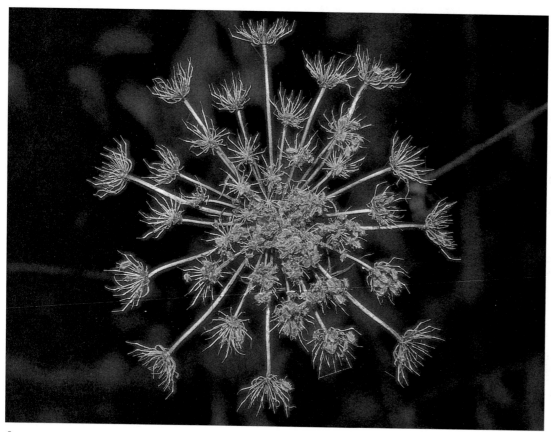

A
Queen Anne's Lace.

EXAMPLES IN NATURE AND ART

A third variety of balance is called **radial balance.** Here all the elements radiate or circle out from a common central point. The sun with its emanating rays is a familiar symbol that expresses the basic idea. Radial balance is not entirely distinct from symmetrical or asymmetrical balance. It is merely a refinement of one or the other, depending on whether the focus occurs in the middle or off center.

Radial patterns are abundant in the natural world. The form of the flower shown in **A** is a visual expression of its growth outward from the stem. Each small floret echoes this pattern.

Circular forms abound in craft areas, where the round shapes of ceramics, basketry, and jewelry often make radial balance a natural choice in decorating such objects. Radial balance can be found in the playful design based on a bicycle wheel in **B.** This whirligig, fashioned from a wheel and funnels to catch the wind, expresses the essence of radial balance.

Cultural Symbols

Radial balance has been used frequently in architecture. The round form of domed buildings such as the Roman Pantheon or our nation's Capitol will almost automatically give a radial feeling to the interior. Such a design has a symbolic function of giving emphasis to the center as a place of cultural significance. Many cultures employ radial balance as part of their spiritual imagery and designs. These range from Tibetan **mandalas** to the rose windows of gothic cathedrals. The advantage of such a design is the clear emphasis on the center and the unity that this form of design suggests.

The Rose, a painting by Jay DeFeo **(C)** is literally radiant with a light center. This is a surprising contrast to the texture and apparent weight of the rest of the painting's surface.

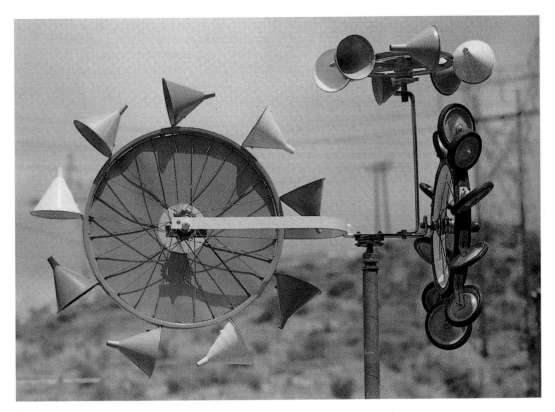

B
Anonymous. "Whirligig."

C
Jay DeFeo. *The Rose.* 1958–1966. Oil with wood and mica on canvas, 128⅞ × 92¼ × 110″ (327.3 × 234.3 × 27.9 cm). Frame: 131¹/₁₆ × 94³/₈ × 50″ (332.9 × 239.7 × 12.7 cm). Collection of Whitney Museum of American Art (gift of the Estate of Jay DeFeo and purchased with funds from the Contemporary Painting and Sculpture Committee and the Judith Rothschild Foundation).

ALLOVER PATTERN

One more specific type of visual effect is often designated as a fourth variety of balance. The examples here illustrate the idea. These works all exhibit an equal emphasis over the whole format—the same weight or eye attraction literally everywhere.

This technique is officially called **crystallographic balance.** Because few people can remember this term—and even fewer can spell it—the more common name is **allover pattern.** This is, of course, a rather special refinement of symmetrical balance. The constant repetition of the same quality everywhere on the surface, however, is truly a different impression from our usual concept of symmetrical balance.

Allover Pattern in Art and Design

In the *Signature Quilt* **(A),** emphasis is uniform throughout. The many blocks are the same size, with each defined in the same degree of contrast to the black background. Each signature on each block is accorded the same value whether that of a president (Lincoln, for example) or a lesser-known individual. There is no beginning, no end, and no focal point—unless, indeed, the whole quilt is the focal point.

The drawing by Eva Hesse **(B)** is very simple and non-representational. The whole composition consists of the repetition of target-like circles in graduated values. The circles are distributed evenly throughout the design by their placement on a grid. There is no point of emphasis, and we are left to ponder the subtle nuances of this quiet, simple structure.

The wall of photographs shown in **C** is also intended for quiet reflection or contemplation. Here are photos of many of the predominantly Jewish residents of an eastern European town. The Jewish community was eliminated by the Nazis, and this wall gives testimony to the loss with each individual having an equal place of commemoration. A balance is present between the unique nature of each photograph and frame, emphasizing the loss of distinct individuals, and the whole collection, which gives some sense of the larger community.

A

Adeline Harris Sears. *Signature Quilt.* 1857–62. Silk, 77 × 80″ (195.6 × 203.2 cm). The Metropolitan Museum of Art, NY, Purchase, William Cullen Bryant Fellow Gifts, 1996. 1996.4.

B

Eva Hesse. *Untitled.* 1966. Pencil, wash, and brush on paper, 11⁷/₈ × 9¹/₈″ (30 × 23.1 cm). The Museum of Modern Art, New York (gift of Mr. and Mrs. Herbert Fischbach).

C
Ralph Appelbaum. Hallway in the United States Holocaust/Memorial Museum, Washington, D.C.

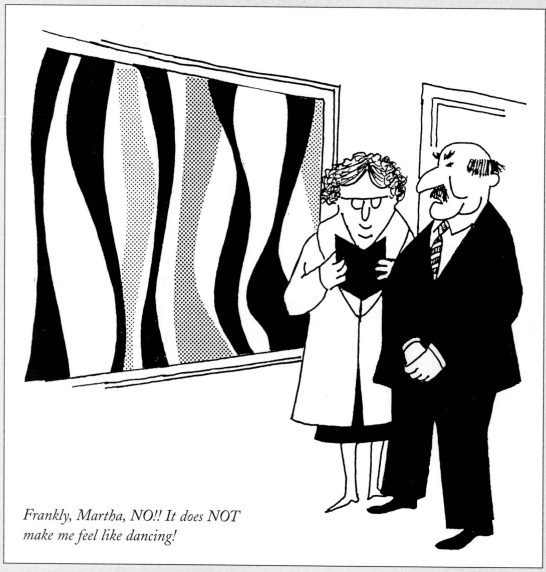

Frankly, Martha, NO!! It does NOT make me feel like dancing!

David Lauer

CHAPTER 6

VISUAL RHYTHM

In conversation we might refer to Bridget Riley's painting in **A** as having a rhythmic feeling. This might seem a strange adjective to use because **rhythm** is a term we most often associate with the sense of hearing. Without words, music can intrigue us by its pulsating beat, inducing us to tap a foot or perhaps dance. Poetry often has *meter*, which is a term for measurable rhythm. The pace of words can establish a cadence, a repetitive flow of syllables that makes reading poems aloud a pleasure. But rhythm can also be a visual sensation. We commonly speak of rhythm when watching the movement displayed by athletes, dancers, or some workers performing manual tasks. In a similar way the quality of rhythm can be applied to the visual arts, in which the idea is again basically related to movement. Here the concept refers to the movement of the viewer's eye, a movement across recurrent motifs providing the repetition inherent in the idea of rhythm. The painting in **A** has this feeling of repetition in the softly flowing vertical forms punctuated by shapes of contrasting value and color. It is not necessarily the nonobjective nature of the shapes that produces this feeling. A similar effect is present in the photograph shown in **B**. Here tree trunks show the same sinuous and graceful rhythm.

Rhythm as a design principle is based on repetition. Repetition, as an element of visual unity, is exhibited in some manner by almost every work of art. However, rhythm involves a clear repetition of elements that are the same or only slightly modified.

The chair shown in **C** has a crisp rhythm in the repetition of vertical slats. The squares formed by crossing horizontals create a rhythmic pattern as well. This second rhythm gains emphasis toward the top of the chair. The curve of the chair's back subtly alters these patterns. In this case the play of a few simple design elements work together to make a dramatic, more complex rhythm.

The senses of sight and hearing are indeed so closely allied that we often relate them by interchanging adjectives (such as "loud" and "soft" colors). Certainly this relationship is shown in the concept of visual rhythm.

A

Bridget Riley. *Drift No. 2.* 1966. Acrylic on canvas, overall: 91$\frac{1}{2}$ × 89$\frac{1}{2}$″ (232.41 × 227.33 cm). Albright-Knox Art Gallery, Buffalo, New York (gift of Seymour H. Knox, Jr., 1967).

B
Albert Renger-Patzsch. *Buchenwald in Fall* (or *Trees*).
1936. Gelatin silver print. $8^3/_4 \times 6^3/_8''$ (22.9 × 16.8 cm).
The Metropolitan Museum of Art, New York (Warner
Communications, Inc., purchase fund, 1978;
1980.1063.1).

B
Charles Rennie Mackintosh. *Chair.* 1904.
Ebonized oak, reupholstered with horsehair,
$46^9/_{16} \times 37 \times 16^1/_2''$ (118 × 94 × 42 cm).
Collection Glasgow School of Art, Glasgow.

A
Bruce Barnbaum. *Dune Ridges at Sunrise, Death Valley.* 1976. Silver gelatin print,
$10^{3}/_{4} \times 13^{1}/_{4}''$ (27.3 × 33.6 cm). Courtesy of the photographer.

SHAPES AND REPETITION

We may speak of the rhythmic repetition of colors or textures, but most often we think of rhythm in the context of shapes and their arrangement. In music, some rhythms are called **legato,** or connecting and slowing. The same word could easily be applied to the visual effect in **A.** The photograph of Death Valley shows the sand dune ridges in undulating, flowing, horizontal curves. The dark and light contrast is quite dramatic, but in several places the changes are soft with smooth transitions. The feeling is relaxing and calm.

A similar rhythm occurs in the sixteenth-century illuminated manuscript by Hoefnagel **(B).** Here the rhythm is faster with more repetitions and more regularity or consistency in the repeated curves. The fluid strokes carry our eye across the text and mark both the beginning and end of the passage with a flourish.

Manipulating Rhythm

It is true that the rhythmic pattern an artist chooses can quickly establish an emotional response in the viewer. For contrast, look at the painting in **C.** The effect here is also rhythmic, but now of an entirely different sort. Small, bold, blue and red

squares move horizontally and vertically around the light canvas. The shapes are rigidly defined with the value changes sudden and startling. Again, music has a term for this type of rhythm: **staccato,** meaning abrupt changes with a dynamic contrast. The recurrence of these dark squares establishes a visual rhythm. The irregular spacing of the small squares causes the pattern (and rhythm) to be lively rather than monotonous. The artist, Piet Mondrian, titled this painting *Broadway Boogie Woogie.* He has expressed in the most abstract visual terms not only the on/off patterns of Broadway's neon landscape but also the rhythmic sounds of 1940s instrumental blues music. The effect for us today is almost like the jumpy, always changing patterns we see in video games.

The rhythms of **B** and **C** are indeed different, but the two examples are also alike in that the rhythm initially established is then consistent and regular throughout the composition. This regularity is not present in Gregory Amenoff's painting **(D).** The eye moves through repeated bent or angular elements, but the points of emphasis are in an irregular pattern. We are pushed and pulled in various directions. Our eyes are jerked quickly back and forth across the composition; the rhythm is exciting but also unsettling.

B
Joris Hoefnagel (illuminator) and Georg Bocskay
(scribe). *Mira Calligraphiae Monumenta (Model Book
of Calligraphy),* folio 21r. 1561–62. Pen and ink,
watercolors on vellum and paper, 6⁹/₁₆ × 4¹³/₁₆″
(16.6 × 12.3 cm). The J. Paul Getty Museum,
Los Angeles (86.MV.527).

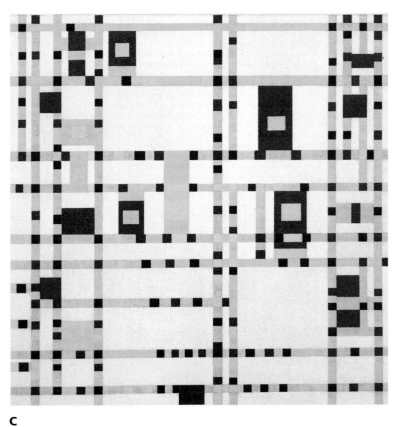

C
Piet Mondrian. *Broadway Boogie Woogie.* 1942–43. Oil on canvas,
50 × 50″ (127 × 127 cm). The Museum of Modern Art, New
York (given anonymously).

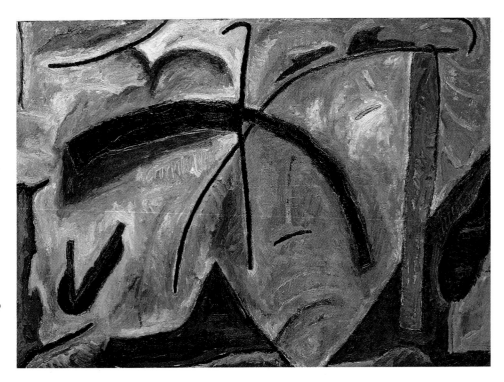

D
Gregory Amenoff. *Out of the Blue and into
the Black.* 1979. Oil on canvas, 60 × 84″
(1.5 × 2.1 m). Collection of Leonard F.,
Cheryl Y., Alys R., Daya A., Quigley,
Jairus, and Tucker Yablon, Steelton, PA.

PATTERNS AND SEQUENCE

Rhythm is a basic characteristic of nature. The pattern of the seasons, of day and night, of the tides, and even of the movements of the planets, all exhibit a regular rhythm. This rhythm consists of successive patterns in which the same elements reappear in a regular order. In a design or painting, this would be termed an **alternating rhythm,** as motifs alternate consistently with one another to produce a regular (and anticipated) sequence. This expected quality of the pattern is not a fault, for unless the repetition is fairly obvious, the whole idea of visual rhythm becomes obscure.

Details in Architecture and Art

A familiar example of this idea can be seen in a building with columns, such as a Greek temple. The repeating pattern of light columns against darker negative spaces is clearly an alternating rhythm. Architectural critics often speak of the rhythmic placement of windows on a facade. Again, it is an alternating pattern—dark glass against a solid wall. The spiral stairway of Wharton Esherick's home **(A)** shows this type of rhythm. The design involves a sequence of forms that not only alternate in dark and light areas but shift regularly back and forth as figure and ground alternate for our attention.

Notice that exactly the same description of alternating themes could be used for the painting in **B.** The artist, Robert Delaunay, titled this work, appropriately, *Rhythm Without End.*

The light and dark areas alternate consistently along the top band of the brick cornice shown in **C.** The lowest decorative band presents an alternating rhythm of "X" and "O" blocks. Alternating rhythms and rhythmic variety can relieve the large surface of predictable patterns such as a brick wall.

A
Wharton Esherick. *Spiral Staircase.* 1930.
The Wharton Esherick Museum, Paoli, PA.

B
Robert Delaunay. *Rhythm Without End.* 1935.
Gouache, brush and ink, on paper, 10⅝ × 8⅝″
(27 × 21 cm). The Museum of Modern Art,
New York (given anonymously).

C
Brick cornice. Published in James Stokoe.
Decorative and Ornamental Brickwork. Dover
Publications, Inc., New York, 1982, page 6.

CONVERGING PATTERNS

Another type of rhythm is called progression, or **progressive rhythm.** Again, the rhythm involves repetition, but repetition of a shape that changes in a regular manner. There is a feeling of a sequential pattern. This type of rhythm is most often achieved with a progressive variation of the size of a shape, though its color, value, or texture could be the varying element. Progressive rhythm is extremely familiar to us; we experience it daily when we look at buildings from an angle. The perspective changes the horizontals and verticals into a converging pattern that creates a regular sequence of shapes gradually diminishing in size.

Inherent Rhythm

In **A** the rhythmic sequence of lines moving vertically across the format is immediately obvious. A more subtle progressive rhythm appears when we notice the dark shapes of the oil stains in the parking spaces. These change in size, becoming progressively smaller farther away from the building. In this photograph from an aerial vantage point, a rhythm is revealed in the ordinary pattern of human habits.

Progressive rhythms are actually rather commonplace in nature although they may not always be readily apparent. Edward Weston's extreme close-up of an artichoke cut in half **(B)** shows a growth pattern. The gradual increase in size and weight creates a visual movement upward and outward. Other natural forms (such as chambered nautilus shells) cut in cross section would also reveal progressive rhythms.

The photographs in **A** and **B** are quite different. Yet they both make visible progressive rhythms from the world around us, whether in the pattern of human activity or in natural forms. It is not surprising then, that we should sense a growth-like pattern in the abstract sculpture by Louise Bourgeois **(C).** This piece is more architectural than organic in its individual parts, yet the progression upward and outward from smaller to larger forms is similar to **B.**

A
Edward Ruscha. *Goodyear Tires, 6610 Laurel Canyon. North Hollywood.* 1967. Photograph, 8¹/₄ × 3⁷/₈″ (21 × 10 cm). From the book *Thirty-four Parking Lots in Los Angeles.* Published by the author, 1974.

B
Edward Weston. *Artichoke, Halved.* 1930. Gelatin silver print, 7¹/₂ × 9¹/₂″ (19 × 24.1 cm). © 1981. Center for Creative Photography, Arizona Board of Regents.

C
Louise Bourgeois. *Partial Recall.* 1979. Wood, 108 × 90 × 66″ (274.3 × 228.5 × 167.6 cm). Private collection.

ENGAGING THE SENSES

Rhythmic structures in visual art and design are often described (as they have been here) in terms borrowed from music vocabulary. The connection between visual rhythms and musical rhythms can be more than a simile or metaphor. In some cases the visual rhythms composed by an artist seem to resonate with memories or associations in our other senses. When a visual experience actually stimulates one of our other senses, the effect is called **kinesthetic.**

Evoking Sight, Sound, and Touch

Charles Burchfield's painting **(A)** is, on one level, a depiction of the roofline of a building set among trees and plants. This description does not tell us the subject of *The Insect Chorus,* however. A description of the painting's many rhythmic patterns would come closer to explaining the title. Repeated curves, zigzags, and straight linear elements throughout the picture literally buzz and create the sensation of a hot summer afternoon alive with the sound of cicadas. Even the sensation of heat is evoked by the rhythm of wavering lines above the rooftop.

The drawing shown in **B** attempts to convey the sensation of "metallic" sounds. This early experiment in Russian **Suprematism** from 1918 reflects the interest in industrial subjects of that era. The jumpy arrangement of shapes, almost lacking in any rhythmic pattern, seems to echo the harsh, dynamic sounds of a factory.

A

Charles Burchfield. *The Insect Chorus.* 1917. Opaque and transparent watercolor with ink and crayon on paper, 19⁷⁄₈ × 15⁷⁄₈″ (50 × 40 cm). Munson-Williams-Proctor Institute. Museum of Art, Utica, New York (Edward W. Root Bequest).

A second drawing by Malevich **(C)** is titled *Sensation of Movement and Resistance.* In this case our physical experiences of moving through the world are simulated. The drawing appeals to our sense of touch and "muscle memory" by repeating horizontal lines of varying weight along a curved path. The rhythmic interruption of the heavier, darker rectangles offers the "resistance" referred to in the title.

B
Kasimir Malevich. *Suprematist Composition: Sensation of Metallic Sounds.* 1916–18. Crayon on paper, 8 × 6¹/₂″ (20.9 × 16.4 cm). Kupferstichkabinett, Oeffentliche Kunstsammlung Basel.

C
Kasimir Malevich. *Suprematist Composition: Sensation of Movement and Resistance.* Crayon on paper, 10¹/₂ × 8″ (26.5 × 20.5 cm). Kupferstichkabinett, Oeffentliche Kunstsammlung Basel.

P A R T 2

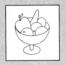

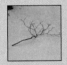

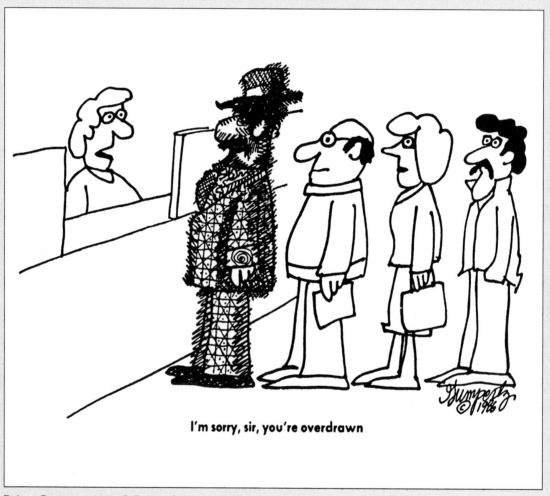

Robert Gumpertz. 1986. © Robert Gumpertz, Mill Valley, CA.

A
Richard Long. *Five Paths*. 2002.
Delabole slate, 61.1 × 17.4 m.
New Art Centre Sculpture Park
& Gallery, Wiltshire, UK.

DEFINING FORM

What is a **line**? If we think of a point as having no dimensions (neither height nor width), and then we set that point in motion, we create the first dimension: line. In theory, line consists only of the dimension of its length, but, in terms of art and design, we know line can have varying width as well. The pathways in **A** are fashioned from irregular rocks, yet we instantly perceive the serpentine paths as lines.

Of all the elements in art, line is the most familiar. Most of our writing and drawing tools are pointed, and we have been making lines constantly since we were young children. Our simplest notion of line comes from our first experiences with outlines such as coloring books. But line is more than mere border or boundary. The dark lines on the fabric billowing in the wind **(B)** are not outlines, rather they reveal the flowing topography of the material. The textural stretch marks on the bark of a gray birch **(C)** suggest lines that go around the limb of this tree. This photograph reveals the cross-contour lines inherent in round forms. In these two examples line defines form by means other than mere outline.

Lines Convey Mood and Feeling

Line is created by movement and is capable of infinite variety. The image in **D** shows just a few of the almost unlimited variations possible in the category of line. A curious feature of line is its power of suggestion. What an expressive tool it can be for the artist! A line is a minimum statement, made quickly with a minimum of effort, but seemingly able to convey all sorts of moods and feelings. The lines pictured in **D** are truly abstract elements: They depict no objects. Yet we can read into them emotional and expressive qualities. Think of all the adjectives we can apply to lines. We often describe lines as being nervous, angry, happy, free, quiet, excited, calm, graceful, dancing, and having many other qualities. The power of suggestion of this basic element is great.

B
Jack Lenor Larsen. *Seascape.* 1977.
Nest Magazine, Winter 2002–03.
Special Section: Jack Lenor Larsen.

C
Lines in the bark reveal the cross contours of the tree.

D
Line has almost
unlimited variations.

A
Ellsworth Kelly. *Calla Lily 1.* 1984. Lithograph
on Rives BFK paper, edition of 30, 30¹/₄ × 39″
(77 × 99 cm). Courtesy of the artist and
Gemini G.E.L.

B
Line, as artistic shorthand, depicts the edges of shapes.

DEFINING SHAPE

Line is important to the artist because it can describe shape,
and by shape we recognize objects. For example, **A** is imme-
diately understood as a picture of a flower. It does not have
the dimension or mass of a flower; it does not have the color
or texture of a flower; it is not the actual size of a flower.
Nevertheless, we recognize a flower. Ellsworth Kelly has
shown us, through his economical use of line, those shapes
he felt to be most characteristic of the calla lily.

Artistic Shorthand

Example **B** is a line drawing—a drawing of lines that are
not present in the photograph **(C)** or in the original collection
of objects. In the photograph, of course, no black line runs

around each object. The lines in the drawing actually show
edges, whereas in **C** areas of different value (or color) meet,
showing the end of one object and the beginning of another.
Line is, therefore, artistic shorthand, useful because with
comparatively few strokes, an artist can describe and identify
shapes through outline and contour.

Line drawings with the lines describing the edges of various
forms abound in art; **D** is just one example. The drawing by
Dufy, done quickly with a brush, outlines the many items in
the artist's studio with free and loose—but descriptive—lines
so that we easily understand the whole scene.

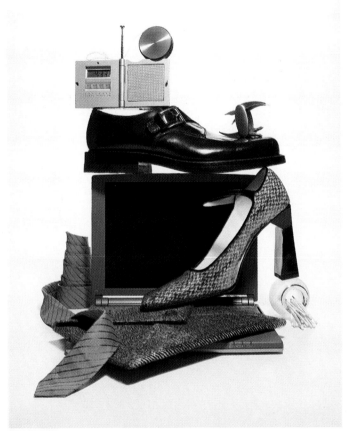

C
Advertisement from *New York Times* Advertising Supplement, Sunday, Nov. 11, 1998, p. 14A. Photo by Thomas Card. Fashion direction by Donna Berg and Heidi Godoff for Twist Productions. Prop styling by Caroline Morrison. Advertorial produced by Comer & Company.

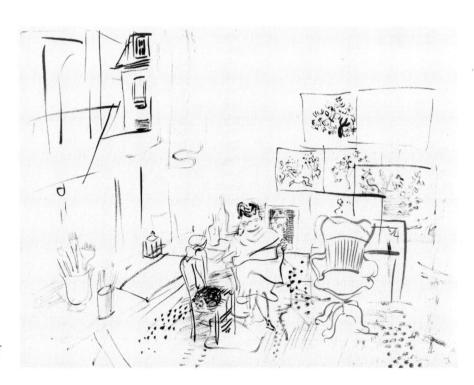

D
Raoul Dufy. *The Artist's Studio.* c. 1942. Brush and ink on paper, 19⅝ × 26″ (49.7 × 66 cm). The Museum of Modern Art, New York (gift of Mr. and Mrs. Peter A. Rubel).

ACTUAL, IMPLIED, AND PSYCHIC LINES

Line has served artists as a basic tool ever since cave dwellers drew with charred sticks on the cave walls. Actual lines **(A)** may vary greatly in weight, character, and other qualities. Two other types of line also figure importantly in pictorial composition.

An **implied line** is created by positioning a series of points so that the eye tends automatically to connect them. The dotted line is an example familiar to us all **(B).** Think also of the line waiting for a bus; several figures standing in a row form an implied line.

A **psychic line** is illustrated in **C.** There is no real line, not even intermittent points, yet we feel a line, a mental connection between two elements. This usually occurs when something looks or points in a certain direction. Our eyes invariably follow, and a psychic line results.

Interpreting Lines

All three types of line are present in Georges de La Tour's *Fortune Teller* **(D).** Actual lines clearly delineate the edges of figures and garments. An implied line is created between the victim's hand on his hip and the fortune-teller's left hand. Along this line we spy (in the shadows) hands at work relieving the victim of his valuables **(E).** A second such line is created by the continuation of the pickpocket's arm on the left through the bottom of the victim's jacket and continuing along to the fortune-teller on the right. Psychic lines occur as our eyes follow the direction in which each figure is looking.

Artists have the potential to lead a viewer's eye movement, and the various types of lines can be a valuable tool to that end.

A
There are many types of actual lines, each varying in weight and character.

B
The points in an implied line are automatically connected by the eye.

C
When one object points to another, the eye connects the two in a psychic line.

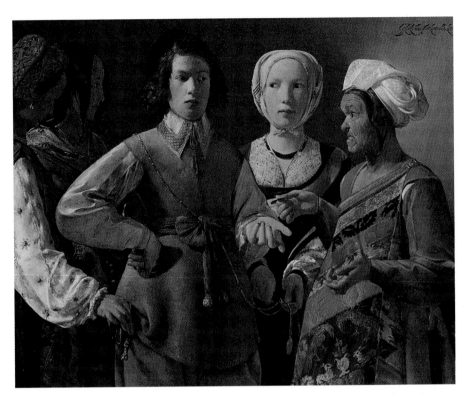

D
Georges de La Tour. *Fortune Teller.*
1632–35. Oil on canvas, 102 × 123.5 cm.
The Metropolitan Museum of Art,
New York (Rogers Fund, 1960).

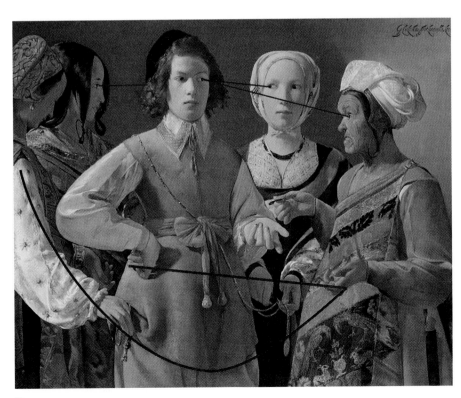

E
Actual, implied, and psychic lines organize the composition.

HORIZONTAL, VERTICAL, AND DIAGONAL LINES

One important characteristic of line that should be remembered is its direction. A horizontal line implies quiet and repose, probably because we associate a horizontal body posture with rest or sleep. A vertical line, such as a standing body, has more potential of activity. But the diagonal line most strongly suggests motion. In so many of the active movements of life (skiing, running, swimming, skating) the body is leaning, so we automatically see diagonals as indicating movement. Whereas **A** is a static, calm pattern, **B** is changing and exciting.

Reinforcing the Format

One other factor is involved in the quality of line direction. The outside format of the vast majority of drawings, designs, paintings, and so forth is rectangular. Therefore, any horizontal or vertical line within the work is parallel to, and repetitive of, an edge of the format. The horizontal and vertical lines within a design are stabilizing elements that reduce any feeling of movement. The lines in **A** are parallel to the top and bottom, but none of the lines in **B** are parallel to any of the edges.

Analyzing Lines in Paintings

George Bellows's painting **(C)** is dominated by a diagonal line that begins with the one fighter's leg on the left, and continues through the second fighter's shoulder and arm. Other diagonals within the figures create the dynamism of the fight scene. The diagonal gesture of the referee balances the group of three figures and completes a triangle. The verticals and horizontals of the fight ring stabilize the composition and provide a counterpoint to the action depicted.

John Moore's *Evangeliste* **(D)** has a subtle but strong underlying structure of verticals and horizontals that lend a calm serenity to the scene. The window frame provides the anchor to this pattern, but the table and building seen outside the window repeat vertical and horizontal lines. The more chaotic line directions on the tabletop and other curved and diagonal lines provide a lyric variety within the dominant order of vertical and horizontal.

The painting shown in **D** does not suggest the kind of dynamic movement of the Bellows **(C),** but it does show that a composition based on verticals and horizontals does not have to be boring!

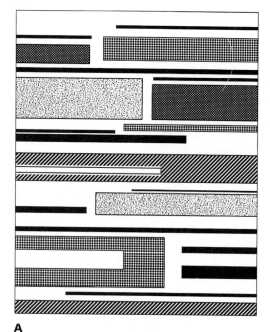

A
Horizontal lines usually imply rest or lack of motion.

B
Diagonal lines usually imply movement and action.

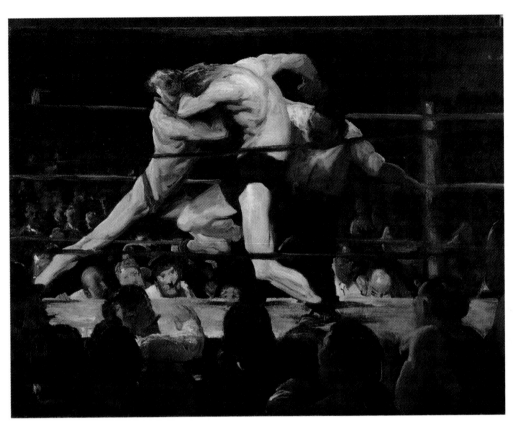

C
George Bellows. *Stag at Sharkey's.* 1909. Oil on canvas, 36 × 48″ (92 × 122.6 cm).
The Cleveland Museum of Art (Hinman B. Hurlbut Collection).

D
John Moore. *Evangeliste.* 2001.
Oil on canvas, 60 × 50″. Hirschl
& Adler Modern, New York.

PRECISION OR SPONTANEITY

Regardless of the chosen medium, when line is the main element of an image, the result is called a drawing. There are two general types of drawings: **contour** and **gesture.**

Contour Drawings

When line is used to follow the edges of forms, to describe their outlines, the result is called a contour drawing. This is probably the most common use of line in art; **A** is an example. This portrait by Ingres is a precise drawing with extremely delicate lines carefully describing the features and the folds of the clothing. The slightly darker emphasis of the head establishes the focal point. We cannot help but admire the sureness of the drawing, the absolute accuracy of observation.

The self-portrait by Giacometti **(B)** is not composed of the precise contours we find in **A.** Instead, we see many lines which, taken together, suggest the mass and volume of the head. The result is more active, and we can more readily observe the artist's process of looking and recording. Many of Giacometti's lines follow the topography of the head and find surface contours within the form of the head, not merely at the outer edge.

Gesture Drawings

The other common type of drawing is called a gesture drawing. In this instance, describing shapes is less important than showing the action or the dynamics of a pose. Line does not stay at the edges but moves freely within forms. Gesture drawings are not drawings of objects so much as drawings of movement, weight, and posture. Because of its very nature, this type of drawing is almost always created quickly and spontaneously. It captures the momentary changing aspect of the subject rather than recording nuances of form. Rembrandt's *Christ Carrying the Cross* **(C)** is a gesture drawing. Some quickly drawn lines suggest the contours, but most of the lines are concerned with the action of the falling, moving figures.

Deborah Butterfield's *Tango* **(D)** is a sculpture that conveys a sense of drawing in three dimensions. The found objects and steel scraps suggest the presence of a horse with almost scribble-like lines. These lines largely define the horse from the inside of the form and the gesture of the pose. Butterfield's work has a spontaneous appearance we would more likely associate with brush and ink than welded steel.

Combining Styles

While quite different approaches to drawing, the two categories of contour and gesture are not mutually exclusive. Many drawings combine elements of both, as can be seen in Giacometti's *Self-Portrait* **(B).** And, as is the case with **D,** the elements of contour or gestural line can also be found in artworks other than traditional drawing.

A
Jean-Auguste-Dominique Ingres. *Portrait of Mme. Hayard and Her Daughter Caroline.* 1815. Graphite on white woven paper, 11¹/₂ × 8⁵/₈″ (29.2 × 21.9 cm). Fogg Art Museum, Harvard University (bequest of Grenville L. Winthrop).

B
Alberto Giacometti. *Self-Portrait.* 1954. Pencil, 16 × 12″ (40.5 × 31 cm).

C
Rembrandt. *Christ Carrying the Cross.* c. 1635. Pen and ink with wash, 5⅝ × 10⅛″ (14 × 26 cm). Kupferstichkabinett, Staatliche Museen, Berlin.

D
Deborah Butterfield. *Tango.* 1987. Steel, 28½ × 42½ × 15″ (72 × 107 × 38 cm). Edward Thorp Gallery, New York.

CREATING VARIETY AND EMPHASIS

To state that an artist uses line is not very descriptive of the artist's work because line is capable of infinite variety. To imagine the qualities that a line may have, just think of an adjective you can place before the word "line," such as thin, thick, rough, or smooth. The illustrations on these two pages give only a sampling of the linear possibilities available to the artist or designer.

Volume

Example **A** shows a drawing by Henry Ossawa Tanner. This figure study shows how varied **line quality** can define three-dimensional form, create emphasis, and transform a flat piece of paper into a spatial experience. Darker, heavier lines create emphasis on the light paper and draw our attention to the figure's hand and face. The darker contour along the back blends into shaded areas, giving **volume** to the figure. Lighter contours along the left arm do not merely suggest an unfinished drawing. These lines allow the figure to subtly emerge from the page.

Expressing Mood and Motion

The untitled drawing by Susan Rothenberg shown in **B** is characterized by heavy, blunt contours echoed by thinner, coarse lines. The brutal line quality that describes dismembered horse shapes is as appropriate to this imagery as the varied and graceful lines are for the nude.

The print by Judy Pfaff **(C)** takes advantage of a variety in line quality from bold to light, from elegant to awkward. Some thin lines perform figures like an ice skater, while the heavier lines sag like the drips of spilled paint. This print does not use line as calligraphy, nor is it representational. In this case line exists for its own expressive qualities.

The lines in **D** quiver and reverberate, suggesting movement. Notice how difference in line weight suggests motion.

The linear technique you choose can produce emotional or expressive qualities in the final pattern. Solid and bold, quiet and flowing, delicate and dainty, jagged and nervous, or countless other possibilities influence the effect on the viewer of your drawing or design.

A

Henry Ossawa Tanner. *Study of a Man for the Resurrection of Lazarus.* Philadelphia Museum of Art.

B

Susan Rothenberg. *Untitled.* 1978. Acrylic, flashe, pencil on paper, 20 × 20″ (51 × 51 cm). Collection Walker Art Center, Minneapolis (Art Center Acquisition Fund, 1979).

C
Judy Pfaff. *Che Cosa è Acqua* from *Half a Dozen of the Other*. 1992.
Color drypoint with spit bite and sugar lift aquatints, and soft
ground etching, 36 × 45″ on 42⅞ × 50¾″ sheet. Edition 20.
Printed by Lawrence Hamlin.

D
Honoré Daumier. *Frightened Woman*. 1828–79.
Charcoal with black crayon, on ivory laid paper,
8 × 9¹/₂″ (21 × 23.9 cm). The Art Institute
of Chicago (gift of Robert Allerton).

USING LINES TO CREATE DARK AND LIGHT

A single line can show the shape of objects. But an outlined shape is essentially flat; it does not suggest the volume of the original subject. The artist can, by placing a series of lines close together, create visual areas of gray. By varying the number of lines and their proximity, an almost limitless number of grays can be produced. These resulting areas of dark and light (called areas of value) can begin to give the three-dimensional quality lacking in a pure contour line. Again, the specific linear technique and the quality of line can vary a great deal among different artists.

Cross-Hatching

The pen-and-ink image of Eve **(A)**—a detail from Dürer's *Adam and Eve*—shows a strong contour edge because the light shading contrasts with a stark brown background. Within the figure Dürer then added parallel lines in a crisscross pattern (called **cross-hatching**) to create areas of gray, which give fullness to the figure. The pen produced necessarily hard, definite

strokes, which Dürer carefully controlled in direction to follow the volumes of body forms.

The same cross-hatching technique is clear in **B.** But in this etching, the artist, Rembrandt, has used the lines in a looser manner. The various densities of line suggest the values and textures of sky and landscape.

Both **A** and **B** use line to create well-defined volumes and shapes. In the drawing by Il Guercino **(C),** the linear technique is very loose, more spontaneous, and quickly scribbled. The volumes of the figure are now more suggested than carefully delineated. Line is used to convey value, but the technique is different.

Applying Line as Value to Textiles

These techniques are by no means limited to drawings and prints. The woven fabric in **D** uses fibers as lines to create different values out of differing densities of the dark threads. Our eye reads the weave of darks and lights to create optical mixtures of various values.

See also: *Value: Techniques,* page 232.

A
Albrecht Dürer. *Adam and Eve,* detail. 1504. Pen and broken ink with wash on white paper; entire work 9⅝ × 8″ (24 × 20 cm). The Pierpont Morgan Library, New York.

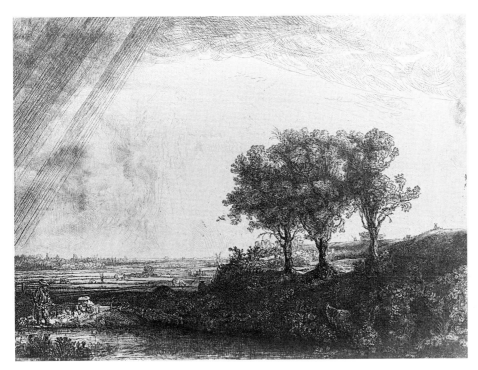

B
Rembrandt. *The Three Trees.* 1643.
Etching with drypoint and burin, only
state. Courtesy of the Wetmore Print
Collection of Connecticut College.

C
Giovanni Francesco Barbieri, called Il Guercino. (1590–1666).
Sibyl Holding a Scroll ("*The Cimmerian Sibyl*"). Pen and brown ink,
$7^3/_4 \times 5^7/_8''$ (19.7 × 15 cm). The Metropolitan Museum of Art,
New York (Rogers Fund, 12.56.11).

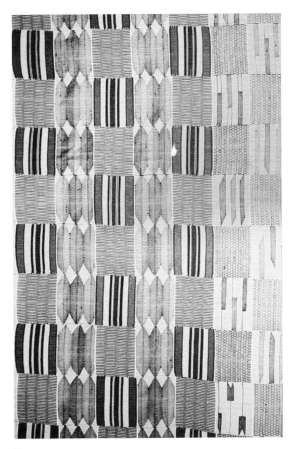

D
West African Kente cloth. No date. Cotton,
$82^1/_4 \times 132^1/_2''$ (23 × 3.5 m). Anacostia
Museum, Smithsonian Institution,
Washington, D.C.

OUTLINE OF FORMS

Line can be an important element in painting. Because painting basically deals with areas of color, its effect is different from that of drawing, which limits the elements involved. Line becomes important to painting when the artist purposely chooses to outline forms, as Alice Neel does in her portrait **(A).** Dark lines define the edges of the figure and the sofa. The lines are bold and quite obvious.

Line can be seen in the detail of Venus from Botticelli's famous painting **(B).** The goddess's hair is a beautiful pattern of flowing, graceful, swirling lines. The hand is delineated from the breast by only the slightest value difference; a dark, now quite delicate line clearly outlines the hand.

Adapting Technique to Theme

Compare the use of line in Botticelli's painting with that in **C.** Both works stress the use of line, but the similarity ends there.

Nurse, by Roy Lichtenstein **(C),** employs the extremely heavy, bold line—almost a crude line typical of the drawing in comic books. Each artist has adapted his technique to his theme. Compare the treatment of the hair. Venus **(B)** is portrayed as the embodiment of all grace and beauty, her hair a mass of elegant lines in a delicate arabesque pattern. The nurse's hair **(C),** by contrast, is a flat, colored area boldly outlined, with a few slashing heavy strokes to define its texture.

Dark Line Technique

The use of a black or dark line in a design is often belittled as a crutch. There is no doubt that a dark linear structure can often lend desirable emphasis when the initial color or value pattern seems to provide little excitement. Many artists, both past and present, have purposely chosen to exploit the impact of dark lines to enhance their work. The heavy lines support the theme of construction in *The Builders* **(D).**

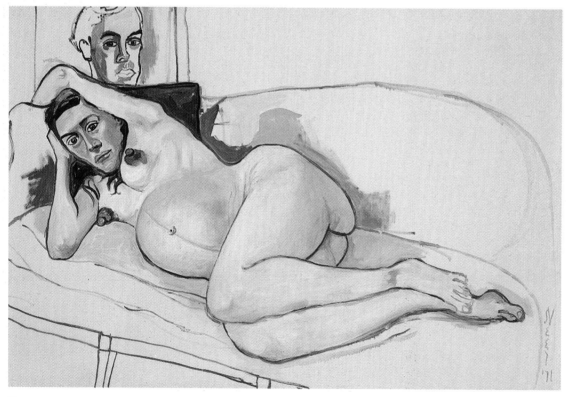

A

Alice Neel. *The Pregnant Woman.* 1971. Oil on canvas, 40 × 60″. The University Art Museum, University of California–Santa Barbara.

B
Sandro Botticelli. *The Birth of Venus,* detail. c. 1480. Oil on canvas; entire work: 5′ 8⁷/8″ × 9′ 1⁷/8″ (1.75 × 2.79 m). Galleria degli Uffizi, Florence.

C
Roy Lichtenstein. *Nurse.* 1964. Magna on canvas, 4′ (1.22 m) square. © Roy Lichtenstein.

D
Fernand Leger. *The Builders.* 1950. Oil on canvas, 9′ 10″ × 6′ 7″ (3 × 2 m). Musée National Fernand Leger, Biot, France.

EXPLICIT LINE

Explicit line is obvious in an image such as the computer-generated trees in **A.** In this case every element from thick trunk to delicate branch is recognizable as line. Such explicit lines can be evident in a variety of media from computer animation to painting.

Defining Shape and Form

Line becomes important in a painting when the contours of the forms are sharply defined and the viewer's eye is drawn to the edges of the various shapes. David's painting *The Death of Socrates* **(B)** contains no actual outlines as we have seen in other examples. However, the contour edges of the many figures are very clearly defined. A clean edge separates each of the elements in the painting, so that a line tracing of these edges would show us the whole scene. The color adds interest, but we are most aware of the essential drawing underneath. As a mundane comparison, remember the coloring books we

had as children and, as we took out our crayons, the parental warnings to "stay within the lines." Despite the absence of actual lines, the David work would be classified as a linear painting.

Applying Color

Explicit lines can play other roles in painting besides the clear definition of shape or form. Some artists use a linear technique in applying color. The color areas are built up by repeated linear strokes that are not smoothed over. *The Artist's Daughter, Julie, with her Nanny* **(C)** by Berthe Morisot is an example of this technique, which was employed by many artists of the **Impressionist** period.

Brice Marden's painting **(D)** is composed of serpentine lines that create a complex pattern. The color of the lines creates different spatial levels and shifting areas of interest or emphasis.

A
Janet Lucroy. Computer-generated image.

B
Jacques-Louis David. *The Death of Socrates.* 1787. Oil on canvas, 4′ 3″ × 6′ 5¼″ (1.3 × 1.96 m). The Metropolitan Museum of Art, New York (Wolfe Fund, 1931. Catharine Lorillard Wolfe Collection, 31.45).

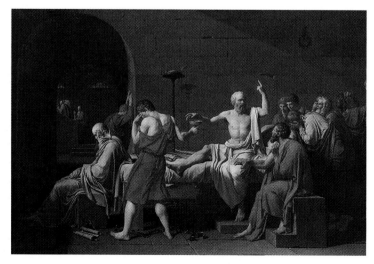

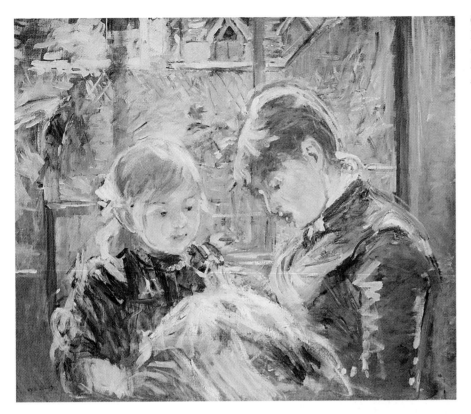

C
Berthe Morisot. *The Artist's Daughter, Julie, with her Nanny.* c. 1884. Oil on canvas, 23 × 28″. The Minneapolis Institute of Arts (John R. Van Derlip Fund).

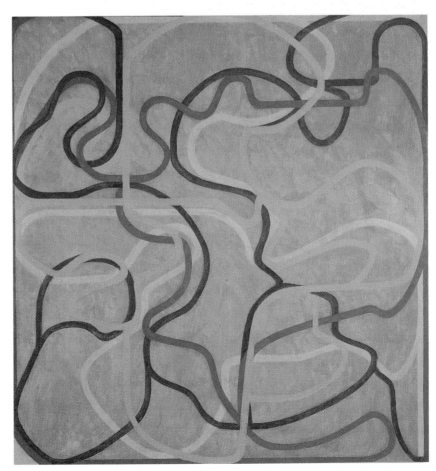

D
Brice Marden. *Epitaph Painting 5.* 1997–2001. Oil on linen, 108.5 × 104″. Matthew Marks Gallery, New York.

SUGGESTIONS OF FORM

Salome with the Head of John the Baptist **(A)** is a painting by Caravaggio that puts more emphasis on color and value than on line. In each of the figures, only part of the body is revealed by a sharp contour, but the edge then disappears into a mysterious darkness. This is termed **lost-and-found contour:** Now you see it, now you don't. The artist gives us a few clues, and we fill in the rest. For example, when we see a sharply defined profile, we will automatically assume the rest of the head is there, although we do not see it. A line interpretation **(B)** of this painting proves that we do not get a complete scene but merely suggestions of form. Bits and pieces float, and it is more difficult to understand the image presented.

Relative Clarity

A strong linear contour structure in a painting provides clarity. Lost-and-found contour gives only relative clarity but is in fact closer to our natural perception of things. Seldom do we see everything before us in equal and vivid contrast. The relief shown in **C** presents a rhythmic linear composition created by only those edges cast in shadow. In this case of a white-on-white relief, it is the illuminated edges that disappear. We can get a better idea of the "lost" contours from the study drawing shown in **D**. Obviously a different composition of lines in **C** would be revealed with a change in the direction of light.

Selected Lighting

Photographers often choose the lighting for a subject to exploit the emotional and expressive effects of lost-and-found contour. Illustration **E** is just one of the countless photographs that have used the technique. Here a very beautiful and dramatic image has been produced from a simple architectural detail.

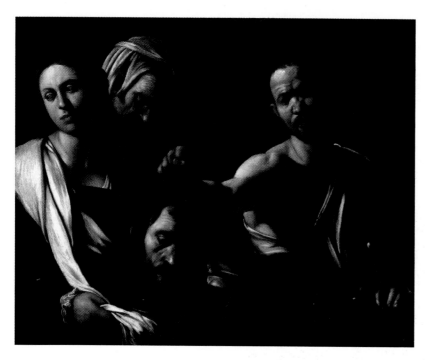

A
Caravaggio. *Salome with the Head of John the Baptist.* c. 1609. Oil on canvas, 116 × 140 cm. National Gallery, London.

B
Only some contours are visible in the painting.

C
Sophie Taeuber-Arp. *Parasols.* 1938.
Painted wood relief, 34 × 24″ (86 × 61 cm).
Rijksmuseum Kroller-Muller, Otterlo.

D
Sophie Taeuber-Arp. *Untitled*
(Study for Parasols). 1937.
Black crayon, 13 1/2 × 10″
(34 × 25 cm). Foundation Jean
Arp and Sophie Taeuber-Arp,
Rolandseck, Germany.

E
Mark Feldstein. *Untitled.* Photograph.

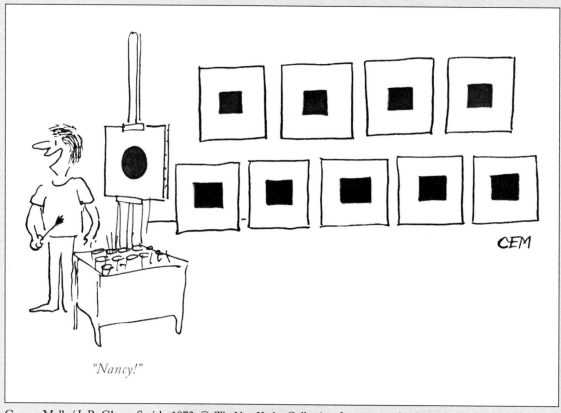

CHAPTER **8**

A
Sydney Licht. *Still Life with Two
Bunches.* Oil on linen, 12 × 12″.
Lyons Wier Gallery, New York.

A **shape** is a visually perceived area created by either an
enclosing line or color or value changes defining the outer
edge. A shape can also be called a **form.** The two terms are
generally synonymous and are often used interchangeably.
"Shape" is a more precise term because form has other mean-
ings in art. For example, "form" may be used in a broad sense
to describe the total visual organization of a work, including
color, texture, and composition. Thus, to avoid confusion, the
term "shape" is more specific.

Design, or composition, is basically the arrangement of
shapes. The still life painted by the contemporary painter
Sydney Licht **(A)** is dominated by oval shapes in various sizes
and combinations. Of course, the color, texture, and value of
these shapes are important, but the basic element is shape,
including the shapes defined by the spaces between objects
and the more complex shapes created through groups or clus-
ters of simple shapes. The pattern on the tablecloth serves as

a simple and more abstract echo of the shapes and negative
shapes found in the asparagus bundles.

Pictures certainly exist without color, without any signifi-
cant textural interest, and even without line, but rarely do
they exist without shape. In representational pictures, only the
most diffuse atmospheric images of light can be said almost
to dispense with shape. The image in **B** is one of Monet's
impressions of the Rouen Cathedral that emphasizes light
and atmosphere over shape. Illustration **C** is a further exag-
geration of these qualities by Lichtenstein. The shape of the
cathedral in **C** barely flickers into focus, and the many dots
make the image compete with the shapes of the architectural
elements for our attention.

If you look closely, you can see that the dots in **C** are small
circles, and so this image has one level of connection with the
still life in **A.** Everything else may be different, but at the level
of shape they have a common element.

B
Claude Monet. *Rouen Cathedral: Portal, Grey Weather.* 1892.
Oil on canvas. Musée d'Orsay, Paris.

C
Roy Lichtenstein. *Cathedral #2 from the Cathedral Series.* 1969.
Color lithograph and screen print in red and blue, 48^{5}/$_{16}$ × 32^{3}/$_{8}$″
(123 × 82.5 cm). Fine Arts Museums of San Francisco, Anderson
Graphic Arts Collection (gift of Harry W. and Margaret
Anderson Charitable Foundation, 1996.74.239).

WORKING IN TWO AND THREE DIMENSIONS

Shape usually is considered a two-dimensional element, and the words "volume" and "mass" are applied to the three-dimensional equivalent. In simplest terms, paintings have shapes and sculptures have masses. The same terms and distinctions that are applied to shapes apply to three-dimensional volumes or masses. Although the two concepts are closely related, the design considerations of the artist can differ considerably when working in two- or three-dimensional media.

Angle of Perception

A flat work, such as a painting, can be viewed satisfactorily from only a limited number of angles and offers approximately the same image from each angle, but three-dimensional works can be viewed from countless angles as we move around them. The three-dimensional design changes each time we move: The forms are constantly seen in different relationships. Unless we purposely stop and stare at a sculpture, our visual experience is always fluid, not static. The two photographs of the piece of sculpture by David Smith **(A)** show how radically the design pattern can change depending on our angle of perception.

Thus, in composing art of three-dimensional volume or mass, the artist has more complex considerations. We may simply step back to view the progress of our painting or drawing. With sculpture we must consider the work from a multitude of angles, anticipating all the viewpoints from which it may be seen.

Architecture is the art form most concerned with three-dimensional volumes. Architecture creates three-dimensional shapes and volumes by enclosing areas within walls. Some artists, both in the past and present, have selected to work with the architecture, not independent from it.

Combining Two- and Three-Dimensional Work

A sharp, clear-cut label for art as either two- or three-dimensional is not always possible. Relief sculptures are three-dimensional, but because the carving is relatively shallow with a flat back, they actually function more as paintings without color. Many contemporary artists now incorporate three-dimensional elements by attaching items to the canvas or presenting them with the canvas. In the work by Jennifer Bartlett **(B),** a painting of boats is juxtaposed against three-dimensional versions of the same image. These sculptural elements refer more to the shapes in the painting than to real boats. They are cropped at the same points as the images are cropped in the painting. In this case, the three-dimensional form seems to copy the painting, rather than the usual idea of the painting following the appearance of the three-dimensional form.

Many artists today attempt to break down the dividing barriers between painting, sculpture, architecture, and even theater. In such cases the content determines the appropriate forms. Malcolm Cochran's *Western Movie* **(C)** includes a wide screen projection of a nineteenth-century painting of Niagara Falls. Moving images of water are projected on top of this from several film projectors. The area in front of the large curved screen is occupied by amusement-ride horses, which are moving up and down. The whole **installation** is presented in a gallery space transformed into a theater-like setting. This complex artwork evokes ideas of the American frontier through a variety of media and incorporates the element of time as well.

A
David Smith. *Blackburn: Song of an Irish Blacksmith,* front and side views. 1949–50. Steel and bronze, 46¹/₄ × 41 × 24″ (117 × 104 × 61 cm); height of base 8″ (20 cm), diameter 7¹/₄″ (18 cm). Wilhelm Lehmbruck Museum, Duisburg, Germany.

B
Jennifer Bartlett. *Boats.* 1987. Sculpture:
painted wood, steel support, pine mast,
66¹/₂ × 47¹/₂ × 46″ each (169 × 121
× 117 cm); painting: oil on canvas,
9′ 10″ × 14″ (3 × 4.3 m). Courtesy
Paula Cooper Gallery, New York.

C
Malcolm Cochran. *Western Movie.* 1990. Installation.

EXAGGERATED SHAPES

The magazine cover in **A** shows the difference between **naturalism** and **distortion.** By a clever adaptation of two well-known paintings, we can see the contrast. The woman on the right (from a Sargent painting) would be described as "naturalistic." The artist has skillfully reproduced the visual image, the forms and proportions seen in nature, with an illusion of volume and three-dimensional space.

Naturalism is what most people call **realism,** meaning, of course, visual realism. On the left side of **A,** there is another woman (from a Picasso painting) shown in what is called "distortion." In using distortion, the artist purposely changes or exaggerates the forms of nature. Sometimes distortion is meant to provoke an emotional response on the part of the viewer; sometimes it serves to emphasize the design elements inherent in the subject matter.

Distortion Old and New

Many people think that distortion is a twentieth-century development. Now that the camera can easily and cheaply reproduce the appearance of the world around us—a role formerly filled by painting—distortion has greatly increased in twentieth-century art to one degree or another. However, distortion has always been a facet of art. Distortion of the figures is clear in the fourteenth-century wooden sculpture in **B.** The subject is Mary holding the crucified Christ. The distortion of the usual body proportions emphasizes the agony of the theme.

The advertisement shown in **C** distorts the human form through elongation. The result is an image that communicates visually the stretching, leaping, and reaching inherent in a basketball game. This distortion puts an emphasis on the action over a naturalistic view of the body.

A

Russell Connor. *The New Yorker* cover drawing. November 23, 1992.

B
Rottgen Pieta. c. 1370. Wood,
10¹/₂″ (27 cm) high. Rheinisches
Landesmuseum, Bonn.

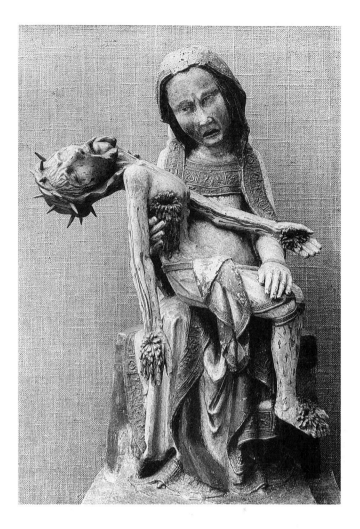

C
Ad for Nike Sportswear. 1995. NYC City
Campaign. Art Director: John C. Jay.
Designer: Pao. Illustrator: Javier Michaelski.
Creative Directors: Dan Wieden, Susan
Hoffman. Source: Page 87, *Print*,
March/April 1996.

A

Catherine Murphy. *Self-Portrait.*
1970. Oil on canvas, 49¹/₂ × 37¹/₈″
(125.7 × 94.3 cm). Museum of Fine
Arts, Boston (gift of Michael and
Gail Mazur, 1998.416).

NATURE IMPROVED

Naturalism is concerned with appearance. It gives the true-to-life, honest visual appearance of shapes in the world around us. In contrast, there is a specific type of artistic distortion called **idealism.** Idealism reproduces the world not as it is but as it should be. Nature is improved on. All the flaws, accidents, and incongruities of the visual world are corrected.

Idealism in Art

The self-portrait by Catherine Murphy **(A)** is naturalistic. Even in painting herself, the artist has indulged in no flattery. The artist's face is in shadow and the emphasis is less on the portrait than the naturalistic presentation of the artist's studio. The fifth-century B.C. statue **(B)** illustrates the opposite approach—idealism. This statue was a conscious attempt to discover the ideal proportions of the human body. No human figure was copied for this sculpture. The statue represents a visual paragon, a conceptual image of perfection that nature simply does not produce.

Idealism is a recurrent theme in art, as it is in civilized society. We are all idealistic; we all strive for perfection. Despite overwhelming historical evidence, we continue to believe we can create a world without war, poverty, sickness, or social injustice. Obviously, art will periodically reflect this dream of a utopia.

Idealism in Advertising

Today, we are all familiar with a prevalent, if mundane, form of idealism. Large numbers of the advertisements we see daily are basically idealistic. Beautiful people in romantically lit and luxurious settings induce an atmosphere that is far different from the daily lives of most of us. Yet we do enjoy the glimpse of the never-never land awaiting if we use a certain product. Governments also often employ idealistic images to convince the world (or themselves) that their particular political system is superior. The world of commerce has also used this figurative language for the same ambition. The heroic figures in **(C)** are an example.

B
Polyclitus. *Doryphorus (Spear Bearer).*
Roman copy after Greek original
of c. 450–440 B.C. Marble, height
6′ 11″ (1.98 m). Museo Nazionale,
Naples.

C
A fence for a construction project
on Fifth Avenue, NY, 1991.
Designer: Dean Alexander.
Painted by Evergreene Studios.

ESSENCE OF SHAPE

A specific kind of artistic distortion is called **abstraction.** Abstraction implies a simplification of natural shapes to their essential, basic character. Details are ignored as the shapes are reduced to their simplest terms. The painting in **A** is an example of abstraction.

Abstraction for Effect

Because no artist, no matter how skilled or careful, can possibly reproduce every detail of a natural subject, any painting could be called an abstraction. But the term "abstraction" is most often applied to works in which simplification is visually obvious and important to the final pictorial effect. Of course, the degree of abstraction can vary. In **A** all the elements have been abstracted to some extent. Most details have been omitted in reducing the boats to basic geometric shapes (primarily sections of circles and rectangles). Still, the subject matter is immediately recognizable, even though we are several steps removed from a naturalistic image. This form of abstraction, where elements are simplified to simple building blocks, is sometimes called "reductive."

For the Love of Shapes

Abstraction is not a new technique; artists have employed this device for centuries. If anything, the desire for naturalism in art is the more recent development. The Eskimo ceremonial mask in **B** clearly shows abstracted forms. Although the result is quite different from **A,** many of the shapes in this mask also seem to suggest geometric forms. This illustrates the widely accepted principle: All form, however complex, is essentially based on, and can be reduced to, a few geometric shapes.

Abstracted form does not always lead simply to an alternative representation of a naturalistic form. Abstraction often arises from a love of shape and form for its own sake, and a delight in manipulating form. The teapot shown in **C** transforms a given mold form of a duck into the form of a teapot in an unexpected way.

Biomorphic Shapes

Not all abstraction necessarily results in a geometric conclusion, and abstraction can result in imagery that is not as directly derived from natural references as the previous examples. The simple petal-like shapes in Arshile Gorky's *Garden in Sochi* **(D)** suggest plants, and even human anatomy, without explicitly resembling anything nameable. Abstract shapes such as these, which allude to natural, organic forms, are called **biomorphic.**

B
Inuit (south of the lower Yukon). Mask of Tunghak, Keeper of the Game. 19th century. Painted wood, width 36$\frac{1}{4}$" (93 cm). National Museum of Natural History, Smithsonian Institution.

A
Paul Resika. *July.* 2001.
Oil on canvas, 52 × 60".
Alpha Gallery, Boston.

C
Rebecca Harvey. *Systema Naturae*. 1998.
Department of Art, Ohio State University.

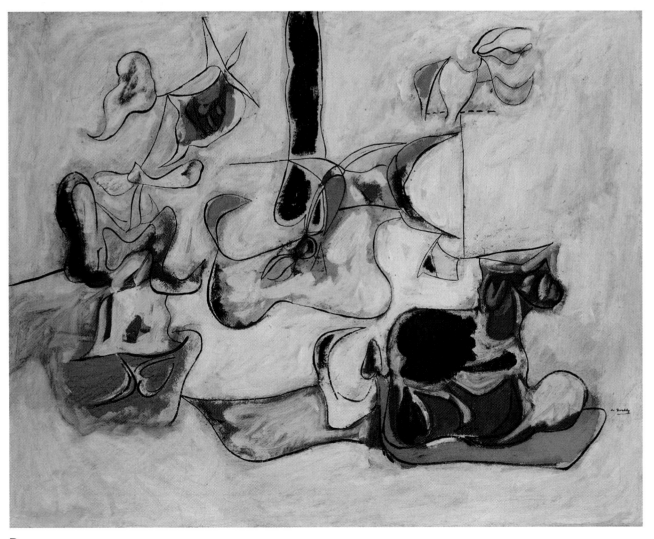

D
Arshile Gorky. *Garden in Sochi*. c. 1943. Oil on canvas, 31 × 29″ (78.7 × 99 cm). The Museum of Modern Art,
New York (acquired through the Lillie P. Bliss Bequest).

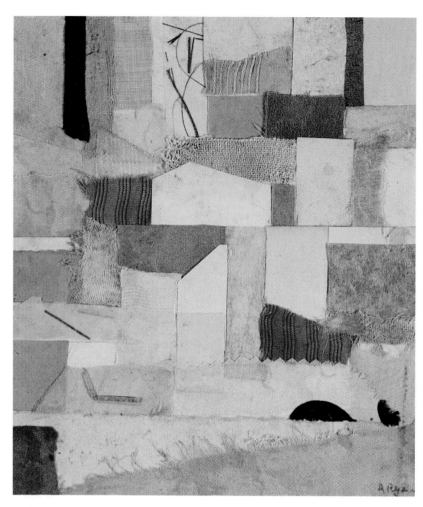

A
Anne Ryan. *No. 74.* Between 1948/1954.
Fabric and paper collage, 8 × 7″ unframed.
Walker Art Center (gift of Elizabeth
McFadden, 1979).

PURE FORMS

According to common usage, the term "abstraction" might
be applied to the collage in **A.** This would be misleading,
however, because the shapes in this work are not natural forms
that have been artistically simplified. They do not represent
anything other than the geometric forms we see. Rather, they
are pure forms. A better term to describe these shapes is
nonobjective—that is, shapes with no object reference and
no subject matter suggestion.

Visual Design

Most of the original design drawings in this book are non-
objective patterns. Often, it is easier to see an artistic principle
or element without a distracting veneer of subject matter. In a
similar way, many twenty-first-century artists are forcing us to
observe their works as visual patterns, not storytelling narra-
tives. Without a story, subject, or even identifiable shapes, a
painting must be appreciated solely as a visual design. Lack of
subject matter does not necessarily eliminate emotional content

in the image. Some nonobjective works are cool, aloof, and
unemotional. Paintings or collages such as **A** present purely
nonobjective, geometric shapes that are, as Plato said, "free
from the sting of desire." Illustration **B** is equally nonobjective,
but the shapes are not geometric and seem to have developed
from the inherently fluid quality of the paint. The canvas
seems to be a record of the paint flowing and pooling under
the artist's direction.

Shape Associations

Whether any shape can be truly nonobjective is a good ques-
tion. Can we really look at a circle just as a circle without
beginning to think of some of the countless round objects in
our environment? Artists often make use of this instinctive
human reflex. A work such as Daniel Wiener's sculpture **(C)**
appears to be a totally nonobjective pattern of forms, yet it is
reminiscent of structures we know from nature: the roots of a
tree or spider legs, to name just two.

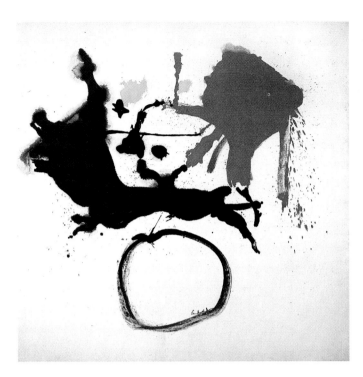

B
Helen Frankenthaler. *Over the Circle.* 1961.
Oil on canvas, 84¹/₈ × 87⁷/₁₆″ (2.13 × 2.21 m).
Jack S. Blanton Museum of Art, The University
of Texas at Austin (gift of Mari and James A.
Michener, 1991).

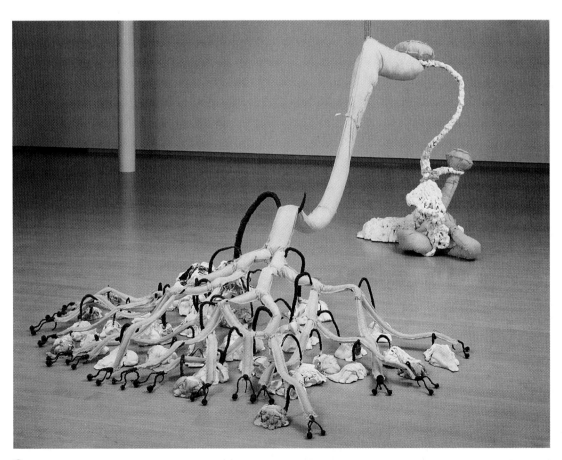

C
Daniel Wiener. *Chorus.* 1993. Hydrocal, acrylic, wire, dyed muslin, 15′ 5¹/₂″ × 13′ × 7′ 7″
(1.66 × 3.96 × 2.31 m). Gorney Bravin & Lee, New York.

A and **B** illustrate the difference in two terms that are commonly applied to shapes: **curvilinear** and **rectilinear.** Two objects with functional priorities are visually quite different in design. The armchair in **A** is one continuous curve mounted on a tubular frame—an example of curvilinear design. The prefabricated house **(B)** emphasizes right angles and rectangular planes—all the forms have straight edges, giving a sharp, angular feeling. "Rectilinear" is the term to describe this visual effect. Interestingly enough, interior photographs of this home show chairs similar to **A.**

The painting by Yeardley Leonard **(C)** is clearly a rectilinear design. The emphasis of this painting is on color interval and relationships. A rectilinear composition keeps the focus on planes of color, and these planes repeat the overall format of a rectangular painting.

The poster in **D** shows an equal emphasis on the opposite curvilinear type of shape. There is barely a straight line to be found. This poster is a product of a late nineteenth-century style called **art nouveau,** which put total pictorial emphasis on curvilinear or natural shapes.

We do think of curvilinear shapes as natural, reflecting the soft, flowing shapes found in nature. Rectilinear shapes, being more regular and precise, suggest geometry and, hence, appear more artificial and manufactured. Of course, these are very broad conclusions. In fact, geometric shapes abound in nature, especially in the microscopic structure of elements, and people design many objects with irregular, free-form shapes.

Examples **C** and **D** concentrate exclusively on a single type of shape. Most art and design combine both types. In architecture we may think of rectilinear design dominating with the verticals and horizontals of doors, windows, and walls. The simple curve of an arch can provide visual relief. Or, as in **E,** a dramatically curved section of the building seems to send a ripple or wave through the design of the rest of the building, even affecting the pattern of rectangular windows.

A
Curved Armchair.

B
Rocio Romero. Prefabricated Home ("LV Home," designed as a second vacation home—production beginning Summer 2003).

C
Yeardley Leonard. *Sita.* 2001. Acrylic on linen on panel, 16½ × 33″.
Elizabeth Dee Gallery, New York.

D
Will H. Bradley. Poster for the Thanksgiving Number
of *The Chap-Book.* 1895. Lithograph, 19⅝ × 18⁵/₁₆″
(49.7 × 33.5 cm). The Metropolitan Museum of Art,
New York (gift of Leonard A. Lauder, 1984.1202.7).

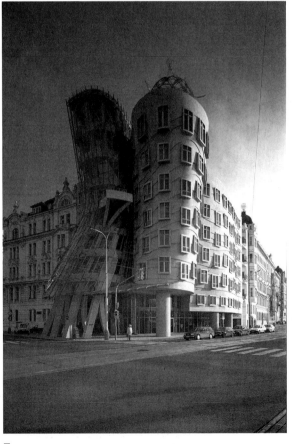

E
Nationale-Nederlanden Building. Prague. Architects: Vladimir
Milunic, Frank Gehry. 1996. Photo: Tim Griffith/Esto.

INTRODUCTION

The four examples in **A** illustrate an important design consideration that is sometimes overlooked. In each of these patterns, the black shape is identical. The very different visual effects are caused solely by its placement within the format. This is because the location of the black shape immediately organizes the empty space into various shapes. We often refer to these as **positive** and **negative shapes.** The black shape is a positive element, the white empty space the negative shape or shapes. **Figure** and **ground** are other terms used to describe the same idea—the black shape being the figure.

Negative Spaces Are Carefully Planned

In paintings with subject matter, the distinction of object and background is usually clear. It is important to remember that both elements have been thoughtfully designed and planned by the artist. The subject is the focal point, but the negative areas created are equally important in the final pictorial effect. Japanese art often intrigues the Western viewer because of its unusual design of negative spaces. In the Japanese print **(B),** the unusual bend of the central figure and the flow of the robes to touch the edges of the picture create two varied and interesting negative spaces. A more usual vertical pose for this figure would have formed more regular, symmetrical shapes in the negative areas. In this composition the dominant shapes

are actually the hair and black borders on the robe. The light ground blends with face and head; only a delicate line marks the boundary of figure and ground here.

Negative shapes are also an aspect of letter design and typography. In this case a black letter may be the "figure" and the white page, the "ground." Aaron Siskind's photograph *Chicago 30* **(C)** is apparently a sideways letter "R." By cropping in on his subject, he has given almost equal weight to the white negative areas, thus giving emphasis to the shapes of both. The play of light and dark or figure and ground is similar to the print by Utamaro **(B).**

Using Negative Space in Three Dimensions

The same positive/negative concept is applicable to three-dimensional art forms. The sculpture of Henry Moore is noted for the careful integration of negative space "holes" within the composition. Architecture is, in essence, the enclosure of negative spaces. The contrast of positive and negative areas may also be a primary consideration in the overall design, as the house by Michael Graves **(D)** shows.

A
The location of shapes in space organizes the space into positive and negative areas.

B
Utamaro. *Ten looks of women's physiognomy/enjoyable looks.*
The Japan Ukiyo-e Museum, Matsumoto, Japan.

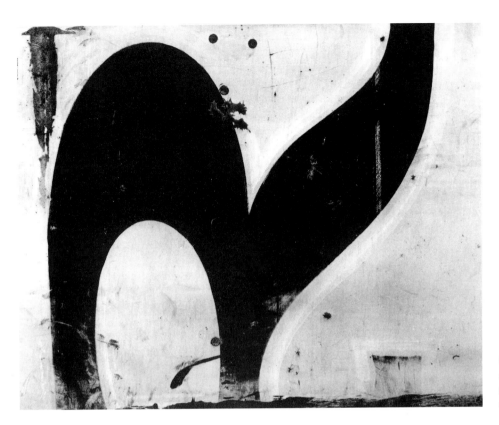

C
Aaron Siskind. *Chicago 30*. 1949. Gelatin
silver, 13⁷/₈ × 17⁵/₈″. International Center
of Photography, New York.

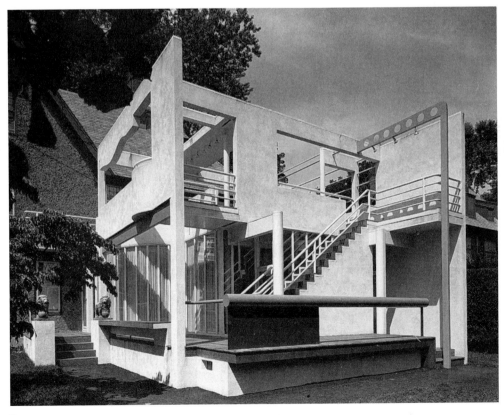

D
Michael Graves. Addition to the Benacerraf House. Princeton, New Jersey, 1969.

INTEGRATION

Design themes and purposes vary, but some integration between positive and negative shapes is generally thought desirable. In **A** the shapes and their placement are interesting enough, but they seem to float aimlessly within the format. They also have what we call a "pasted-on" look, because there is little back-and-forth visual movement between the positive shapes and the negative white background. An unrelieved silhouette of every shape is usually not the most interesting spatial solution. The image in **B** shows similar shapes in the same positions as those in **A,** but the "background" is now broken into areas of value that lend interest as well as better positive/negative integration. The division into positive and negative is flexible.

Three drawings by Georges Seurat demonstrate three degrees of positive/negative integration. The drawing of the female figure shown in **C** presents the figure as a dark shape against a lighter background. For the most part this is a silhouette; positive and negative (figure and ground) are presented as a simple contrast.

The relationship of positive and negative is more complex in **D.** The left side of the figure is dark against a lighter ground, and the right side of the figure is light against a darker ground. This alternation of dark and light makes us aware of the negative shapes, and they take on a stronger visual interest than in **C.**

The composition of **E** presents the most complex integration of positive and negative shapes of the three Seurat drawings. Here, dark, light, and middle values are present as both figure and ground. There are areas of sharp distinction, such as the edge of the arm against the background, and there are also areas of soft or melting transitions where the eye moves smoothly from foreground to middle ground to background. The soft boundaries of the hair melt into the surrounding background shapes.

The range of positive/negative integration can be found in abstract or nonobjective artworks, as well as in representational images. The shapes in **E** work both as representations (head and wall, for example) and as an abstract composition of light and dark shapes.

A
When positive and negative spaces are too rigidly defined, the result can be rather uninteresting.

B
If the negative areas are made more interesting, the positive-negative integration improves.

C
Georges Seurat. *Silhouette of a Woman*. 1882–84.
Conté crayon on paper, 12 × 8⁷/₈″ (30.5 × 22.5 cm).
Collection of the McNay Art Museum, San Antonio,
Texas (bequest of Marion Koogler McNay).

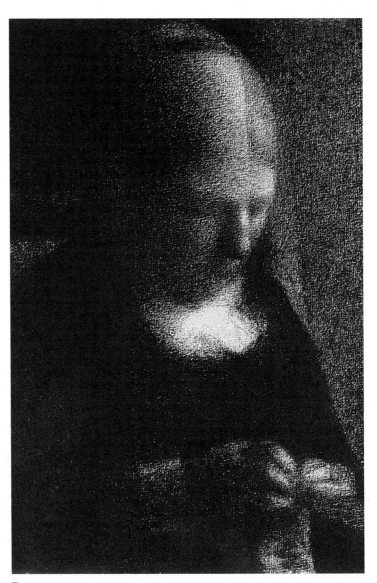

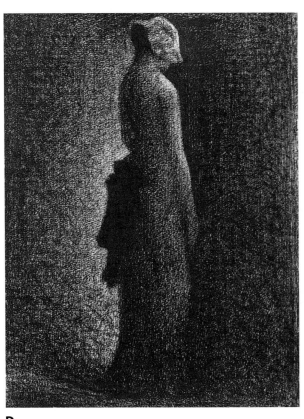

E
Georges Seurat. *The Artist's Mother (Woman Sewing)*. 1882–83. Conté
crayon, 12¹/₄ × 9¹/₂″ (31 × 24 cm). Metropolitan Museum of Art,
New York (Purchase, Joseph Pulitzer Bequest, 1951; acquired from
The Museum of Modern Art, Lillie P. Bliss Collection, 55.21.1).

D
Georges Seurat. *The Black Bow*. c. 1882. Conté crayon,
12³/₁₆ × 9¹/₆″ (31 × 32 cm). Musée d'Orsay, Paris.

CONFUSION

Sometimes positive and negative shapes are integrated to such an extent that there is truly no visual distinction. When we look at the painting in **A,** we automatically see some black shapes on a background. But when we read the artist's title, *White Forms,* suddenly the view changes, and we begin to focus on the white shapes, with the black areas now perceived as negative space. The artist has purposely made the positive/negative relationship **ambiguous.**

The film poster in **B** has this same quality, as our eyes must shift back and forth from dark to light in seeking the positive element. We may at first see two black heads, one in top hat, silhouetted against a light shape. Then we notice the light area is a woman's profile. The image is appropriate for the title, *The Bartered Bride.*

Deliberate Blending of Positive/Negative Shapes

In most paintings of the past, the separation of object and background was easily seen, even if selected areas merged visually. But several twentieth-century styles literally do away with the distinction. We can see that the subject matter of the painting in **C** is a figure. Despite the **cubist** abstractions of natural forms into geometric planes, we can discern the theme. But it is difficult to determine just which areas are part of the figure and which are background. The artist, Picasso, also broke up the space in the same cubist manner. There is no clear delineation of the positive from the negative.

Deliberate Delineation of Positive/Negative Shapes

Picasso's painting invites the viewer to a slow reading of figure and ground relationships. In graphic design the goal is more often for a quicker impact. An integration of positive and negative shapes not only is a way to get a viewer's attention with high-contrast simple forms, but often it can present surprising or memorable results. The logo for Multicanal, an Argentine cable company **(D),** takes advantage of an alternating figure ground reading. Our attention is captured by the back-and-forth reading of stars and "M".

A
Franz Kline. *White Forms.* 1955. Oil on canvas, 6′ 2³/₈″ × 4′ 2¹/₄″ (188.9 × 127.6 cm). Museum of Modern Art, New York (gift of Philip Johnson).

B
Hans Hillmann. Poster for the film *The Bartered Bride.* 1972. Source: Page 105, *Print,* March/April 1988.

C
Pablo Picasso. *Daniel–Henry Kahnweiler.* 1910.
Oil on canvas, $39^5/8 \times 28^5/8''$ (101 × 73 cm).
Photograph courtesy of The Art Institute of
Chicago (gift of Mrs. Gilbert W. Chapman,
1948.561).

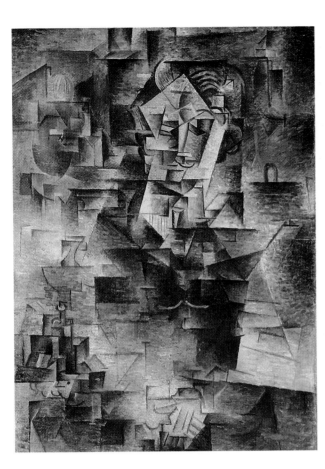

D
Multicanal (logo design for cable television company, Buenos Aires, Argentina). Chermayeff
& Geismar, Inc., New York.

"Oh, for Pete's sake, lady! Go ahead and touch it."

CHAPTER 9

ADDING VISUAL INTEREST

Texture refers to the surface quality of objects. Texture appeals to our sense of touch. Even when we do not actually feel an object, our memory provides a sensory reaction or sensation of touch. In effect, the various light and dark patterns of different textures give visual clues so that we can enjoy the textures vicariously. Of course, all objects have some surface quality, even if it is only an unrelieved smooth flatness. The element of texture is illustrated in art when an artist purposely exploits contrasts in surface to provide visual interest.

Texture in Craft Forms

Many art forms have a basic concern with texture and its visual effects. In most of the craft areas, texture is an important consideration. Ceramics, jewelry, and furniture design often rely heavily on the texture of the materials to enhance the design effect. In weaving and the textile arts, texture is a primary consideration. The interior designer must be sensitive to the visual effects that textural contrasts can achieve.

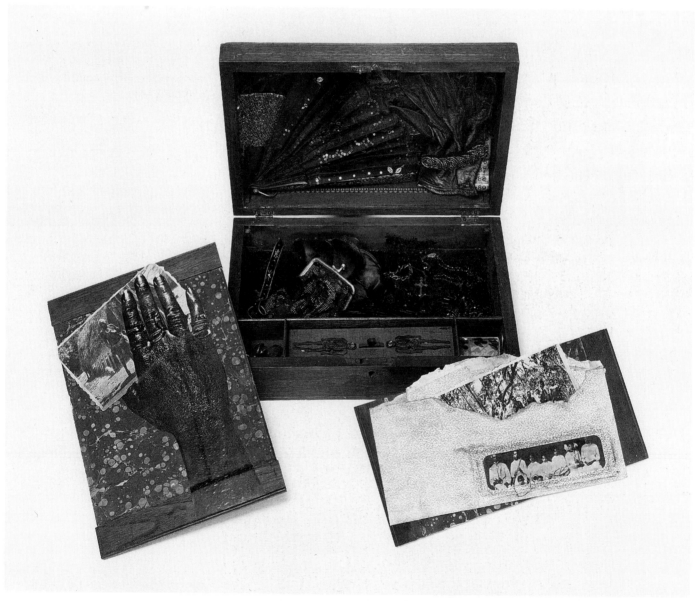

A

Betye Saar. *The Time Inbetween*. 1974. Wooden box containing photos, illustration, paint, envelope, metal findings, beads, fan, glove, tape measure, lace, buttons, coin purse, velvet ribbon, cloth, feathers, bones; closed dimensions: $3^3/8 \times 8^1/2 \times 11^5/8''$ (8.6 × 21.6 × 29.6 cm). San Francisco Museum of Modern Art (purchase).

Texture in Sculpture

In sculpture exhibits, Do Not Touch signs are a practical (if unhappy) necessity, for so many sculptures appeal to our enjoyment of texture that we almost instinctively want to touch. The smooth translucence of marble, the rough grain of wood, the polish or patina of bronze, the irregular drop of molten solder—each adds a distinctive textural quality.

Textural Variety

Betye Saar's *The Time Inbetween* **(A)** contains a variety of textures and seems to invite us to explore this intimate collection by handling it. Beads, feathers, bone, and velvet provide a variety of tactile sensations. A photocopy of the artist's hand underscores the primacy of the sense of touch for this artwork.

The photograph in **B** shows a contrast between the smooth eggs and the rough stones. It also shows the effect of scale on our visual impression of texture. At close range we might observe an individual rock or stone. At a further distance a textural pattern takes over. At an even further distance the pattern becomes finer and textural contrasts apparently soften. When seen from an airplane, a hillside cloaked in trees may appear to be soft in texture.

B
Chester Higgins. *Egg vendor along commuter rail tracks in Ghana.* 1974. Photograph.

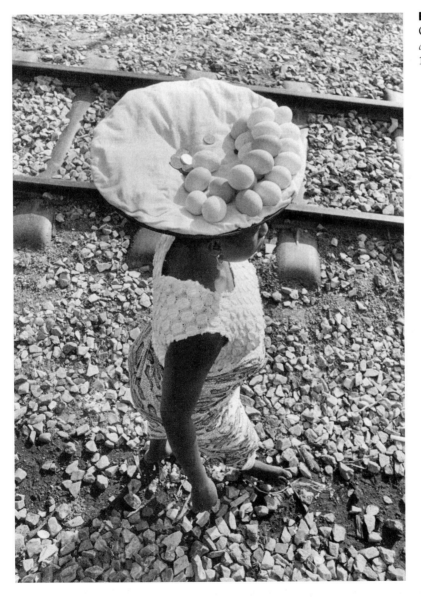

ACTUAL AND IMPLIED

There are two categories of artistic texture—tactile and visual. Architecture and sculpture employing actual material have what is called **tactile texture**—texture that can actually be felt. In painting, the same term describes an uneven paint surface, when an artist uses thick pigment (a technique called **impasto**) so that a rough, three-dimensional paint surface results.

Texture as Paint on Canvas

As the need and desire for illusionism in art faded, tactile texture became a more common aspect of painting. Paintings now could look like what they truly were—paint on canvas. Modifying the painting's surface became another option available to the artist. Van Gogh was an early exponent of the actual application of paint as a further expressive element. The detail in **A** shows how short brushstrokes of thick, undiluted paint are used to build up the agitated, swirling patterns of van Gogh's images. The ridges and raised edges of the paint strokes are obvious to the viewer's eye.

The Next Step

The "relief painting" by Thornton Dial **(B)** shows a next step in bringing tactile texture into a painting. This painting is so complex with contrasts of value (light and dark) and added materials that we have to look closely at some parts to determine what is tactile texture and what is implied texture. In this case materials include cans, bottles, and a desiccated cat! The surprising result is one of paint and other materials working together to create a unified composition. The dividing line between painting and sculpture disappears in many such contemporary works when actual items are attached to the painted surface.

Texture in Architecture

Wharton Esherick designed a home **(C)** with gentle curves, muted colors, and the textures of stone, wood, and shingles. All of these elements echo the surrounding tactile textures of the environment. In this case the sense of touch can accompany that of sight. Tactile texture can be felt as well as seen in an architectural context.

A
Vincent van Gogh. *Portrait of the Artist*. 1889. Oil on canvas, 65 × 54.5 cm. Musée d'Orsay, Paris.

B
Thornton Dial. *Contaminated Drifting Blues.* 1994. Desiccated cat, driftwood, aluminum cans, glass bottle, found metal, canvas, enamel, spraypaint, industrial sealing compound on surplus plywood, 67 × 49 × 17¹/₂″ (170 × 124 × 44 cm). Collection of William S. Arnett.

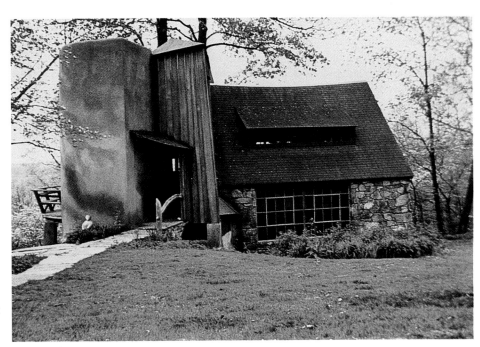

C
Wharton Esherick. Esherick House. Wharton Esherick Museum, Paoli, PA.

A

Mary Bauermeister. *Progressions.* 1963. Pebbles and sand on four plywood panes, 51¼ × 47⅜ × 4¾″ (130.1 × 120.4 × 12 cm). The Museum of Modern Art, New York (Matthew T. Mellon Foundation Fund).

COLLAGE

Creating a design by pasting down bits and pieces of colored and textured papers, cloth, or other materials is called **collage.** This artistic technique has been popular for centuries, mainly in the area of **folk art.** Only since the twentieth century has collage been seriously considered a legitimate medium of the fine arts.

Why Collage?

The collage method is a very serviceable one. It saves the artist the painstaking, often tedious task of carefully reproducing textures in paint. Collage is an excellent **medium** for beginners. Forms can be altered or reshaped quickly and easily with scissors. Also, compositional arrangements can more easily be tested (before pasting) than when the design is indelibly rendered in paint.

Creating a Range of Tactile Sensations

Mary Bauermeister's collage titled *Progressions* **(A)** is composed of stones and sand on board. Even in the reproduction, one can imagine a range of tactile sensations, from bumpy to rough.

Bauermeister has emphasized the textural qualities of her materials by reducing the composition to a few squares of progressively larger size. Within two of the squares there is also a progression in the size of the pebbles, creating a gradation in texture from fine to coarse. The real physical presence of the materials can be seen in the shadows cast by this collage.

Anne Ryan, an American, worked mainly in collages of cloth. Her untitled collage in **B** shows various bits of cloth in contrasting weaves and textures interspersed with some scraps of printed papers. The dark and light pattern is interesting, but our attention is drawn mainly to the contrast of tactile textures.

Using Found Materials

Folk art is often characterized by an inventive use of found materials and may in fact be considered one of the oldest forms of collage. Uninhibited by academic conventions about "appropriate" art materials, artists outside the mainstream have frequently taken joy in transforming trash into treasure. The many bottle caps in **C** take on a new life as the "skin" of a fantasy giraffe.

B
Anne Ryan. *Untitled,* No. 129. c. 1948–54.
Collage on paper, 4³/₄ × 4¹/₄″ (12.1 ×
10.8 cm). Courtesy Joan T. Washburn
Gallery, New York.

C
Unidentified Artist. *Bottlecap Giraffe.* c. 1966.
Bottle caps on painted wood with marbles and
animal hair and fur, 72¹/₂ × 54 × 17¹/₂″
(184.2 × 137.2 × 44.5 cm). National Museum
of American Art. Smithsonian Institution,
Washington, D.C. (gift of Herbert Waide
Hemphill, Jr., and Museum Purchase made
possible by Ralph Cross Johnson).

VISUAL IMPRESSION

In painting, artists can create the impression of texture on a flat, smooth painted surface. By reproducing the color and value patterns of familiar textures, painters encourage us to see textures where none actually exist. This is called **visual texture.** The impression of texture is purely visual; it cannot be felt or enjoyed by touch. It is only suggested to our eyes.

Choosing Subject Matter Rich in Texture

One of the pleasures of still-life paintings is the contrast of visual textures. These works, lacking story or emotional content, can be purely visual delights as the artist plays one simulated texture against another. Figure paintings can also delight the viewer with an emphasis on visual texture.

The self-portrait in **A** splendidly recreates a variety of textures, especially the feathers and the lustrous satin skirt. These textural qualities come across even in the lights and darks of a black-and-white reproduction. The more contemporary painting **B** shows how the sheen of satin subtly reflects color from the surroundings and reveals one more aspect of that texture.

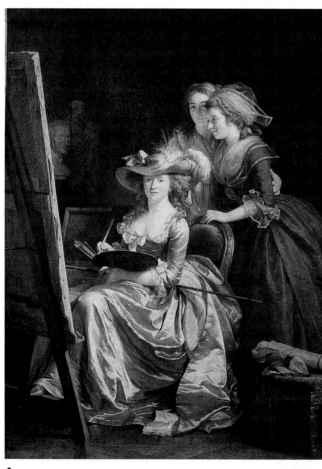

A
Adelaide Labille-Guiard. *Self-Portrait with Two Pupils.* 1785. Oil on canvas, 83 × 59¹/₂″ (210.8 × 151.1 cm). The Metropolitan Museum of Art, New York (gift of Julia A. Berwind, 1953.225.5).

B
Kurt Kauper. *Diva Project #12.* 1999. Deitch Projects, New York.

Selecting Texture to Create a Mood

The surrealist artist Max Ernst uses visual texture to help create the eerie mood of his painting *The Eye of Silence* **(C).** A dark, stagnant pool is surrounded by rocks and ruins, all encrusted with creeping, decaying vegetation. The convincing rendering of these textures gives the picture its weird, frightening atmosphere.

Texture as Design Element

Visual texture can be an interesting design element even without subject matter or any pictorial reference. The work in **D** is titled *Exploration with a Pencil*. The artist used pencil and watercolor to create a composition based solely on areas of contrasting visual textures.

See also: *Value: Techniques,* page 232.

C
Max Ernst. *The Eye of Silence.* 1943–44. Oil on canvas, 43¹/₄ × 56¹/₄″. Washington University Gallery of Art, St. Louis. University purchase, Kende Sale Fund, 1946.

D
Irene Rice Pereira. *Exploration with a Pencil.* 1940. Pencil, gouache, and metallic paint, 14 × 17¹/₂″ (35.8 × 44.4 cm). The Museum of Modern Art, New York (gift of Mrs. Marjorie Falk).

TROMPE L'OEIL

The ultimate point in portraying visual texture is called **trompe l'oeil,** the French term meaning "to fool the eye." This style is commonly defined as "deceptive painting." In trompe l'oeil, the objects, in sharp focus, are delineated with meticulous care. The artist copies the exact visual color and value pattern of each surface. A deception occurs because the appearance of objects is so skillfully reproduced that we are momentarily fooled. We look closer, even though our rational brain identifies the image as a painting and not the actual object.

Continuing Popularity

You might think that now, with the camera able to capture easily all the details of appearance, we would have lost our appreciation for this type of painting. But we seem as intrigued as our ancestors in admiring the skill of an artist who can produce these effects. The 13-inch-high contemporary painting by Michael Flanagan **(A)** is incredible in the amount of tiny detail the artist has meticulously rendered.

Trompe L'oeil in Sculpture, Painting, and Architecture

Certainly, twentieth- and twenty-first-century artistic emphasis has been on abstractions, distortion, and nonobjective patterns. But in much art the trompe l'oeil tradition continues. In sculpture, the hanging jacket **(B)** by Marilyn Levine is incredibly realistic. But it is made of ceramic. The illusion is superb, and we enjoy being visually fooled.

Artists working in this area often purposely arrange contrasting textures as in **C.** Here the reflective glass and cold metal contrast with the powdery sugar inside the container.

It would also be a mistake to think of trompe l'oeil art as confined to painters with fine brushes laboring over easel paintings. More and more today in our cities, we are seeing examples of trompe l'oeil art such as **D.** This "painting" is truly enormous in scale. The entire blank wall of the side of a building has been painted with carefully rendered architectural features and details matching the actual three-dimensional facade.

A
Michael Flanagan. *Chalybeate Springs.* 1991. Acrylic, ink, and graphite on composition board, 13 × 17″ (33 × 43 cm). Courtesy of the Artist and P.P.O.W., New York.

B
Marilyn Levine. *Thom's Jacket.* 1989. Ceramic and mixed media, 34³/₄ × 23 × 5″ (88 × 58 × 13 cm). OK Harris Works of Art, New York.

C
Ralph Goings. *Sugar Shaker.* 2002. Oil on canvas,
35 × 32″ (40.64 × 50.8 cm). OK Harris Works
of Art, New York.

D
Richard Haas. *112 Prince Street Facade,* Prince and Greene
Streets, New York. 1974–75. Painted building commissioned
by City Walls, Inc. Brooke Alexander, Inc., New York.

VARIATION VERSUS REGULARITY

It would be difficult to draw a strict line between texture and **pattern.** We immediately associate the word "pattern" with printed fabrics such as plaids, stripes, polka dots, and florals. Pattern is usually defined as a repetitive design, with the same motif appearing again and again. Texture, too, often repeats, but its variations usually do not involve such perfect regularity. The difference in the two terms is admittedly slight. A material such as burlap would be identified readily as a tactile texture. Yet the surface design is repetitive enough that a photograph of burlap could be called pattern.

The essential distinction between texture and pattern seems to be whether the surface arouses our sense of touch or merely provides designs appealing to the eye. In other words, although every texture makes a sort of pattern, not every pattern could be considered a texture.

Evoking Our Sense of Touch

This distinction between what the eye takes to be simply pattern and the qualities that evoke our sense of touch can be seen in the three examples beginning with **A.** This decorative motif is regular, high in contrast, and representational of a plant. It is clearly a pattern. The image in **B** is also a Victorian era decorative motif, but its irregular pattern and lack of a representational image allow it to be read as a series of ridges and thus it has some textural associations. The image in **C** is a close-up of pleated silk. The pattern is again rippled, but there is also a variety of grays. It is more complex than **B** and more suggestive of texture. An irony is that the resulting image in **C** is rather like tree bark and might not be recognized as silk due to this close-up view.

The small, intricate designs that dominate the illustration in **D** read predominantly as pattern and create decorative areas that do not appeal to our sense of touch. However, as with **B,** some areas do evoke texture, especially when viewed from a distance. Some areas take on a prickly appearance and others seem pebbly. The simple areas of white for the two faces emerging from the patterned surface provide a startling contrast.

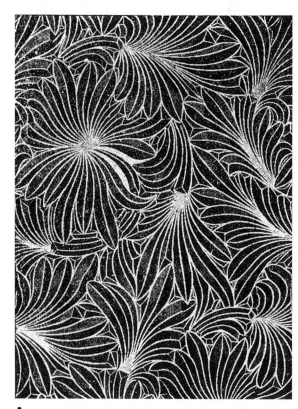

A
Figured Glass.

B
Figured Glass.

C
Gretchen Belinger (fabric designer).
Isadora (pleated silk fabric). 1981.
From *Contemporary Designers,*
St. James Press, London, 1990.

D
Harry Clarke. *Illustration to Edgar Allan
Poe's "Tales of Mystery and Imagination."*
1919. Half-tone engraving, 10 × 7½″
(25.3 × 19 cm). Private collection.

OCCUPYING SPACE IN TWO DIMENSIONS

Several art forms are three-dimensional and therefore occupy space: ceramics, jewelry and metalwork, weaving, and sculpture, to name a few. In traditional sculpture or in a purely abstract pattern of forms, it is important for us to move about and enjoy the changing spatial patterns from various angles. Architecture, of course, is an art form mainly preoccupied with the enclosure of three-dimensional space. A photograph of architecture such as that of the interior court of BCE Place in Toronto **(A)** can only hint at the spectacular feeling of space and volume we experience when actually in the area. The many arches form a concave shell when seen from the interior, yet our feeling of the *space* is that of a convex volume pushing upward.

In two-dimensional art forms, such as drawings, paintings, and prints, the artist often wants to convey a feeling of space or depth. Here space is an illusion, for the images rendered on paper, canvas, or boards are essentially flat.

Exploring Options

This illusion of space is an option for the artist. The painting in **B,** by John McLaughlin, is a simple composition of rectangles that are parallel to the frontal plane of the painting. Contrasts of color and position vie for our attention, but we are always aware of the two-dimensional surface. On the other hand, Gustave Caillebotte's painting **C** pierces the **picture plane.** We are encouraged to forget that a painting is merely a flat piece of canvas. Instead, we are almost standing with the figures in the painting, and our eyes are led to the distant buildings across the plaza and down the streets that radiate from the intersection. Caillebotte's images suggest three-dimensional forms in a real space. The picture plane no longer exists as a **plane,** but becomes a window into a simulated three-dimensional world created by the artist. A very convincing illusion is created. Artists throughout the centuries have studied this problem of presenting a visual illusion of space and depth. By the nineteenth century a variety of devices were known and used. With the advent of photography these devices became less important to many painters.

A
The Galleria, BCE Place,
Toronto.

B

John McLaughlin. *Y-1958.* 1958. Oil on canvas, 32 × 48″. Addison Gallery of American Art,
Phillips Academy, Andover, MA (1995.69).

C

Gustave Caillebotte. *Rue de Paris; Temps de
Pluie.* 1876–77. Oil on canvas, 83 1/2 × 108 3/4″
(212.2 × 276.2 cm). The Art Institute of
Chicago (Charles H. and Mary F. S.
Worcester Fund Collection.)

SIZE

The easiest way to create an illusion of space or distance is through size. Very early in life we observe the visual phenomenon that as objects get farther away they appear to become smaller. Thus, when we look at the landscape by Bruegel **(A)**, we immediately see the relative sizes of the various elements and understand the space that is suggested. The contrast of a large foreground tree with the smaller trees and the diminishing size of figures in the distance convincingly evoke depth. We forget the innate flatness of a picture, and the picture plane becomes like a window through which we view a three-dimensional scene.

Sizing in Foreground, Middle, and Distance

A difference in size to give a feeling of depth is not confined to naturalistic paintings. Abraham Walkowitz **(B)** uses exactly the same device. In this case the elements of the landscape are painted as flatter shapes; however, the foreground figures are larger than those in the middle and far distance.

Spatial Effect with Abstract Shapes

Notice that the size factor can be effective even with abstract shapes, when the forms have no literal meaning or representational quality **(C)**. The smaller squares automatically begin to recede, and we see a spatial pattern. With abstract figures, the spatial effect is more pronounced if (as in **C**) the same shape is repeated in various sizes. The device is less effective when different shapes are used **(D)**.

A
Pieter Bruegel the Elder. *The Harvesters.* 1565. Oil on wood; Overall, including added strips at top, bottom, and right, 46^{7}/$_{8}$ × 63^{3}/$_{4}$″ (119 × 162 cm); original painted surface 45^{7}/$_{8}$ × 62^{7}/$_{8}$″ (116.5 × 159.5 cm). The Metropolitan Museum of Art, New York (Rogers Fund, 1919; 19.164).

B
Abraham Walkowitz. *Bathers on the Rocks.* 1935. Oil on canvas, 25 × 30$^{1}/_{8}$″.
Collection of the Tampa Museum of Art, Museum (purchase, 84.15).

C
If the same shape is repeated in different sizes,
a spatial effect can be achieved.

D
With differing shapes, the spatial illusion is not
as clear.

EXAGGERATED SIZE

Using relative sizes to give a feeling of space or depth is very common to many periods and styles of art. Some artists have taken this basic idea and exaggerated it by increasing the size differences. In the Japanese woodcut **(A)**, the one fish kite is very large and hence seems quite close. By contrast, the other smaller kites and the tiny figures, trees, and hills seem far in the distance. There are two advantages to this practice. First, seeing a kite drawn larger than human figures automatically forces us to imagine the great distance involved. Second, this very contrast of large and tiny elements can create a dynamic visual pattern.

The circus scene by Demuth **(B)** uses the same idea. One performer is shown very large and hence is in the foreground. The other trapeze artists are shown smaller and, therefore, recede into the background.

Hieratic Scaling

Artists in the past sometimes ignored size as a way to show spatial location. In looking at the fifteenth-century painting in **C**, we notice that the figures at the center of the picture are considerably smaller than the three that form the dominant triangle of the composition. This is not a mistake or lack of skill on the artist's part. Often in the past, size was used to denote some conceptual importance and not to indicate how close or far away the figure was spatially. In **C** the figures of God, Christ, and Mary are larger simply to show their status and importance to the people around them, who are thus smaller in scale. This use of relative size to show importance and not space is called **hieratic scaling.** Although not naturalistic visually, this practice is quite common in art history. Images of gods, angels, saints, and rulers often arbitrarily were shown in a large size to indicate their thematic importance.

Creating Illusions

The use of size to denote depth is such a commonly recognized device that it is amusing to see a drawing such as **D.** Which figure is the largest? The one on the right, of course! But measure it against the others; actually they're all the same size. This illusion occurs as all the other elements are diminishing in size in the "distance," and our brain is fooled. This shows how instinctively we use size difference to give an impression of space.

A
Ando Hiroshige. *Suido Bridge and Surugadai (Suidobashi Surugadai)* from *One Hundred Famous Views of Edo.* 1857. Color woodblock print, 13³/₄ × 8⁷/₈″ (35 × 22.5 cm). Brooklyn Museum of Art (gift of Anna Ferris).

B
Charles Henry Demuth. *Circus.* 1917. Watercolor and pencil on paper, $8^{1}/_{16} \times 13''$ (20.5 × 33 cm). Hirshhorn Museum and Sculpture Garden, Smithsonian Institution (gift of Joseph H. Hirshhorn Foundation, 1966).

C
Attributed to Lorenzo Monaco (Piero di Giovanni). *The Intercession of Christ and the Virgin.* Early 15th century. The Metropolitan Museum of Art. The Cloisters Collection, 1953 (53.37).

D
Size-distance illusion.

OVERLAPPING

Overlapping is a simple device for creating an illusion of depth. When we look at the design in **A,** we see four elements and have no way to judge their spatial relationships. In **B** the relationship is immediately clear due to overlapping. Each shape hides part of another because it is on top of or in front of the other. A sense of depth is established.

Overlapping with and without Size Differences

In Jacob Lawrence's painting **(C),** there is no size difference between the cabinetmakers in the front and those in back. But we do understand their respective positions because of the overlapping that hides portions of the figures. Because overlapping is the primary spatial device used, the space created is admittedly very shallow. The pattern of two-dimensional shapes is stronger than an illusion of depth. Notice that when overlapping is combined with size differences, as in Hayllar's painting **(D),** the spatial sensation is greatly increased.

Spatial Depth with Abstract Shapes

The same principle can be illustrated with abstract shapes, as the designs in **E** show. The design on top, which combines overlapping and size differences, gives a much more effective feeling of spatial recession.

See also: *Transparency,* page 206.

A
No real feeling of space or depth can be discerned.

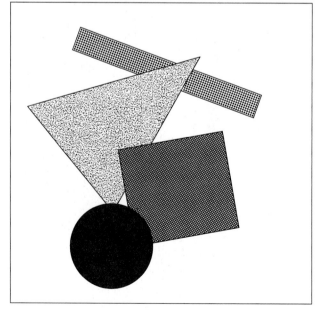

B
Simple overlapping of the shapes establishes the spatial relationships.

C
Jacob Lawrence. *Cabinet Makers*. 1946. Gouache with pencil underdrawing on paper, sheet: 22 × 30³/₁₆″ (55.9 × 76.6 cm). Image: 21³/₄ × 30″ (55.2 × 76.1 cm). Hirshhorn Museum and Sculpture Garden, Smithsonian Institution (gift of Joseph H. Hirshhorn, 1966; 66.2915).

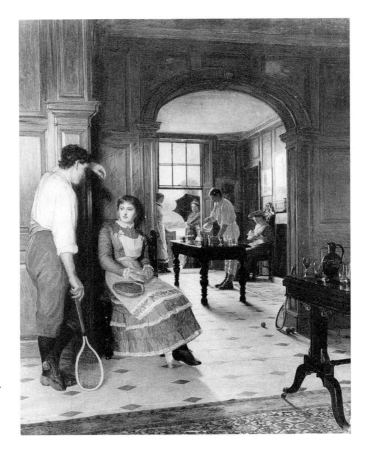

D
Edith Hayllar. *Summer Shower*. 1883. Oil on board, 20 × 16³/₄″ (51 × 43 cm).

E
The design on bottom does not give as much feeling of spatial depth as the one on top.

VERTICAL LOCATION

Vertical location is a spatial device in which elevation on the page or format indicates a recession into depth. The higher an object, the farther back it is assumed to be. In the painting shown in **A**, the artist is relying mainly on vertical location to give us a sense of recession into depth. To our eyes, the effect, though charming and decorative, seems to have little suggestion of depth. The figures appear to sit almost on top of each other all in one plane. However, this device was used widely in Near Eastern art and often in Oriental art and was immediately understandable in those cultures.

Emphasizing Figures and Objects

As the image in **B** shows, the use of vertical location in a composition can emphasize the figures, objects, and architectural features. These elements, the figures on a blanket, the card table, and the bridge, are given more importance than an accurate depiction of spatial relationships.

The painting and collage by Tom Wesselmann **(C)** shows that this device can be effective even when aspects of the work are "photorealistic." In this painting we can see an arrangement based on a flat grid evident in the tablecloth pattern and other verticals and horizontals. Objects are arranged within this grid, and we sense the space presented based mainly on vertical location.

The Changing Horizon

Vertical location is based on a visual fact. As we stand and look at the scene before us, the closest place to us is the ground down at our feet. As we gradually raise our eyes upward, objects move farther away until we reach what is called the **horizon,** or **eye level.** Thus, a horizon reference is an integral part of vertical location. Since the twentieth century when we gained the ability to fly, the traditional ground-horizon-sky visual reference has been considerably altered. We are increasingly accustomed to aerial photographs or bird's-eye views **(D)** in which the traditional horizon has disappeared, and the point farthest from us can indeed be at the bottom of the picture. Vertical location is still an effective spatial device but not as automatically perceived as in the past.

A

Miskina. *The Disputing Physicians (or Philosophers).* 1593–95. From the *Khamsa of Nizami,* f.23v. Painting on paper, 30 × 19.5 cm. British Library Or. 12.208.

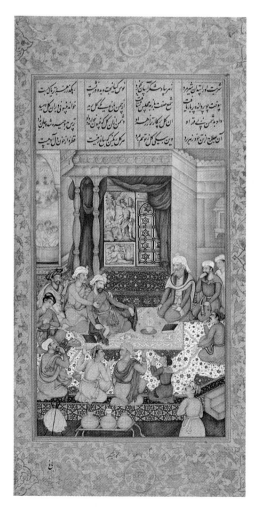

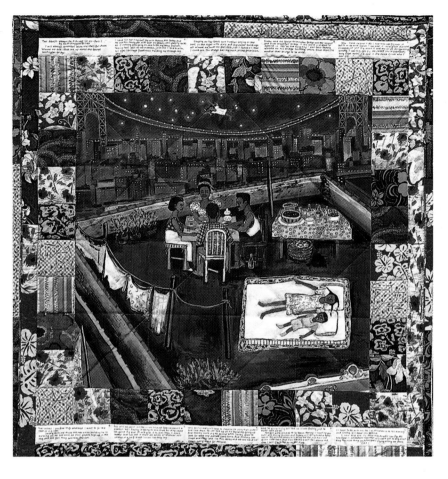

B
Faith Ringgold. *Tar Beach.* 1988. Acrylic
paint on canvas and pieced tie-dyed fabric,
74 × 68^1/$_2$″. Collection of the Solomon
R. Guggenheim Museum, New York.

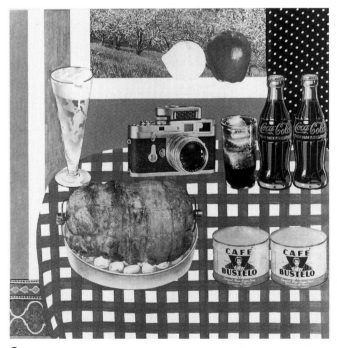

C
Tom Wesselmann. *Still Life #12.* 1962. Acrylic and collage of fabric,
photogravure, metal, etc., on fiberboard, 4 × 4′ (1.22 × 1.22 m).
National Museum of American Art, Smithsonian Institution,
Washington, D.C.

D
Berenice Abbott. *Wall Street, Showing East River from
Roof of Irving Trust Company.* 1938. Photograph.
Museum of the City of New York.

AERIAL PERSPECTIVE

Aerial, or **atmospheric, perspective** describes the use of color or value (dark and light) to show depth. The photograph in **A** illustrates the idea: The value contrast between distant objects gradually lessens, and contours become less distinct. Greater contrast advances, diminished contrast retreats. The color would change also, with objects that are far away appearing more neutral in color and taking on a bluish character.

Using Size with Value to Create Perspective

In **B** the feeling of spatial recession is based entirely on differences in size. Illustration **C** shows the same design, but the spatial feeling is greatly increased because the smaller shapes become progressively darker and show less value contrast with the background.

We ordinarily think of aerial perspective and value changes to show distance as applied to vast landscapes with distant hills, as in **A.** But look at **D.** Of course, the overlapping immediately establishes that the standing woman is behind the figure in the foreground. But notice how the sense of depth is increased because the light dress is similar to the light mirror and wall. If the standing figure were dark, she would tend to merge with the crouching figure, creating a flatter composition. Aerial perspective has many applications.

See also: *Value and Space,* page 230; *Color and Space,* page 256.

A

Ansel Adams. *Yosemite Valley from Inspiration Point.* c. 1936. Photograph. Copyright © 1993 by the Trustees of the Ansel Adams Publishing Rights Trust. All rights reserved.

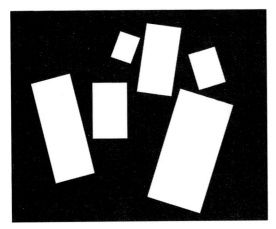

B

A feeling of spatial recession can be achieved simply by reducing the size of elements as they apparently recede into the distance.

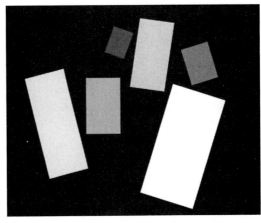

C

Spatial recession can be made even more effective if the receding objects blend more and more with the background.

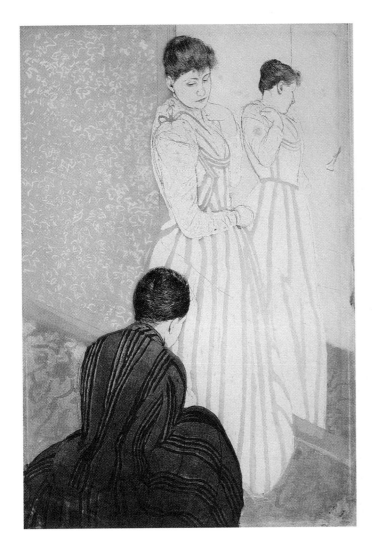

D

Mary Cassatt. *The Fitting.* 1890–1891.
Drypoint and aquatint on laid paper, plate:
14³/₄ × 10″ (37.5 × 25.4 cm); sheet:
18¹³/₁₆ × 12¹/₈″ (47.8 × 30.8 cm).
National Gallery of Art, Washington, D.C.
(Chester Dale Collection, 1963.10.252).

LINEAR PERSPECTIVE

Linear perspective is a complex spatial system based on a relatively simple visual phenomenon: As parallel lines recede, they appear to converge and to meet on an imaginary line called the horizon, or eye level. We have all noticed this effect with railroad tracks or a highway stretching away into the distance. From this everyday visual effect, the whole science of linear perspective has developed. Artists had long noted this convergence of receding parallel lines, but not until the Renaissance was the idea introduced that parallel lines on parallel planes all converge at the same place (a **vanishing point**) on the horizon. The poster in **A** illustrates the idea. The parallel lines of the street and buildings gradually taper, leading to one common point. The letters for "Chicago" dramatically follow the same pattern, receding to the same common point. The result is an effective impression of very deep space, including the letterforms in this case.

Linear Perspective as Unifier

Linear perspective was a dominant device for spatial representation in Western art for several hundred years. It is easy to see why. First, linear perspective does approximate the visual image; it does appear realistic for artists striving to reproduce what the eye sees. Second, by its very nature, perspective acts as a unifying factor. With all the lines in **A** receding to a common point, a strong emphasis is created by the converging lines, adding a dynamic quality to the poster's title.

A
Philippe Apeloig. *Chicago-Naissance d'une Metropole.* 1987. Poster for the first exhibition at the Musée d'Orsay, Paris.

Because our view is of the corner of the gas station in **B,** the sloping parallel lines of the building would meet at two points on the low horizon line: the right one at the corner of the painting and the left one outside the format.

Linear Perspective in Nonwestern Cultures

Although the introduction of, and continued fascination with, linear perspective as a spatial device was mainly a Western development, examples can be found from other cultures.

The Japanese woodcut in **C** is an example. The diagonals of the room's floor, walls, and ceiling are clearly receding to a common vanishing point. This print combines a Western system of spatial depiction with the Japanese emphasis on two-dimensional shapes and patterns.

B
Edward Ruscha. *Standard Station, Amarillo, Texas.* 1963. Oil on canvas, 5′ 4$^{15}/_{16}$″ × 10′ 1$^{13}/_{16}$″ (1.65 × 3.09 m). Hood Museum of Art, Dartmouth College, Hanover, NH (gift of James J. Meeker, Class of 1958, in memory of Lee English).

C
Kitagawa Utamaro. *Moonlight Revelry at the Dozo Sagami.* Edo Period, Japan. Ink and color on paper, 147.0 × 318.6 cm. Freer Gallery of Art, Smithsonian Institution, Washington, D.C. (gift of Charles Lang Freer, F1903.54).

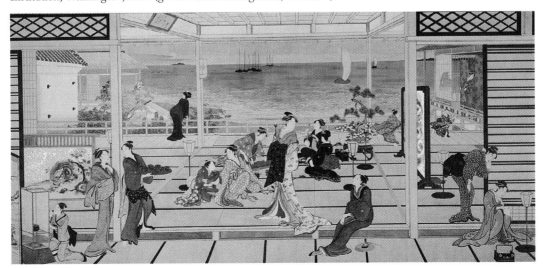

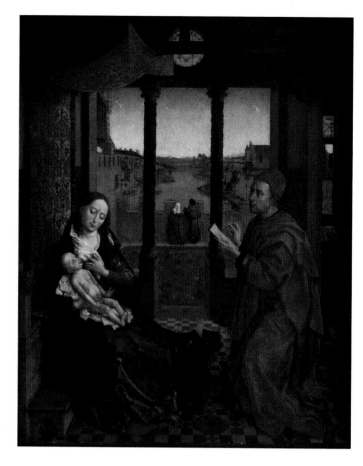

A
Rogier van der Weyden. *Saint Luke Drawing the Virgin and Child.* c. 1435. Oil and tempera on panel, 54 1/8 × 43 5/8″ (137.5 × 110.8 cm). Museum of Fine Arts, Boston (gift of Mr. and Mrs. Henry Lee Higginson, 1893, 93.153).

ONE-POINT PERSPECTIVE

The complete study of **linear perspective** is a complicated task. Entire books are devoted to this one subject alone, and it cannot be fully described here. The procedures for using linear perspective were rediscovered and developed during the Renaissance period. From drawings, we see that in the fifteenth and sixteenth centuries many artists preceded paintings with careful perspective studies of the space involved.

Probably few recent painters have made such a strict use of linear perspective. For the architect, city planner, interior designer, set designer, and so on, an ability to do perspective drawing is essential for presenting their ideas. But it is important for any designer or artist to know the general principles of linear perspective, for it is a valuable tool for representing an illusion of depth.

Positioning the Horizon

The concept of linear perspective starts with the placement of a horizontal line, the "horizon," that corresponds to the "eye level" of the artist. On this line is located the needed number of vanishing points to which lines or edges will be directed. It might seem that working by a "formula" such as linear perspective provides would lead to a certain sameness and monotony in pictures. This is not true, because the artist's

choice in the placement of the horizon and vanishing points on the format (or outside it) is almost unlimited. The same scene drawn by the same artist would result in radically different visual compositions by altering these initial choices.

Exploring One-Point Perspective

Rogier van der Weyden's painting **(A)** is an example of what is called **one-point perspective.** A single point has been placed on the horizon line, and all the lines of objects at right angles to the plane of the canvas converge toward that point. The lines of the tiled floor, the throne, and architectural details in the landscape, if extended, would meet at this common point **(B).** The figures are placed in this created volume. In this case the view actually extends to the horizon. The horizon is another term for eye level, which can be found even if our view is more limited. Often the eye level is coincident with the eyes in the figures depicted. In the van der Weyden painting, we can observe that our vantage point is slightly elevated (the horizon line is higher that the eyes of the figures), and we are looking down on the figures.

No diagram is needed to illustrate the one-point perspective used in **C.** This poster, commemorating the flight of Danish Jews to Sweden, transforms one triangle of the Star of David into receding lines suggestive of movement to the distance.

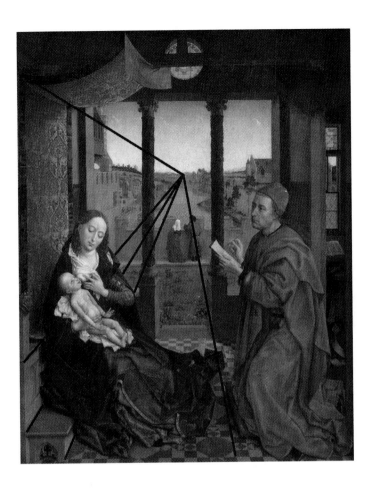

B
The composition of the painting in **A** involves parallel lines converging at a vanishing point on the horizon.

C
Per Arnoldi (Denmark). 1993 poster commemorating the 50th Anniversary of the Danish Jews' flight to Sweden. Client: Thanks to Scandinavia, NY.

A
Antonio Canal Canaletto (1697–1798). *Santa Maria Zobenigo.* Oil on canvas, 18¹/₂ × 30⁵/₈″ (47 × 78 cm). Private Collection, New York.

TWO-POINT PERSPECTIVE

One-point perspective presents a very organized and unified spatial image. **Two-point perspective** probably appears to us as more natural and lifelike. Here we are not looking head on at the scene. Now, it is being viewed from an angle. No objects are parallel to the picture plane and all edges recede to two points on the horizon line. This more nearly approximates our usual visual experience.

The painting by Canaletto **(A)** illustrates the idea. In the diagram **(B)** the horizon line is shown on which there are two points, and the various architectural lines of the different buildings recede to them.

A Static Effect

In a perspective drawing or painting, strict two-point perspective can appear a bit posed and artificial. It assumes we are standing still and looking without moving. This is possible and does happen but is not typical of our daily lives. Our visual knowledge is gained by looking at objects or scenes from many changing viewpoints. Photography can capture a still view, and film and video have conditioned us to rapidly changing points of view. Perhaps for these reasons linear perspective is not as frequently used in painting today as it was for centuries.

A Dramatic Element

However, painting and drawing still have the power to share a still and careful observation. The contemporary painting by Felix de la Concha shows how perspective can be a dramatic element of composition and can resonate with our daily experience **(C)**.

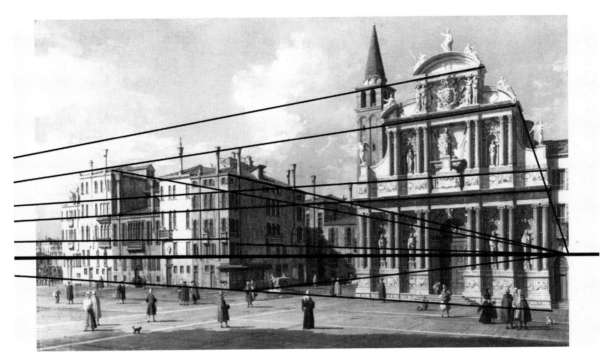

B
Diagram superimposed over painting **A.** The angled lines of the architecture would meet at two points on the horizon.

C
Felix de la Concha. *Así en el ceilo (As in Heaven).* 2001. Oil on canvas on board, 48 × 29.5″ (121.9 × 74.9 cm). Karl and Jennifer Salatka Collection, Concept Art Gallery, Pittsburgh.

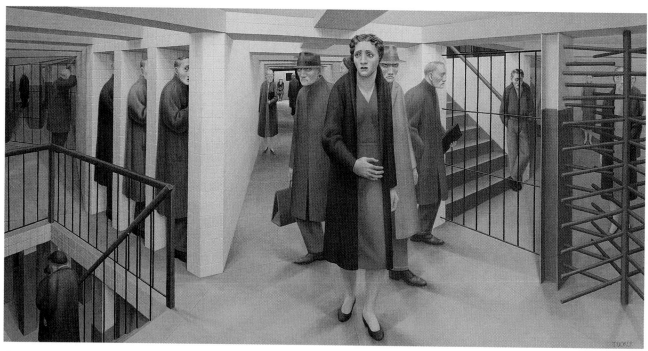

A

The angled corridors use several vanishing points. George Tooker. *Subway.* 1950. Egg tempera on composition board.
Sight: 18¹⁄₈ × 36¹⁄₈″ (46 × 91.8 cm). Frame: 26 × 44″ (66 × 111.8 cm). Collection of Whitney Museum of American Art,
New York (with funds from the Juliana Force Purchase Award).

MULTIPOINT PERSPECTIVE

In perspective drawing the vertical edges of forms generally remain vertical. Sometimes a third vanishing point is added above (or below) the horizon so that the vertical parallels also taper and converge. This technique is useful to suggest great height, such as looking up at (or down from) a city skyscraper.

Although city streets or a line of buildings might be laid out in orderly rectangular rows of parallel lines, often in real life a variety of angles will be present. This entails the use of **multipoint perspective.** Different objects will have separate sets of vanishing points if they are not parallel to each other. If they are all on a plane parallel to the ground plane, all vanishing points will still be on a common horizon line. This can reproduce our visual experience where rarely in any scene are all the elements in neat, parallel placement. In the painting by Tooker **(A),** the long corridors of the subway recede at several different angles from the center foreground. Each area thus has a different vanishing point **(B).** The anxiety-producing feeling of the subway as a maze is clearly presented.

For Dynamic Spatial Effect

Multiple vanishing points create a dynamic spatial effect in a two-dimensional composition even when the composition is as abstract as the example seen in **C.** The source of this image may be architectural, but there are no representational details. The linear perspective leading to three vanishing points conveys the sense of space. Two vanishing points are on the horizon line. A third vanishing point (below the bottom of the picture) is implied by the converging vertical lines suggesting a downward view.

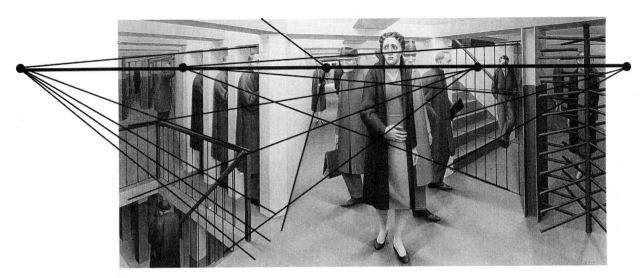

B
Diagram superimposed over painting **A.**

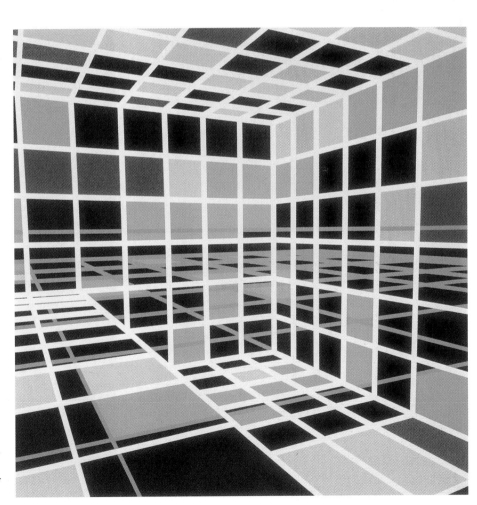

C
Sarah Morris. *Pools–Crystal House (Miami).*
2002. Gloss household paint on canvas,
84.25 × 84.25″ (214 × 214 cm). Courtesy
Friedrich Petzel Gallery, New York.

A DIFFERENT POINT OF VIEW

To introduce a dramatic, dynamic quality into their pictures, many artists have used what is called **amplified perspective.** This device reproduces the visual image but in the very special view that occurs when an item is pointed directly at the viewer.

Playing with Perspective

A familiar example is the old army recruiting poster, where Uncle Sam's pointing finger is thrust forward ("I Want You") and right at the viewer. The same effect can be seen in **A,** in which the figure's legs are thrust directly at us. In this exaggerated example we are presented with the image of the feet being unbelievably large in **juxtaposition** with the body. The photograph heightens a phenomenon that we see in less dramatic terms every day but which we unconsciously adjust to conform to our knowledge of the human figure.

In Alexander Rodchenko's *At the Telephone* **(B),** we are presented with the top of the figure's head pointing directly at us. In this case we can see a foreshortened view of the receding body. The body looks shorter than we know it to be in profile, and we are shown a dramatic, unfamiliar view of the figure.

The contrast of size we see in Yvonne Jacquette's painting in **C** creates an amplified space in a composition that might first capture our attention for its color, pattern, or shapes. The river and harbor make a large essentially flat shape. The pattern of lights and shadows creates a jewel-like decorative effect. Against this surface composition an amplified perspective evokes a deep space. Individual windows on the foreground tower are as large as the distant image of the Statue of Liberty. This juxtaposition might be hard to hold in one view in actual experience but a painting can render it visible.

A

Ad for Din Sko shoe store, Sweden. Agency: Inform Advertising Agency, Gothenburg. Art Director: Tommy Ostberg. Photo: Christian Coinberg.

B

Alexander Rodchenko. *At the Telephone.* 1928. Gelatin-silver print, 15½ × 11½″ (39.4 × 29.2 cm). The Museum of Modern Art, New York (Mr. and Mrs. John Spencer Fund).

C

Yvonne Jacquette. *Mixed Heights and Harbor from World Trade Center II.* 1998. Oil on canvas,
70¹/₄ × 58³/₈″. Private collection, courtesy of DC Moore Gallery, New York.

A PICTORIAL DEVICE

Looking at a figure or object from more than one vantage point simultaneously is called **multiple perspective.** Several different views are combined in one image. This device has been used widely in twentieth- and twenty-first-century art, although the idea is centuries old.

Multiple Perspective in Ancient Art

Multiple perspective was a basic pictorial device in Egyptian art, as illustrated in a typical Egyptian painted figure **(A).** The artist's aim was not necessarily to reproduce the visual image but to give a composite image, combining the most descriptive or characteristic view of each part of the body. In **B** which view of the head is most descriptive, which most certainly a head? The profile obviously says "head" more clearly. But what about the eye **(C)**? The eye in profile is a confusing shape, but the front view is what we know as an eye. The Egyptians solved this problem by combining a side view of the head with a front view of the eye. Each body part is thus presented in its most characteristic aspect: a front view of the torso, a side view of the legs, and so forth.

Multiple Perspective Today

Since the twentieth century, with the camera able to effortlessly give the fixed visual ("realistic") view, artists have been free to explore other avenues of perception, including multiple perspective. Douglas Cooper employs multiple perspective to capture a dramatic breadth of experiences in one two-dimensional composition **(D).** The hilly, winding river valley of Pittsburgh is brought together in a mural where the space seems to bend and curve. The straight lines of linear perspective curve when a two-dimensional picture expands to hold more than the view of a single picture plane.

Straight lines yielding to a curved pattern are evident in David Hockney's photographic **montage** of the Brooklyn Bridge **(E).** The point of view shifts from downward to forward to upward, creating multiple picture planes and multiple perspectives.

As you have noticed, multiple perspective does not give a clear spatial pattern of the position occupied by each element. This aspect has been sacrificed to give a more subjective, **conceptual** view of forms.

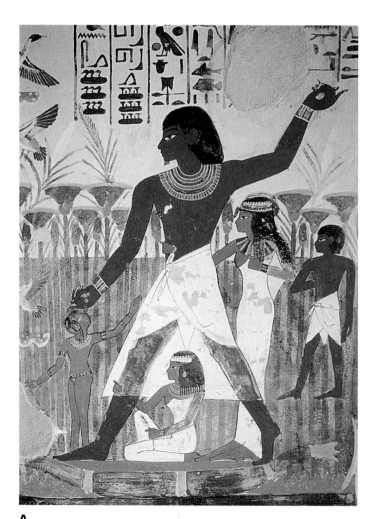

A
Detail of Wall Painting in the Tomb of Nakht, Thebes. c. 1410 B.C. Victor R. Boswell, Jr. *National Geographic* photographer.

B
To the Egyptians the head shown in profile seemed to be the most characteristic view.

C
The front view of the eye gives the clearest, most descriptive view.

D
Douglas Cooper. Portion of *Senator John Heinz Regional History Center Mural (1992–3)*. Courtesy of the artist.

E
David Hockney. *The Brooklyn Bridge, November 28, 1982*. Photographic collage, 109 × 58″. Collection: Chase Manhattan Bank (JP Morgan Chase).

A SPATIAL ILLUSION

For centuries Oriental artists did not make wide use of linear perspective. Another spatial convention was satisfactory for their pictorial purposes. In Oriental art planes recede on the diagonal, but the lines, instead of converging to a vanishing point, remain parallel. Illustration **A** shows a box drawn in linear perspective; **B** shows the box drawn in the Oriental method. In the West we refer to image **B** as an **isometric projection.**

Isometric Projection in the East

Traditional Japanese prints such as **C** illustrate this device. The effect is different from Western perspective but certainly not disturbing. The rather flat decorative effect seems perfectly in keeping with the treatment of the figure, with a strong linear pattern and flat color areas. The artist does not stress three-dimensional solidity or roundness in the figure, so we do not miss this quality in the architecture or the space.

Isometric Projection in the West

Isometric projection, although used extensively in engineering and mechanical drawings, is rarely seen in Western painting. The self-portrait by David Hockney **(D)** uses this device, and the change from the linear perspective is fresh and intriguing. Hockney has explored virtually every method of spatial organization mentioned in this chapter in prints, drawings, paintings, and photography.

The work by Josef Albers **(E)** uses this idea in a purely abstract way. The artist creates a geometric shape drawn in an isometric-type view. The interesting aspect of the design, however, is the shifting, puzzling spatial pattern that emerges. The direction of any plane seems to advance, then recede, then to be flat in a fascinating ambiguity.

A

In linear perspective parallel lines gradually draw closer together as they recede into the distance.

B

In isometric projection parallel lines remain parallel.

C
Kubo Shunman. *Women in a Tea House.*
Late 1780s. Color woodblock print,
sheet: 33 × 23 cm. The Cleveland
Museum of Art (bequest of Edward L.
Whittemore, 1930.208).

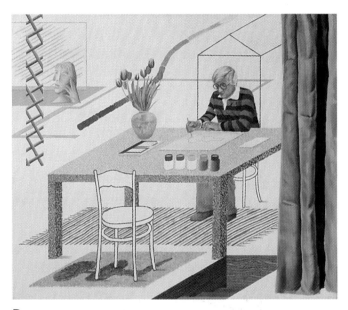

D
David Hockney. *Self Portrait with Blue Guitar.* 1977.
Oil on canvas, 5 × 6′ (1.52 × 1.83 m).

E
Josef Albers. *Structural Constellation II.* c. 1950.
Machine-engraved vinylite mounted on board,
17 × 22¹/₂″ (43.2 × 57.1 cm). Collection,
The Josef Albers Foundation.

THE CONCEPT OF ENCLOSURE

One other aspect of pictorial space is of concern to the artist or designer. This is the concept of enclosure, the use of what is referred to as **open form** or **closed form.** The artist has the choice of giving us a complete scene or merely a partial glimpse of a portion of a scene that continues beyond the format.

Exploring Closed Form

In **A** Chardin puts the focal point in the center of the composition, thus our eyes are not led out of the painting. The still life of musical instruments and sheet music is effectively framed by the curved border of the picture, which echoes the many ovals in the composition. The book on the left and the candle on the right bracket the composition and keep our attention within the picture. This is called closed form.

Exploring Open Form

By contrast, example **B** is clearly open form. The landscape painting by Robert James Foose does not include the entire tree but only part of it. Most of the foliage is outside the picture. The focus is on the lower part of the tree and the reflection in the water. This reflection provides a vertical balance, and the picture feels complete, even if the forms are cropped or incomplete.

The ultimate extension of the open-form concept is illustrated in **C.** This painting has actual elements that extend outside the rectangular format and effectively destroy any framed, or contained, feeling. In fact, shapes within the painting extend outward, and the white wall creates shapes that both cut into the painting but also expand to include a field well beyond the painting's boundary.

It may be most surprising to encounter open form when the subject is the human figure. Figures are often cropped in the action photographs of athletes, and this suggests the dynamics of sports. A cropped figure can also simply suggest a unique point of view. The print by Alex Katz shown in **D** is cropped to form an unexpected composition. The open form implies a figure beyond the picture, while emphasis is given to an unusual focus on the feet.

As you can see, closed form generally gives a rather formal, structured appearance, whereas open form creates a casual, momentary feeling, with elements moving on and off the format in an informal manner.

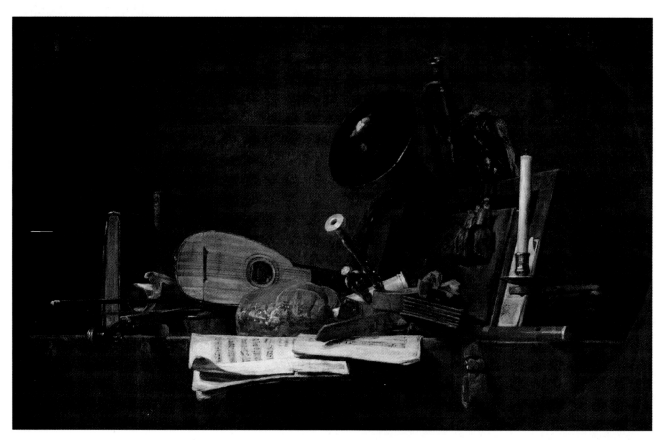

A
Jean-Baptiste-Siméon Chardin. *The Attributes of Music.* 1765. Oil on canvas, 35 7/8 × 56 7/8″ (91 × 145 cm). Musée du Louvre, Paris.

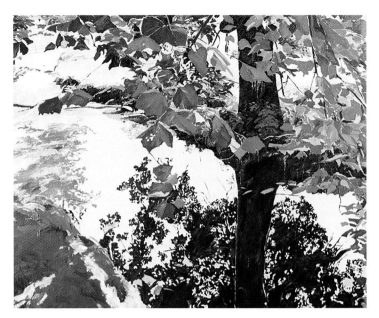

B
Robert James Foose. *Light's Course.*
1997. Oil on linen, 38 × 47″
(97 × 119 cm).

C
Elizabeth Murray. *Keyhole.* 1982. Oil on canvas,
8′ 3¹/₂″ × 9′ 2¹/₂″. Agnes Gund Collection,
New York.

D
Alex Katz. *Ada's Red Sandals.*
1987. Oil on canvas, 48 × 60″.
Alex Katz Studio II, New York.

EQUIVOCAL SPACE

Most art in the twentieth and twenty-first centuries has not been concerned with a purely naturalistic reproduction of the world around us. Photography has provided a way we can all record appearance in a picture. This is true in the area of spatial and depth representation also. Many artists have chosen to ignore the device of overlapping. Instead, they have used what is called **transparency.** When two forms overlap and both are seen completely, the figures are assumed to be "transparent" **(A).**

Interest in Ambiguity

Transparency does not give us a clear spatial pattern. In **A** we are not sure which form is on top and which behind. The spatial pattern can change as we look at it. This purposeful ambiguity is called **equivocal space,** and many artists find it a more interesting visual pattern than the immediately clear spatial organization provided by overlapping in a design.

There is another rationale for the use of transparency. Just because one item is in front and hides another object does not mean the item in back has ceased to exist. In **B** a bowl of fruit is depicted with the customary visual device of overlapping. In **C** the same bowl of fruit is shown with transparency, and we discover another piece of fruit in the bottom of the bowl. It was always there, simply hidden from our view. So, which design is more realistic? By what standards do you decide?

Exploring Equivocal Space

The sweatshirt design in **D** was done on a computer. Created to celebrate a fifth anniversary, the letters spelling "Five" are clear. But they overlap and become transparent with differing visual textures. The design takes a simple theme and creates an interesting pattern from a few elements.

Spatial ambiguity can also be suggested through the use of open form. A large "X" seems to expand beyond the boundaries of the rectangle in **E.** The same composition can be seen in a moment of figure/ground reversal to be four small triangular shapes against a yellow ground. A spatial ambiguity is created in this reversal.

B
Overlapping sometimes can be deceptive.

A
The use of overlapping with transparency confuses our perception of depth.

D
Sweatshirt Design for a Fifth
Anniversary. 1990. Designer:
Jennifer C. Bartlett. Design firm:
Vickerman-Zachary-Miller
(VZM Transystems), Oakland,
CA.

C
The use of transparency reveals what
is hidden by overlapping.

E
Al Held. *Yellow.* 1956. Acrylic on paper
mounted on board, 57.5 × 77.5 cm.
Oeffentliche Kunstsammlung Basel,
Switzerland (Legat Anne-Marie and
Ernst Vischer-Wadler, 1995).

IGNORING CONVENTIONS

Artists all have learned the various devices to give an illusion of depth or space. At times certain artists purposely ignore these conventions to provide an unexpected image. A confusion of spatial relationships is intriguing because the viewer is confronted with a visual dilemma that may invite further consideration of the artwork.

Distortion and Surrealism

Piranesi, in one of his many etchings of prisons **(A)**, not only ignores the rules but actually distorts them to create a weird, spatially intricate scene. Our sense of scale is disturbed as we try to measure features in the architecture against the few small figures that provide a scale reference. The confused, mazelike complexity of the enormous chamber serves as an ominous symbol of government bureaucracy and repression.

Illustration **B** is a surrealist painting. The whole thrust of surrealism is to illustrate the impossible world of dreams and the subconscious mind. The Magritte painting in **B** has a very simple, straightforward subject. But the picture is intriguing because the spatial relationships are all confused. Subject and background are not separate. They become one as they replace each other at unexpected places.

Spatial Distortion in Architecture

Spatial distortions and deceits are not limited to the visual sleight of hand possible in two-dimensional art. Architects and sculptors have used devices to manipulate our reading of perspective, often to visually expand a limited space. This is the case with Borromini's Arcade for the Palazzo Spada in Rome **(C).** The columns decrease in size, their spacing gets shorter, and the pavement narrows down the arcade. This very short corridor appears longer due to these systematic reductions in size, shape, and spacing.

A
Giovanni Battista Piranesi. *The Round Tower.*
c. 1749–50. Etching, engraving, sulphur tint or open bite, burnishing; 21⁷/₈ × 16⁷/₁₆″ (55.6 × 41.8 cm). The Metropolitan Museum of Art, New York (Harris Brisbane Dick Fund, 1937; 37.45.3.27).

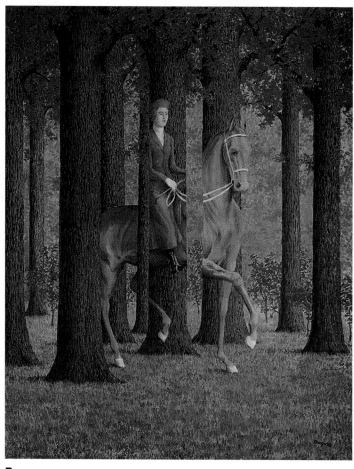

B
René Magritte. *The Blank Signature.* 1965. Oil on canvas, 32 × 25⁵/₈″ (81.3 × 65.1 cm). National Gallery of Art, Washington, D.C. (collection of Mr. and Mrs. Paul Mellon).

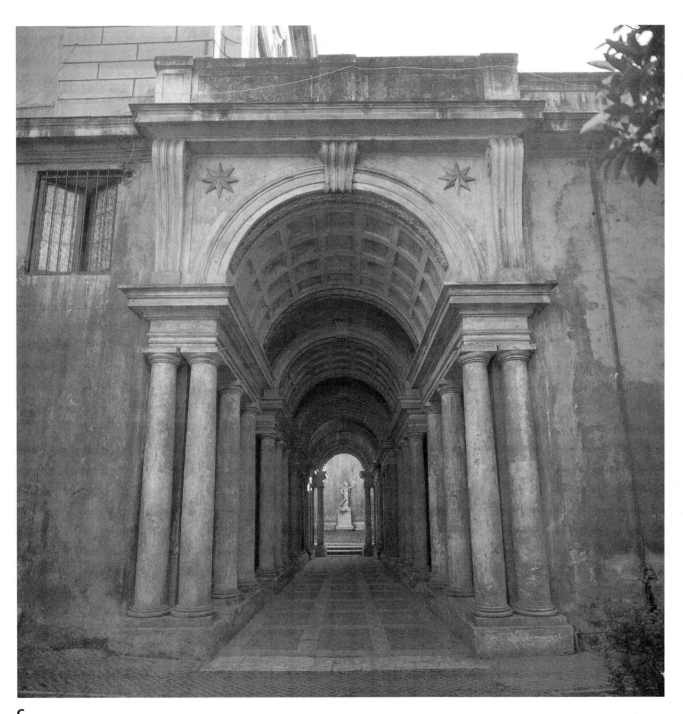

C
Francesco Borromini. Arcade, Palazzo Spada, Rome. ca. 1635–1650.

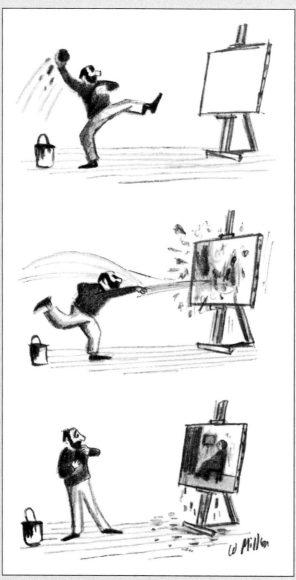

Warren Miller. 1970. © *The New Yorker* Collection from
cartoonbank.com. All Rights Reserved.

CHAPTER **11**

REFLECTING THE WORLD AROUND US

Change and movement are basic characteristics of existence. Our world is a world of movement. Almost every aspect of life involves constant change. We humans cannot sit or stand motionless for more than a moment or so; even in sleep we turn and change position. But if we could stop our body movements, the world about us would still continue to change. Thus motion is an important consideration in art.

With the advent of rapid forms of transportation and communication in the last century, a significant number of artworks began to reflect an interest in speed or motion. The Italian Futurists, in the second decade of the twentieth century, said the speeding automobile had replaced Venus de Milo as a standard of beauty. Some artworks, such as mobiles or mechanized sculptures, actually move; we apply the term **kinetic** to them.

Technology and Art in Motion

Recent art and technology have also revealed new images from a world in motion. Photography has made visible images that are otherwise invisible to us due to a motion too rapid for the eye to perceive. Harold Edgerton's photograph of a bullet piercing an apple **(A)** is one such example. Edgerton pioneered techniques of strobe lighting, which coordinates the camera with an instant of light to capture such images.

Only movies, television, or videos can actually show us moving pictures. In paintings or drawings that are static images, any feeling of motion or change is always merely a suggestion or an illusion. This illusion, however, has intrigued artists of many periods and countries.

Abstract Art in Motion

The artworks shown in **B** and **C** have a great many visual differences. But they both are twentieth-century nonrepresentational images that present a feeling of motion. In the print by Shoichi Ida **(B),** our eyes move quickly across the page. Reading from left to right in a Western fashion, the line speeds to an apparent "splatter" at the end. Reading the image from right to left we might be tempted to see the horizontal stripe as a speed line or trail shooting back from the splatter mark.

Bridget Riley's painting **(C)** shows a very different technique. It is a controlled, simply repetitive pattern of definite, hard-edged curving lines. But when we stare at it, the edges begin to blur and the lines begin to "swim" as the black and white areas vibrate. Even the painting's surface appears no longer flat but seems to undulate and become a rippling surface. This type of painting is called **Op Art,** which are static images that give optical illusions of movement.

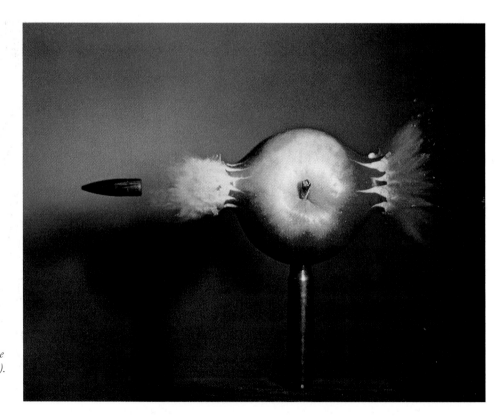

A
Harold Edgerton. *Making Applesauce at MIT (.30 Bullet Piercing an Apple).* 1964. Photograph. Courtesy of the Edgerton Foundation.

B
Shoichi Ida. *Between Vertical and Horizon, San Pablo Avenue No. 1.* 1984. Color aquatint with soft ground etching on Gampi paper chine colle, $23^1/_2 \times 23^1/_2''$ (60×60 cm) on $40^1/_4 \times 37^1/_4''$ (102×95 cm) sheet. Edition 21. Crown Point Press.

C
Bridget Riley. *Current.* 1964. Synthetic polymer paint on composition board, $4'\ 10^3/_8'' \times 4'\ 10^7/_8''$ (148.1×149.3 cm). The Museum of Modern Art, New York (Philip Johnson Fund).

"SEEING" THE ACTION

Much of the implication of movement present in art is caused by our memory and past experience. We recognize temporary, unstable body positions and realize that change must be imminent. For example, we immediately "see" the action shown in **A.** The plantation workers are in poses that we recognize as momentary, and we anticipate the change that is imminent. By contrast, the landowner is depicted at rest as he watches the laborers.

Kinesthetic Empathy

In a process called **kinesthetic empathy,** we tend to recreate unconsciously in our own bodies the actions we observe. We actually "feel" in our muscles the exertions of the athlete or dancer; we simultaneously stretch, push, or lean, though we are only watching. This involuntary reaction also applies to static images in art, where it can enhance the feeling of movement.

A feeling of **anticipated movement** can be created by implied lines and gestures. Thus in **B** the standing figure seems ready to strike. The gestures of limbs and flowing fabric (captured in porcelain) heighten the sense of anticipated motion.

Anticipated Motion by Design

Even utilitarian objects can express an anticipated motion as is evident in streamlined design from the 1930s to the present day. A romance with modern technology led to the streamlining of objects such as toasters and telephones, which would never speed down a highway or through the sky. Even when parked at the curb, a "street rod" such as **C** expresses speed through its long sweeping lines.

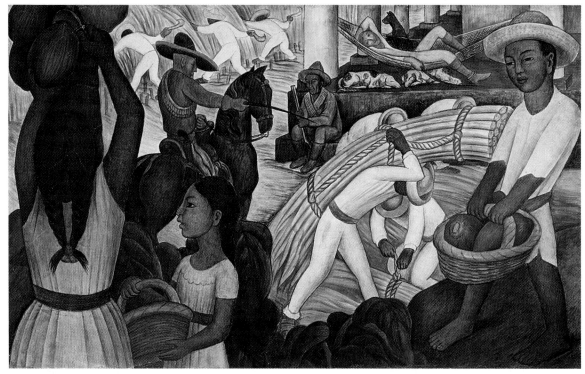

A

Diego Rivera. *Sugar Cane.* 1931. Frescoed panel, 58″ (147 cm) high.
Philadelphia Museum of Art (gift of Mr. and Mrs. Herbert Cameron Morris).

B
Doccia Porcelain Factory; Giovanni Battista
Foggini, sculptor; Gaspero Bruschi, modeler.
Mercury and Argus. 1749. Porcelain, polychrome,
and parcel gilt. The Getty Center, Los Angeles,
94.SE.76.

C
Larry Erickson and Billy F. Gibbons (designers). *CadZZilla.* 1989.
Custom automobile. Design patent DES. 320, 959.

A

David slays Goliath and cuts off his head; Abner brings David with the head of Goliath to Saul; Jonathan, smitten with love of David, gives him his garments. Manuscript illumination (M638 f 28v) from *Old Testament Miniatures*, Paris. c. 1245–1250. Tempera on vellum. The Pierpont Morgan Library, New York.

FIGURE REPEATED, FIGURE CROPPED

Figure Repeated

Over the centuries artists have devised various conventions to present an illusion of motion in art. One of the oldest devices is that of **repeating a figure.** As the thirteenth-century illumination in **A** illustrates, the figure of David from the Bible appears in different positions and situations. Architectural elements divide the format into four areas. In the upper left area David with his slingshot meets the giant Goliath and prepares for battle. To the upper right David cuts off the slain giant's head as the Philistine soldiers leave. David presents the head to the King of Israel in the lower left vignette, and in the final scene David receives the gift of a cloak from an admirer.

This repetitive device was used widely in Oriental cultures as well as in Western medieval art. The figure of Krishna appears over and over in different positions and situations in the Indian miniature **(B)**.

Figure Cropped

A second dramatic way to express motion is by cropping the figure. The composition in **C** effectively crops the lunging basketball player to enhance the feeling of movement. The head and basketball are barely contained in the frame and form a tense line spanning the picture. The forward leg is cropped, heightening the sense of the player bursting through the confines of the frame. In this case the framing rectangle is essential to the suggestion of motion.

Comic strips employ both techniques of figure repetition and figure cropping to create a sense of motion. Bill Watterson's *Calvin and Hobbes* was creative in the use of these devices to bring life to Calvin's real and imagined worlds **(D)**.

B

Krishna Revealing His Nature As Vishnu.
Miniature from Malwa, India. c. 1730.
Gouache or watercolor on paper, 8 × 14³/₄″
(20 × 38 cm). Victoria and Albert Museum,
London. Crown Copyright.

C
Taliek Brown of UConn.
December 10, 2002.
Photograph.

D
Bill Watterson. *Calvin and Hobbes.* © 1985. Reprinted with permission of
Universal Press Syndicate. Allrights reserved.

BLURRED OUTLINES

We readily interpret a photograph, or a painting based on a photograph, such as **A,** as a symbol of movement because of the **blurred outlines.** With a fast shutter speed, moving images are frozen in "stop-action" photographs. Here the shutter speed is relatively slow, so that the figure becomes a blurred image that we read as an indication of the subject's movement. This is an everyday visual experience. When objects move through our field of vision quickly, we do not get a clear mental picture of them. A car will pass us on the highway so fast that we perceive only a colored blur. Details and edges of the form are lost in the rapidity of the movement.

The figure in the sixteenth-century Italian drawing in **B** suggests movement in this way. The dancer is drawn with sketchy, incomplete, and overlapping lines to define her form.

The photograph in **C** freezes some of the figures but the blurred image of one musician conveys motion as do the red lines suggesting other exposures that record the movement of the photographer's hand. The effect is to capture the energy of a live performance and rock music.

The repetition of blurred color boundaries in **D** suggests a flickering flame. Even fairly abstract pictures such as this computer-generated image can evoke motion through blurred edges or outlines.

A
Gerhard Richter. *Woman Descending the Staircase.* 1965.
6' 9" × 4' 3" (200.7 × 129.5 cm). Art Institute of
Chicago (Roy J. and Frances R. Friedman Endowment;
Gift of Lannan Foundation).

B
Anonymous (Italian or Spanish). *Angel (Dancing Figure).*
16th century. Red chalk, 6¼ × 5¼" (16 × 13 cm).
The Metropolitan Museum of Art, New York (gift of
Cornelius Vanderbilt, 1880; 80.3.72).

C
Jack Deutsch. *Rock Concert.*
Photograph.

D
George S. Boznos. *White Flame.*
2001. Computer art, 2 × 3′.
GSBX Design, Libertyville, IL,
DesignGSBX@hotmail.com.

MULTIPLE IMAGE

Another device for suggesting movement, called **multiple image,** is illustrated in **A.** When we see one figure in an overlapping sequence of poses, the slight change in each successive position suggests movement taking place. The photograph in **A** is from the 1880s. The photographer, Thomas Eakins, was intrigued with the camera's capabilities for answering the visual problem of showing movement and analyzing it.

Illustration **B** shows this idea in a drawing by Ingres. Though Ingres's motive was probably just to try two different positions for the figure, we get a clear suggestion of the figure moving in dancelike gestures.

Lines of Force

Painters of the twentieth and twenty-first centuries have often been concerned with finding a visual language to express the increasingly dynamic quality of the world around us. Although at first glance very different, Duchamp's famous *Nude Descending a Staircase* **(C)** is much like the Eakins photograph in **A.** Again, multiple images of a figure are shown to suggest a body's movement in progress. Now the body forms are abstracted into simple geometric forms that repeat diagonally down the canvas as the nude "descends." Many curved lines (called **lines of force**) are added to show the pathway of movement. This is a device we commonly see, and immediately understand, in today's comic strips.

Grouping Multiple Images

The group of photographs in **D** is a collection of six similar subjects from different sources. They have the effect of a "multiple image" and create movement across the grid. A sense of motion is created like that of an old film or a flicker book.

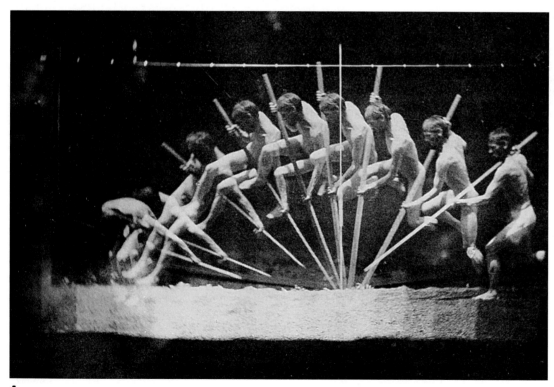

A
Thomas Eakins. *Pole Vaulter: Multiple Exposure of George Reynolds.* c. 1884. Photograph, 9.5 × 12.3 cm. The Metropolitan Museum of Art, New York (gift of Charles Bregler, 1941; 41.142.11).

B
Jean-August-Dominique Ingres. *Female Nude.*
c. 1826–1834. Pencil on white paper, $10^{7}/8 \times 11^{1}/2''$
(27.8×29.6 cm). Musée Bonnat, Bayonne.

C
Marcel Duchamp. *Nude Descending a Staircase, No. 2.* 1912.
Oil on canvas, $4'\ 10'' \times 2'\ 11''$ (1.47×0.89 m). Philadelphia
Museum of Art (Louise and Walter Arensberg Collection).

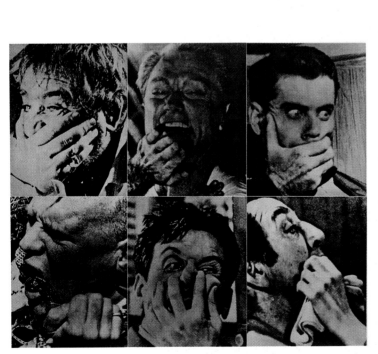

D
John Baldessari. *Six Colorful Gags (Male).* 1991. Photogravure
with color aquatint and spit bite aquatint, $47 \times 54''$, edition 25.
Crown Point Press, San Francisco.

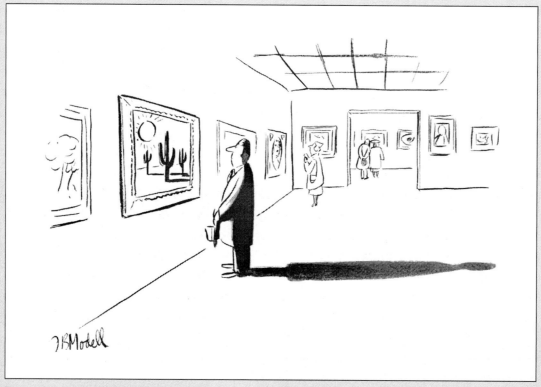

Frank Modell. 1951. © *The New Yorker* Collection from cartoonbank.com. All Rights Reserved.

CHAPTER **12**

INTRODUCTION
Light and Dark 224

VALUE PATTERN
Variations in Light and Dark 226

VALUE AS EMPHASIS
Creating a Focal Point 228

VALUE AND SPACE
Using Value to Suggest Space 230

TECHNIQUES
An Overview 232

LIGHT AND DARK

Value is simply the artistic term for light and dark. An area's value is its relative lightness or darkness in a given context. Only through changes of light and dark can we perceive anything. Light reveals forms; in a dark room at night we see nothing and bump into furniture and walls. The page you are reading now is legible only because the darkness of the type contrasts with the whiteness of the background paper. Even the person (or animal) who is physiologically unable to perceive color can function with only minimal difficulties by perception based on varying tones of gray.

Illustration **A** is a scale of seven values of gray. These are termed **achromatic** grays, as they are mixtures of only black and white; no color (or chroma) is used.

The Relationship between Light and Dark Areas

The term **value contrast** refers to the relationship between areas of dark and light. Because the scale in **A** is arranged in sequential order, the contrast between any two adjoining areas is rather slight and termed "low-value" contrast. The center gray circles are all the same middle value. It is interesting to note how this consistent center gray seems to change visually depending on the background. Indeed, it is hard to believe that the circles on the far left and far right are precisely the same value.

The scale in **A** shows only seven basic steps. Theoretically, between black and white there could be an almost unlimited number of steps. Studies have shown that the average eye can discern about forty variations in value. The artist may use as many or as few values as his or her artistic purposes indicate, though at times the nature of the chosen medium may influence the result. The drawing of the interior in **B** uses a very broad range of values. The artist, Charles Sheeler, drawing with a Conté crayon, skillfully exploited the medium's softness to create many grays and an interesting design of dark and light contrasts.

The Relationship between Value and Color

Value and color are related. Color, based on wavelengths of light, offers a much broader field of visual differences and contrasts. But grayed neutrals (now called **chromatic** grays) can also be produced by mixing certain colors, which results in different **tones** from those in **A**. A further relationship of value and color is that every color is, in itself, also simultaneously a certain value. Pure yellow is a light (high-value) color corresponding to a very light gray in terms of light reflection. Purple is basically a dark, low-value color that would match a very dark gray.

The early American painting in **C** does not begin to have the range of values seen in **B**. Here, in fact, there are perhaps only two or three value changes with almost no subtle gradations from dark to light. Yet the theme is perfectly understandable. A color reproduction would add some interest, but showing only the values makes a readable image. This reproduction shows what is called the "value pattern" of the original painting.

A
A value scale of gray. The center circles are identical in value.

B
Charles Sheeler. *The Open Door*. 1932.
Conté crayon on paper, mounted on
cardboard, 23³/₄ × 18″ (60.7 × 46.7 cm).
The Metropolitan Museum of Art,
New York (Edith and Milton Lowenthal
Collection, bequest of Edith Abrahamson
Lowenthal, 1992.24.7).

C
Anonymous (American). *The Quilting Party*. Late 19th century. Oil on wood, 13 × 25″
(33.4 × 63.6 cm). Abby Aldrich Rockefeller Folk Art Center, Williamsburg, Virginia.

VARIATIONS IN LIGHT AND DARK

In describing paintings or designs, we speak often of their **value pattern.** This term refers to the arrangement and the amount of variation in light and dark, independent of the colors used.

High Key or Low Key

When value contrast is minimized and all the values are within a limited range with only small variation, the result is a restrained, subtle effect. The impression is one of understatement, whether the value range is limited to lights ("high key" is a term used often) or darks ("low key"). In illustration **A** the values are all extremely light, with a few contrasting dark spots. Light even reflects into the shadows. The painting in **B** shows the opposite approach, an extreme contrast of dark and light. This is a Baroque painting, done in a period when artists purposely accentuated value contrasts to portray exciting themes. The violent and gory subject of Artemisia Gentileschi's painting **(B)** receives an aptly emotional visual treatment. The candlelit picture has dramatic, sudden shadows throughout the scene, achieving an almost theatrical effect.

Creating an Emotional Response

Our different responses to **A** and **B** illustrate how value alone can create an immediate emotional reaction. The artist can choose a value pattern to elicit emotional reactions in the viewer. Closely related values are calm and quiet. The impression of **A** is light-filled and warm. On the other hand, sharp value contrasts suggest drama, excitement, even conflict. Certainly, the gruesome theme of **B** would not be communicated by the limited range of values in **A**. An entirely different mood would have been presented.

In the same way overall darkness may provide feelings of sadness, depression, and even mystery. Lighter values, being brighter, seem less serious or threatening. Specific colors will always evoke emotional reactions, but the value pattern alone can be important in expressing a theme.

The painting by Agnes Martin shown in **C** could not be further removed from the drama of **B.** In this case the simple composition of lines creates a quiet meditative feel in a light key. The delicate line weight and grid composition produces an allover pattern across the pale canvas.

A
Giovanni Paolo Pannini. *Scalinata della Trinità dei Monti.* ca. 1756–58. The Metropolitan Museum of Art, New York (Rogers Fund, 1971; 1971.63.1).

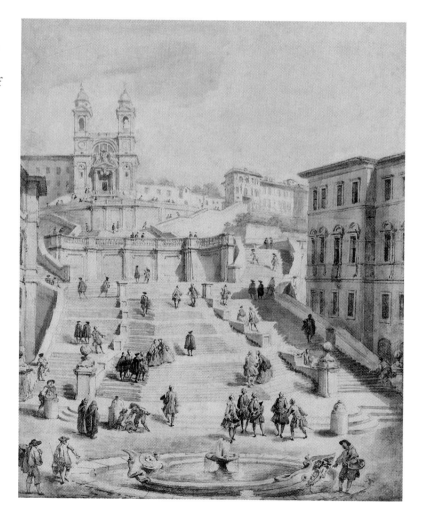

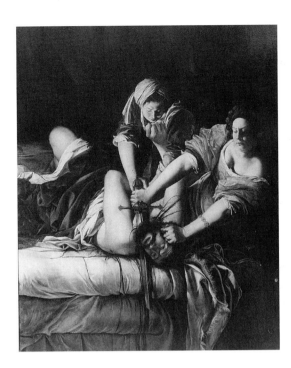

B
Artemisia Gentileschi. *Judith Decapitating
Holofernes.* c. 1620. Oil on canvas, 70 × 60″
(199 × 152.5 cm). Galleria degli Uffizi,
Florence.

C
Agnes Martin. *Morning.* 1965.
Acrylic and pencil on canvas,
182.6 × 181.9 cm. Tate Gallery,
London.

CREATING A FOCAL POINT

A valuable use of dark-and-light contrast is to create a focal point or center of attention in a design. A visual emphasis or "starting point" is often desired. A thematically important character or feature can be visually emphasized by value contrast. High dark-and-light contrast instantly attracts our attention because of **value emphasis.** By planning high contrast in one area and subdued contrast elsewhere, the artist can be assured where the viewer's eye will be directed first.

Homer's watercolor of a leaping trout **(A)** emphasizes the trout through value contrast. The light underbelly stands out against the dark background and the darker tail stands out against the backdrop of reflected light on the water.

The etching in **B** places emphasis on the light window at the right-hand side of the composition. Our eye follows the path of the gentle light to the softly illuminated figure grouping of the Holy Family. All other features of the interior melt into the darkness as we move away from that spot.

An Experiment in Value Contrast

Strong contrast of value creates an equal emphasis in both **C** and **D.** These photographs have precisely the same vantage point and appear almost like a positive and negative of the same image. In reality the artist has collaborated with nature to produce two striking images of contrast. In **C** a wet sycamore stick is seen against the snow. The photograph in **D** shows the same stick the next day, stripped of its bark, against the ground after the snow has melted away. In each case the form of the branch stands in contrast to the ground, but for very different reasons!

Value Before Color

All of these images, of course, exist in color. But the black-and-white reproductions here are valuable to show the artists' reliance on value contrast, irrespective of the particular colors involved. Most artists are as aware of the value pattern they create as the pattern of various colors. The artistic choice is often not green or red but how dark (or light) a green or red to use.

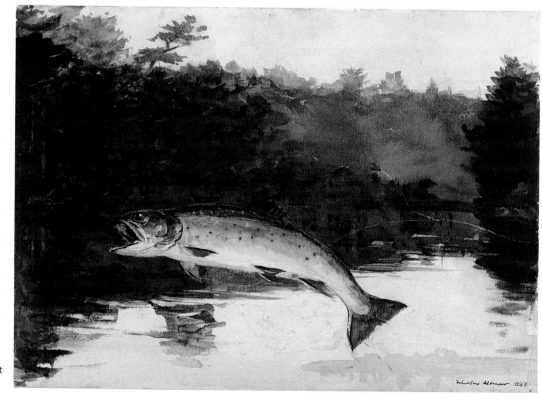

A
Winslow Homer. *Leaping Trout.* 1889. Watercolor on paper, 13⁷/₈ × 19″. Portland Museum of Art, Portland, Maine (bequest of Charles Shipman Payson).

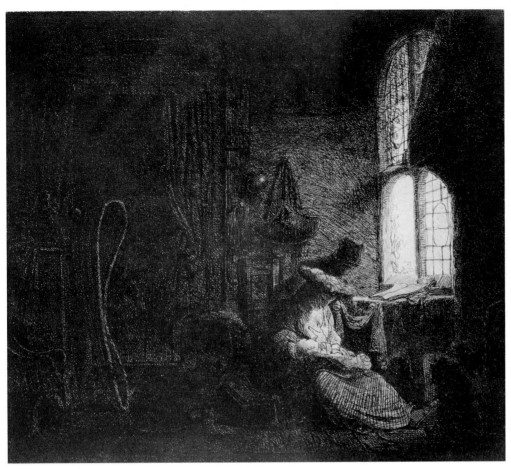

B
Ferdinand Bol. *Holy Family in an Interior*. 1643. Etching, drypoint and engraving; sheet: $7^1/8 \times 8^1/2''$ (18.1 × 21.6 cm). The Metropolitan Museum of Art, New York (The Elisha Whittelsey Collection, The Elisha Whittelsey Fund, 1995; 1995.100).

C
Andy Goldsworthy. Photograph, January, 1981. Sycamore stick placed on snow/raining heavily. Middleton Woods, Yorkshire. From *Andy Goldsworthy: A Collaboration with Nature*, Harry N. Abrams, Inc., Publishers, New York, 1990.

D
Andy Goldsworthy. Photograph, January, 1981. Snow gone by next day, bark stripped, chewed and scraped off. From *Andy Goldsworthy: A Collaboration with Nature*, Harry N. Abrams, Inc., Publishers, New York, 1990.

USING VALUE TO SUGGEST SPACE

One of the most important uses of gradations of dark and light is to suggest volume or space.

On a flat surface value can be used to impart a three-dimensional quality to shapes. During the Renaissance the word **chiaroscuro** was coined to describe the artistic device of using light and dark to imply depth and volume in a painting or drawing. Chiaroscuro is a combination of the Italian words for "light" and "dark." A drawing using only line is very effective in showing shapes. By varying the weight of the line, an artist may imply dimension or solidity, but the effect is subtle. When areas of dark and light are added, we begin to feel the three-dimensional quality of forms. This is apparent in Michelangelo's *Madonna and Child* **(A).** The baby has been shaded in dark and light, giving it a feeling of volume and three dimensions, especially in comparison with the figure of the Madonna. Being drawn just in line, she remains a fairly flat portrayal.

Artists constantly use value differences (or shading) to suggest three-dimensional form on a flat surface. The watercolor in **B** shows how effectively the feeling of volume and space can be presented.

In **C** the artist, Ivan Albright, has greatly exaggerated slight visual changes in value. The result is a lumpy, almost decayed, feeling to the flesh. This painting shows that value can be used to provoke an emotional response.

Effective Use of Value in Landscapes

Much art has been, and is, concerned with producing a simulation of our three-dimensional world. On a two-dimensional piece of paper or canvas, an illusion of space is desired—and perhaps not just the roundness of a head but a whole scene receding far into the distance. Here again the use of value can be an effective tool of the artist. High-value contrast seems to come forward, to be actually closer, whereas areas of lesser contrast recede or stay back, suggesting distance. Notice how effectively Caspar Friedrich has used this technique in his painting **(D).** The figure on the rocks in front is sharply dark against the rest of the picture. Then each receding rock, wave, and bit of land becomes progressively lighter and closer to the value of the sky. An illusion of great depth is thus created by manipulating the various values. This technique does reproduce what our eyes see: Far-off images visually become grayer and less distinct as the distance increases. In art, this is called **aerial,** or **atmospheric, perspective.**

A

Michelangelo. *Madonna and Child.* 1535–40(?). Black and red chalk and white pigment on prepared paper, 21³⁄₈ × 15⁵⁄₈″ (54 × 40 cm). Casa Buonarotti, Florence.

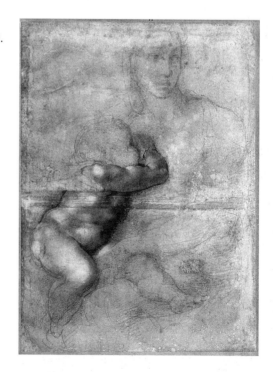

B
Sue Hettmansperger. *Untitled Drawing.* 1975.
Watercolor and pencil, 23 × 25″ (58 × 64 cm).
Collection of North Carolina National Bank.

C
Ivan Le Lorraine Albright. *Three Love Birds.*
1930. Charcoal and oil on canvas, 78^1/$_2$ × 42″
(198.8 × 106.7 cm). Art Institute of Chicago
(gift of Ivan Albright).

D
Caspar David Friedrich. *The Wanderer Above the Sea
of Mist.* c. 1817–1818. Oil on canvas, 28^3/$_8$ × 29^1/$_4$″
(99 × 75 cm). Kunsthalle, Hamburg.

AN OVERVIEW

The use of value in a work of art is what we would commonly call **shading.** However, to say that an artist uses shading does little to describe the final work, as there are so many techniques and hence many visual effects available. Artistic aims vary from producing a naturalistic rendition of some visual image to a completely nonobjective work that uses dark and light simply to provide added visual interest to the design. Even with a similar purpose, the same subject done by the same artist will be very different depending on the chosen medium and technique. These examples can show you just a few of the almost unlimited possibilities.

Choosing the Medium

Pencil, charcoal, chalk, and Conté crayon are familiar media to art students. Being soft media they are capable of providing (if desired) gradual changes of dark to light. The Prud'hon drawing **(A)** shows the subtle and gradual transitions possible.

Experimenting with Technique

A medium such as black ink, by its nature, gives decidedly sharp value contrast. But this can be altered in several ways. The artist may use what is called **cross-hatching** (black lines of various densities that, seen against the white background, can give the impression of different grays). Again, variations are possible. These lines may be done with careful, repetitive precision or in a more atmospheric manner as in **B.**

An artist may also choose the technique of **wash drawing,** in which dark ink or watercolor is mixed with water, diluting the medium to produce desired shades of gray (or brown). The **mixed media** drawing shown in **C** creates value shapes in this manner. The value created by the wash contrasts with the bright lighter values. Darker values are created by combining parallel hatching of dark ink lines within the middle value wash.

Visual Grays

The use of dots to create visual grays is a very common procedure, though we may not realize it. All of the black-and-white halftones we see daily in newspapers, books, and magazines are actually areas of tiny black dots in various concentrations to produce visual grays. This is a photomechanical process, but the same effect can be seen in Seurat's drawing **(D).** Here the dots are created by the artist scraping a soft Conté crayon over a heavily textured white paper. Again, dots of black produce visual grays.

With the same idea **E** presents a definite visual feeling of grays and, hence, dimension and volume. But this "drawing" is accomplished by computer manipulation of a photograph. The grays are actually created by the positioning of hundreds of small numerals of various densities that combine with the white background to give us the impression of many different grays.

A
Pierre-Paul Prud'hon. *La Source.* c. 1801.
No. 833, black and white chalk on blue
paper, 21³/₁₆ × 15⁵/₁₆″ (54 × 39 cm).
Sterling and Francine Clark Art Institute,
Williamstown, MA.

B
Georgio Morandi. *Striped Vase with Flowers.*
1924. Etching on zinc, 239 × 204 mm.
Museo Morandi, Bologna.

C
Giovanni Domenico Tiepolo. *St. Ambrose Addressing the Young St. Augustine.* c. 1747–1750. Black chalk, pen, and brown ink with brown wash on paper. Arkansas Arts Center, Little Rock (The Arkansas Arts Center Foundation Collection: Purchased with a gift from James T. and Helen Dyke, 1993.93.35).

D
Georges Seurat. *Seated Boy with Straw Hat* (Study for *The Bathers*). 1882. Conté crayon, 9¹/₂ × 12¹/₄″ (24.13 × 31.1 cm). Yale University Art Gallery, New Haven (Everett V. Meeks Fund).

E
Spread from catalog featuring fashion by R. Newbold, a Paul Smith subsidiary, Autumn/Winter, 1996. Art Director: Alan Aboud. Photographer: Sandro Sodano. Computer Manipulation: Nick Livesey. Aboud, Sodano.

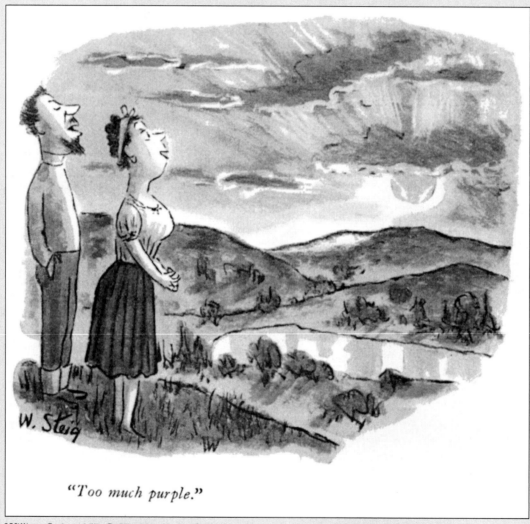

"Too much purple."

COLOR THEORY

It is not only the professional artist or designer who deals with color. All of us make color decisions almost every day. We constantly choose items to purchase of which the color is a major factor. Our world today is marked by bold uses of color in every area of ordinary living. We can make color choices for everything from home appliances to bank checks—it seems that most things we use have blossomed into bright colors. Fashion design, interior design, architecture, industrial design—all fields in art are now increasingly concerned with color.

Therefore, everyone can profit by knowing some basic color principles. Unfortunately, the study of color can be rather complex. The word "color" has so many aspects that it means different things to a physicist, optician, psychiatrist, poet, lighting engineer, and painter; and the analysis of color becomes a multifaceted report in which many experts competently describe their findings. Shelves of books in the library on the topic attest that a comprehensive study of color from all viewpoints is impossible in a limited space.

The Essentials

However, any study of color must start with a few important, basic facts. The essential fact of color theory is that color is a property of light, not an object itself. Sir Isaac Newton illustrated this property of light in the seventeenth century when he put white light through a prism. The prism broke up white light into the familiar rainbow of hues **(A).** Objects have no color of their own but merely the ability to reflect certain rays of white light, which contain all the colors. Blue objects absorb all the rays except the blue ones, and these are reflected to our eyes. Black objects absorb all the rays; white objects reflect all of them. The significance of this fact for the artist is that as light changes, color will change.

Color Mixing

But although color indeed comes from light, the guidelines of color mixing and usage are different depending on whether the color source is light or pigments and dyes. Rays of light are direct light, whereas the color of paint is reflected light.

Color from light combines and forms new visual sensations based on what is called the **additive system.** On the other hand, pigments combine in the **subtractive system.** This term is appropriate. Blue paint is "blue" because when light hits its surface the pigment absorbs (or "subtracts") all of the color components except the blue that is reflected to our eyes. Artists should be aware of both systems. The painter, of course, will be mainly concerned with the subtractive, whereas the stage lighting designer, photographer, and often the interior designer will be concerned with the additive.

Lights projected from different sources mix according to the additive method. The diagram in **B** shows the three **primary colors** of light—red, green, and blue—and the colors produced where two hues overlap. The three primaries combined will produce white light. Complementary (or opposite) hues in light (red/cyan, blue/yellow, green/magenta) when mixed will again produce an achromatic (neutral) gray or white. Where light from a cyan (blue-green) spotlight and from a separate red spotlight overlap, the visual sensation is basically white. Combining these two colors in paint would produce a dark neutral "mud"—anything but white.

This latter mixture of pigments functions according to the subtractive system. The red paint reflects little or no blue-green, and the blue-green paint reflects little or no red. When mixed together they act like two filters that now combine to reflect less light, thus approaching black (or a dark neutral) as the result. All paint mixture is to some degree subtractive; that is, the mixture is always weaker than at least one of the parent colors.

Because this book is primarily for use in studio art classes, where the usual medium is paint, the information in this section refers mainly to the subtractive system of color usage.

A
The spectrum of colors is created by passing white light through a prism.

B
Colors of light mix according to the additive process.

LIGHT AND COLOR PERCEPTION

In any discussion of color, it is important to acknowledge that color is a product of light. Therefore, as light changes, the color we observe will change. What color is grass? Green? Grass may be almost gray at dawn, yellow-green at noon, and blue-black at midnight. The colors of things are constantly changing with the light. Though this is a simple visual fact, there is also the factor of the **color constancy** effect, which is our mind insisting that the grass is green despite the visual evidence to the contrary. This **constancy effect** is actually useful from the standpoint of human adaptation and survival. Imagine the problems if we questioned the colors of things with each new perception. Yet it is just this kind of questioning that has led artists such as Monet to reveal the range of color sensations around us. Monet's two paintings of poplars along the River Epte **(A** and **B)** are typical of this artist's reinvestigation of the same setting under different circumstances. Season, time of day, and weather conditions all contribute to different light and a difference in the color we perceive.

Observing Color in Our Surroundings

The changing colors of the landscape under varying light conditions is easy to understand based on our daily experiences. Such changes occur all around us in subtle ways as well. The Italian painter Morandi revisited the same still-life objects over a period of years. The simple confines of his studio set a stage for careful observation of color nuance and light.

The paintings shown in **C** and **D** (from 1939 and 1948) include an object in common. This "white" object takes on a slightly yellow cast in the 1939 painting and a slightly violet complexion in the 1948 painting. The light may have been different, or, quite simply, Morandi's perception may have been altered by new insights or the influence of surrounding elements.

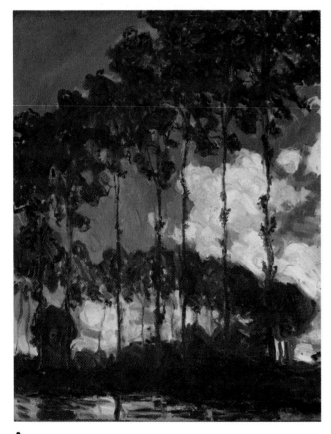

A
Claude Monet. *Poplars on the Epte.* 1891. Oil on canvas, 92.4 × 73.7 cm. Tate Gallery, London.

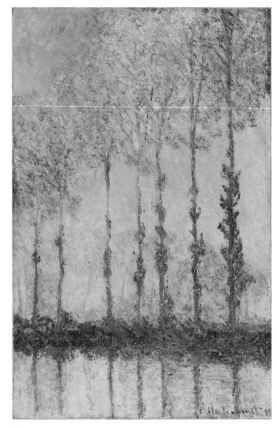

B
Claude Monet. *Poplars.* 1891. Oil on canvas, 39 3/8 × 25 5/8″ (100 × 65 cm). Philadelphia Museum of Art.

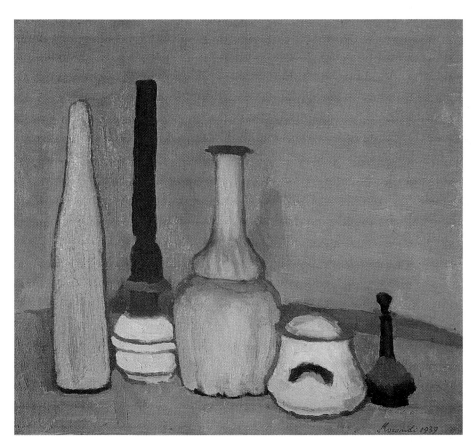

C
Giorgio Morandi. *Still Life.* 1939.
Oil on canvas, 41.5 × 47.3 cm.
Museo Morandi, Bologna.

D
Giorgio Morandi. *Still Life.* 1948.
Oil on canvas, 35.9 × 50 cm.
Museo Morandi, Bologna.

INFLUENCE OF CONTEXT

Color has a basic, instinctive, visual appeal. Great art has been created in black and white, but few artists have totally ignored the added visual interest that color lends. The uninhibited use of color has been a primary characteristic of art in the twentieth century. Some artists use color primarily as an emotional element, and many artists use color in a strictly intuitive way. However, there have been artists who studied color per se and thereby have added immeasurably to our knowledge of color and color usage.

Today's artists and students (and authors) owe a great debt to the twentieth-century artist Josef Albers, who as a painter and teacher devoted a career to the study of color and color relationships. His books and paintings have contributed invaluably to our knowledge of color. Many of the concepts in this discussion are reflections of his research and teaching.

Color and Its Surroundings

Related to the idea of color changing with the light, one other color phenomenon is important: Our perception of colors changes according to their surroundings. Even in the same light, a color will appear different depending on the colors that are adjacent to it. Rarely do we see a color by itself. Normally colors are seen in conjunction with others and the visual differences are often amazing. A change in value (dark and light) is a common occurrence. Illustration **A** shows that not only the value but also the color changes. The smaller "pink" squares are identical; the visual differences are caused by the various background colors these squares are placed against. In **B,** however, the two yellow areas, despite different background colors, still look about the same. With pure vibrant colors, optical changes will be very slight. Grayed, neutral colors are constantly changing in different contexts as you can see in **C.**

These manipulations of our perception are not mere "tricks." Illustrations **A** and **C** are not exceptions to our everyday experiences: They are examples of contextual influences that surround our every perception.

A
The red-purple squares, although seemingly different, are identical.

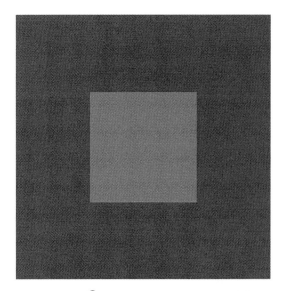

C
The gray sample looks different against the two background colors.

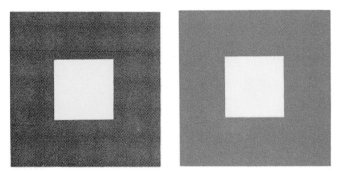

B
A brilliant, vibrant color will not show much change despite different surroundings.

HUE

The first property of color is what we call **hue.** Hue simply refers to the name of the color. Red, orange, green, and purple are hues. Although the words "hue" and "color" are often used as synonyms, this is a bit confusing as there is a distinction between the two terms. Hue describes the visual sensation of the different parts of the color **spectrum.** However, one hue can be varied to produce many colors. So even though there are relatively few hues, there can be an almost unlimited number of colors. Pink, rose, scarlet, maroon, and crimson are all colors, but the hue in each case is red. We are all aware that in the world of commercial products, color names abound; plum, adobe, colonial blue, desert sunset, Mayan gold, and avocado are a few examples. These often romantic images are extremely inexact terms that mean only what the manufacturers think they mean. The same hue (or color) can have dozens of different commercial names. You will even notice that the same hue can have different names in different color systems. "Blue," for instance, may be a blue-violet in one system and a cyan in another. One system may use the term "purple" and another "violet." Try to see past the names given to the colors and look instead at the relationships.

Color Wheels

The most common organization for the relationships of the basic colors is the **color wheel** shown in **A.** The wheel system dates back to the early eighteenth century, and this version is one updated by Johannes Itten in the twentieth century. This particular organization uses twelve hues, which are divided into three categories.

The three primary colors are red, yellow, and blue. From these, all other colors can theoretically be mixed. The three **secondary colors** are mixtures of the two primaries: Red and yellow make orange; yellow and blue make green; blue and red make violet. The six **tertiary** colors are mixtures of a primary and an adjacent secondary: Blue and green make blue-green, red and violet make red-violet, and so on.

The color wheel of twelve hues is the one still most commonly used. If you look closely, however, you will notice that the complements are not consistent with those shown in the illustration of additive and subtractive primaries. Furthermore, if you try mixing colors based on this wheel (such as blue and red to make violet), you will find the results to be dull and unsatisfactory. The color wheel shown in **B** is based on the Munsell Color System, and this version has ten equal visual steps. Mixtures of complements on this wheel will more closely produce neutrals (when tested as light mixtures on a computer, for example), and the positions of the colors are more useful in predicting paint mixtures as well.

A
The twelve-step color
wheel of Johannes Itten.

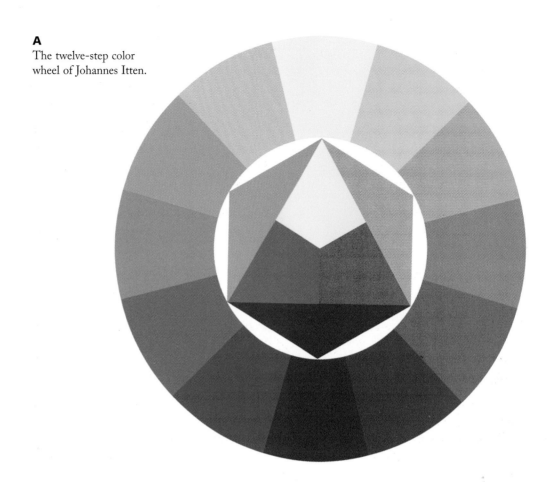

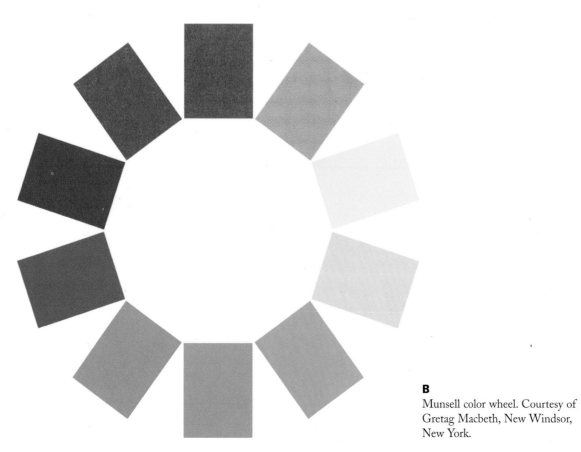

B
Munsell color wheel. Courtesy of
Gretag Macbeth, New Windsor,
New York.

A
Value scales for blue, gray, and yellow with equal visual steps.

VALUE

The second property of color is **value,** which refers to the lightness or darkness of the hue. In pigment adding white or black paint to the color alters value. Adding white lightens the color and produces a **tint,** or high-value color. Adding black darkens the color and produces a **shade,** or low-value color. Individual perception varies, but most people can distinguish at least forty tints and shades of any color.

"Normal" Color Values Differ

Not all the colors on the color wheel are shown at the same value. Each is shown at normal value, with the pure color unmixed and undiluted. The normal values of yellow and of blue, for example, are radically different **(A).** Because yellow is a light, or high-value, color, a yellow value scale shows many more shades than tints. The blue scale shows more tints, because normal blue is darker than a middle value.

Changing Color Vs

When working with paint and pigments, the value of a color can also be altered by thinning the color with medium. The more transparent color will be a lighter value when applied over a white background. The value of a color can also be altered by mixture with other hues: A naturally dark violet will darken a yellow, for example.

Value, like color itself, is variable and depends entirely on surrounding hues for its visual sensation. In **B** the center green area appears much lighter and more luminous on the black background than on the white.

Color Interaction

Colors changed by their context is a well-known occurrence. Amounts and repetition are also critical factors in color interaction. The same green shown in **B** takes on a different complexion when it is "woven" through the black or white as shown in **C.** In this case the white and green interact in a mixture effect, producing a lighter value field of color than the green and black pattern.

B
The same color will appear to change in value, depending upon the surrounding color.

C
The visual mixture of green with black and white.

INTENSITY/COMPLEMENTARY COLORS

The third property of color is **intensity,** which refers to the brightness of a color. Because a color is at full intensity only when pure and unmixed, a relationship exists between value and intensity. Mixing black or white with a color changes its value and at the same time affects its intensity. To see the distinction between the two terms, look at the two tints (high value) of red in example **A.** The tints have about the same degree of lightness, yet one might be called "rose," the other "shocking pink." The two colors have very different visual effects, and the difference comes from brightness or intensity. Intensity is sometimes called chroma, or saturation.

How to Lower Intensity

There are two ways to lower the intensity of a color, to make a color less bright, more neutral, and duller. One way is to mix gray with the color. Depending on the gray used, you can dull a color without changing its value. The second way is to mix a color with its **complement,** the color directly across from it on the color wheel. Illustration **B** shows an intensity scale involving the complementary colors blue and orange. Neutralized (low intensity) versions of a color are often called tones. In **B** we see two intensity levels of blue and two intensity levels of orange with gray in the middle. As progressively more orange is added to the blue, the blue becomes duller, more grayed. The same is true of the orange, which becomes browner when blue is added. Note this effect in the photograph of orange chairs seen through the blue glass table **(C).**

The Degas painting in **D** is characterized by varying intensities of a single hue. The warm red orange ranges in intensity to include flesh tones and browns. When other hues are not present, the effect of intensity is even more obvious.

How to Increase Intensity

Complementary colors are direct opposites in position and in character. Mixing complementary colors together neutralizes them, but when complementary colors are placed next to each other, they intensify each other's brightness. When blue and orange are side by side, each color appears brighter than in any other context. This effect is called **simultaneous contrast,** meaning that each complement simultaneously intensifies the visual brilliance of the other, so that the colors appear to vibrate. Artists use this visual effect when they wish to produce brilliant color.

Afterimage

Another phenomenon that defines complementary color is the **afterimage** effect. Stare at an area of intense color for a minute or so, and then glance away at a white piece of paper or wall. Suddenly, an area of the complementary color will seem to appear. For example, when you look at a white wall after staring at a red shape, a definite blue-green area in somewhat the same shape will seem to take form on the wall.

A
Two tints of red at the same value
have different intensities.

B
Complementary colors neutralize each other in mixture.

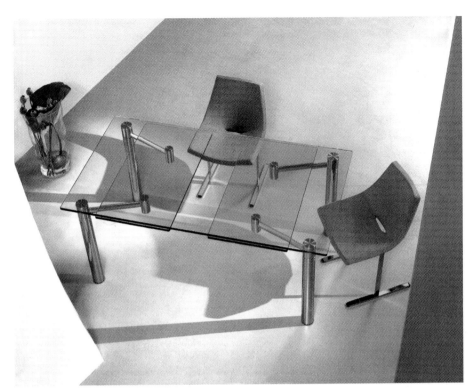

C
Casanova Table and Side Chairs.
Domus Design Collection, New York.

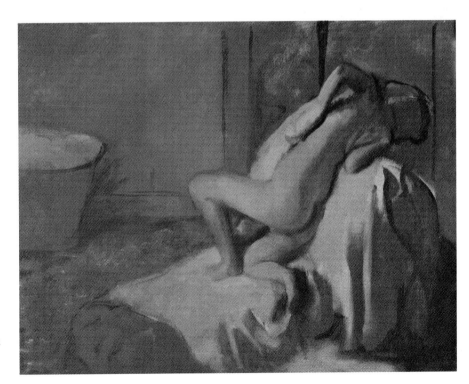

D
Edgar Degas. *After the Bath, Woman
Drying Herself.* c. 1896. Oil on canvas,
35 × 45²/₃″ (89 × 116 cm). Philadelphia
Museum of Art (Purchased, Estate of the
late George D. Widener, 1980-6-1).

A

(Opposite, top left) Chuck Close. *April.* 1990–91. Oil on canvas, 100 × 84″. Courtesy Pace Wildenstein, New York.

B

(Opposite, top right) Chuck Close. *April* (detail). 1990–91. Oil on canvas, 100 × 84″. Courtesy Pace Wildenstein, New York.

TECHNIQUES THAT SUGGEST LIGHT

The mixing of pigments combines along certain guidelines to create new colors. However, muddy or dull colors are often the result. Even when mixing adjacent colors on the color wheel you may find the results to be less intense than you anticipated, and the farther apart the hues, the more subtractive (darker and duller) the mixture. To understand this process, think of the pigments as acting like filters, which in combination (or mixture) allow less light or color to reflect off the colored surface to the viewer's eye.

Visual Color Mixing Techniques

Pigment simply will never reproduce the luminous and brilliant quality of light. Recognizing this, artists have struggled with the problem and tried various techniques to overcome it. One attempt is called **visual color mixing** or **optical mixture.** Rather than mixing two colors on the palette, artists place two pure colors side by side in small areas so the viewer's eye (at a certain distance) will do the mixing. Or perhaps they drag a brush of thick pigment of one color loosely across a field of another color. The uneven paint application allows bits and pieces of the background to show through. Again, the pure colors are mixed in our perception, not on the canvas.

Visual Mixing in Art and Television

Visual mixing is often associated with the post-Impressionist era of the late nineteenth century and can be observed in the works of artists such as Seurat and van Gogh. The techniques of **pointillism** and divisionism both use small bits of juxtaposed color to produce different color sensations. In a way, these artists anticipated the truly additive color mixing that occurs on a color television screen. A TV screen is composed of thousands of luminous pixels. The colors we see are a visual mix of the light primaries, red, blue, and green. Such luminosity is not possible with the surface of painting. Still, artists continue to explore the possibilities of visual mixture, as can be seen in *April* **(A)** by the contemporary painter Chuck Close. The large scale of this portrait assures that we will always be aware of the pattern of color bits and that they will not absolutely merge into a mixture. In fact, this technique is usually most luminous when this is the case.

This particular painting by Close has large obvious units of color as can be seen in the detail **(B).** Earlier paintings by the artist employed smaller, more subtle dots and dashes. The larger marks in the newer work allow us to easily see the components of the "mixture." It is evident that the closer the value of the color bits, the more easily they merge.

Visual Mixing in Other Art Forms

The basic idea of visual mixing is used in many areas. In creating mosaics, stirring a bowl of red and blue tiles will not, of course, produce purple tesserae. Instead, small pieces of pure-colored tiles are interspersed to produce the effect of many other intermediate colors. The same process is employed in creating tapestries. Weavers working with a limited number of colored yarns or threads can intermingle them, so that at a distance the eye merges them and creates an impression of many hues, values, or intensities. **C** is a plaid, or tartan, fabric that demonstrates this phenomenon. From a distance the material can seem to be a pattern of many colors and values. Close inspection might reveal that just three colored threads have been woven in various densities to produce all the visual variations.

A version of the pointillist technique is now used every day in a photomechanical adaptation in the printing of color pictures. The numerous colors we see in printed reproductions, such as those on these pages, are usually produced by just four basic colors in a small dot pattern. The dots in this case are so tiny that we are totally unaware of them unless we use a magnifying glass to visually enlarge them.

C
Black Watch Plaid for Band
Regimental Tartan (#396).
House of Tartan, Ltd.,
Perthshire, Scotland.

IDENTIFYING COLOR WITH THE SENSES

"Cool" colors? "Warm" colors? These may seem odd adjectives to apply to the visual sensation of color, as cool and warm are sensations of touch, not sight. Nevertheless, we are all familiar with the terms and continually refer to colors this way. Because of the learned association of color and objects, we continue to identify and relate the sensations of the different senses. Hence, red and orange (fire) and yellow (sunlight) become identified as warm colors. Similarly, blue (sky, water) and green (grass, plants) are always thought of as cool colors.

A Psychological Effect

Touching an area of red will assuredly not burn your hand, but looking at red will indeed induce a feeling of warmth. The effect may be purely psychological, but the results are very real. Perhaps you have read of the workers in an office painted blue complaining of the chill and actually getting colds. The problem was solved not by raising the thermostat but by repainting the office in warm tones of brown. The painting by Archibald Motley in **A** creates a nighttime scene dominated by the dark values of intense blue. This blue might even evoke the cool relief that night brings after a hot summer day.

Color Context Makes a Difference

We generally think of the colors yellow through red-violet as the warm side of the color wheel and yellow-green through violet as the cool segment. The visual effects are quite variable, however, and again depend a great deal on the context in which we see the color. In **B** the green square appears very warm surrounded by a background of blue. But in **C** the identical green, when placed on an orange background, shifts and becomes a cooler tone.

Creating Depth and Volume

Because warm colors tend to advance, whereas cool colors seem to recede, the artist may use the warm/cool relationship to establish a feeling of depth and volume. Probably no group of artists has investigated and expanded our ideas of color more than the Impressionists. The blue and purple shadows (instead of gray and black) that so shocked the nineteenth-century public seem to us today perfectly logical and reasonable.

These warm lights and cool shadows are apparent on the "white" objects in Paul Cézanne's still-life painting **(D)**. Often shadows contain a cool reflected light from the sky, while bright, illuminated areas show the warmth of sunlight. This effect can be seen in the "blue" shadows on snow.

A
Archibald J. Motley, Jr. *Gettin' Religion.*
1948. Oil on canvas, 31⁷/₈ × 39¹/₄″.
Collection Archie Motley and Valerie
Gerrard Browne, Evanston, IL.

B
A colored area on a cool background will appear warmer in tone.

C
The same color surrounded by a warm background seems cool.

D
Paul Cézanne. *Still Life with Plaster Cast.* c. 1894. Oil on paper, mounted on panel, $27^1/_2 \times 22^1/_2''$ (70.6 × 57.3 cm). Courtauld Institute Gallery, Somerset House, Strand, London.

COLOR DOMINANCE

Areas of emphasis in a work of art create visual interest and, naturally, have been carefully planned by the artist. Color is very often the means chosen to provide this emphasis—color is probably the most direct device to use. When planning emphasis, we might think of using a larger size somewhere, or perhaps a change in shape, or isolating one element by itself. As the diagrams in **A** show, the use of color dominates these other devices. You will notice that the accented color is not a radically different hue or very different in value or intensity. Such contrasts, of course, would heighten the effect. But **A** shows that color by its very character commands attention.

Color as Attention-Grabber

Sometimes the artist or designer may wish to create a definite focal point or center of attention that the observer will see first. A bright or vivid color, such as the red of the Target logo will capture our attention in a lively composition **(B).** The red logo contrasts with the predominantly cool blue background, and our eye is drawn to it even though it is placed in the corner away from the action.

The unusual arrangement of autumn leaves in *Elm* by Andy Goldsworthy in **C** shows how color can create an emphasis so strong that it dominates other elements. In this case Goldsworthy tore similar dark and yellow leaves and mated a dark half to a yellow half of another similarly shaped leaf. These mated leaves form the boundary, which contains many other yellow leaves set off against the field of darker and duller older leaves. The result emphasizes the larger yellow shape and gives the appearance of the dark leaves having been painted within that larger oval.

The very strong emphasis that color can provide is one reason some artists consider color to be the most powerful of the visual elements.

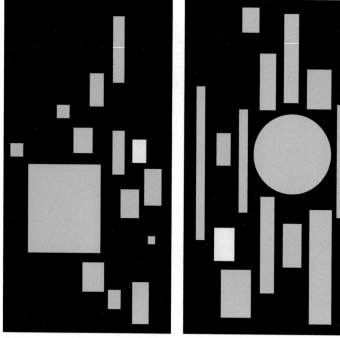

A
Color is so strong a visual element that it will dominate other devices to establish emphasis.

B
Advertisement for Target department store. *New York Times Magazine,* October 13, 2002.

C
Andy Goldsworthy. *Elm.* Middleton Woods, Yorkshire. 1980. From *Andy Goldsworthy: A Collaboration with Nature.* Harry N. Abrams, Inc., Publishers, New York, 1990.

ACHIEVING BALANCE WITHIN ASYMMETRICAL COMPOSITION

Unlike symmetrical balance, asymmetry is based on the concept of using differing objects on either side of the center axis. But to create visual balance, the objects must have equal weight or attraction. Color is often used to achieve this effect.

Color Balance Value

A comparison of **A** and **B** will illustrate the idea. In **A** Joan Miró's painting is shown just in black and white. From this reproduction, the composition might appear off balance. The left side, with the contrasting white circle, solid black triangle, and notched rectangle, seems to have more visual interest than the right side where there is less delineation of the shapes and little value contrast. But when the same painting is seen in color **(B)**, the balance is immediately clear. A circular shape on the right is actually a brilliant red. This very vivid color note in a predominantly neutral painting attracts our eye and can balance the elements on the left.

The use of color to balance a composition is very common and seen in many different periods and different styles of art. Wayne Thiebaud's *Rabbit* **(C)** is at first glance the simplest of compositions: a white rabbit placed in the center of a white field. The rabbit's head is the natural focus of the composition, and this directs our attention to the left side of the painting. The intense blue shadow on the right-hand side of the composition provides the balance.

In Anne Vallayer's painting **(D),** the violets and crimsons in the basket of plums balance the light values on the left side of the painting. This balance is also accentuated by a complementary contrast between the color violet and golden yellow of the lighter bread.

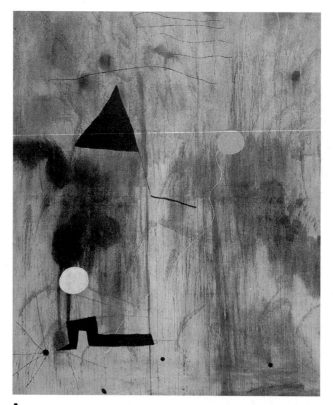

A

Joan Miró. *The Birth of the World.* Montroig, summer 1925. Oil on canvas, 8′ 2¾″ × 6′ 6¾″ (250.8 × 200 cm). The Museum of Modern Art, New York (acquired through an anonymous fund, the Mr. and Mrs. Joseph Slifka and Armand G. Erpf funds and by gift of the artist).

B

Seeing **A** in color shows us how color achieves the balance.

C
Wayne Thiebaud. *Rabbit.* 1966.
Pastel on paper, 14³/₄ × 19¹/₂″
(37 × 50 cm). Courtesy, Collection
Mrs. Edwin A. Bergman and the
artist.

D
Anne Vallayer. *Basket of Plums.* 1769.
Oil on canvas, unframed: 38 × 46.2 cm.
The Cleveland Museum of Art (Mr.
and Mrs. William H. Marlatt Fund,
1971.47).

COLOR'S SPATIAL PROPERTIES

There is a direct relationship between color and a visual impression of depth, or pictorial space. Colors have an innate advancing or receding quality because of slight muscular reactions in our eyes as we focus on different colors. Intense, warm colors (red, orange, yellow) seem to come forward; cool colors (blue, green) seem to go back. The design of numbers in various colors **(A)** illustrates this principle. When we look at this design, we can see that some numbers immediately pop forward and actually seem closer than others. Some numbers appear to stay back, with others seeming to be far in the background. Relative size can influence this effect, with larger items automatically seeming closer. But notice that size is not really a consideration here. There are numbers of equal size and weight that advance or recede based solely on their color.

Another aspect of the relationship of color and spatial illusion is that the dust in the earth's atmosphere breaks up the color rays from distant objects and makes them appear bluish. As objects recede, any brilliance of color becomes more neutral, finally seeming to be gray-blue.

Creating Depth

Artists can use color's spatial properties to create either an illusion of depth or a flat, two-dimensional pattern. The strange landscape in **B** gives a feeling of great distance. The overlapping planes of the receding fragments change in color and value. The artist has concentrated warm browns and oranges in the close foreground. Then, as distance increases, the elements become grayer and cooler in color. Value and color contrasts are more pronounced in the foreground and more subtle in the distance.

Using Color to Emphasize Flatness

In contrast, David Hockney in *Mulholland Drive: The Road to the Studio* **(C)** consciously flattens and compresses space by his use of color. Hills, groves of trees, and the towers of power lines are obvious images from the landscape, but the shapes, colors, and patterns are laid out like a crazy quilt. Even the maplike patterns at the top add emphasis to the essential flatness of the arrangement. In this case, hot oranges work as both foreground and background. You can see blue along the bottom or "foreground" of the painting as well as farther up or "back" in the landscape.

Color Value and Spatial Illusion

Color values are also important in spatial illusion. Whatever the colors used, high contrast comes forward visually, whereas areas of lesser contrast generally recede. Illustrations **A** and **B** show this effect. The dark-colored numbers in **A** generally stay back, being close in value to the black background. The value-contrasting light yellows come forward.

A
Giovanni Pintori. Advertisement for Olivetti calculators. 1949. Associazione Archivo Storico Olivetti, Ivrea, Italy.

B
Edward Burtynsky. *Shipbreaking #10, Chittagong, Bangladesh*. 2000.
Photograph. Charles Cowles Gallery, New York.

C
David Hockney. *Mulholland Drive: The Road to the Studio*. 1980. Acrylic on canvas, 86 × 243″ (218.44 × 617.22 cm).
Los Angeles County Museum of Art (purchased with funds from the F. Patrick Burns Bequest).

MONOCHROMATIC/ANALOGOUS

Certain color schemes are thought of as **color harmonies.** These schemes are organized by simple color relationships.

Monochromatic Color Scheme

A **monochromatic** color scheme involves the use of only one hue. The hue can vary in value, and pure black or white may be added. Painter Mark Tansey has varied the values in **A** by a process of wiping away the paint to reveal the white "ground" underneath. The use of monochrome unites the montage of images that come together in this painting. Tansey also uses monochrome as a way to emphasize textural difference over color difference and to suggest the qualities of an old photograph.

Analogous Color Scheme

An **analogous** color scheme combines several hues that sit next to each other on the color wheel. Again, the hues may vary in value. The Navajo textile **(B)** shows the related, har-monious feeling that analogous color lends to a design. This blanket includes colors adjacent to red on the color wheel.

Tonality

Color unity is described by another term. We often speak of the "tonality" of a design or painting. **Tonality** refers to the dominance of a single color or the visual importance of a hue that seems to pervade the whole color structure despite the presence of other colors. Monochromatic patterns (as value studies in one color) give a uniform tonality, because only one hue is present. Analogous color schemes can also produce a dominant tonality, as **B** shows. When colors are chosen from one part of the color wheel, they will share one hue in common. In **B** the red, orange, and brown all derive from red and so yield a red tonality.

A
Mark Tansey. *Forward Retreat.* 1986. Oil on canvas, 94 × 116″ (2.4 × 2.9 m). Collection of Eli Broad Family Foundation, Santa Monica, CA. Courtesy Gagosian Gallery, New York.

B
Navaho blanket/rug. c. 1885–95. 55 × 82″ (140.5 × 207.8 cm).
Natural History Museum of Los Angeles County (William Randolph
Hearst Collection, A.5141.42–153).

COMPLEMENTARY/TRIADIC

A **complementary** color scheme, as the term implies, joins colors opposite each other on the color wheel. This combination produces a sense of contrast, as in Stuart Davis's painting titled *Visa* **(A).** This painting has the graphic qualities of a billboard or sign. The complementary contrast of magenta letters and green background makes use of the eye-catching devices of advertising.

Split Complementary Color Scheme

A split complementary color scheme is related to the complementary scheme but employs colors adjacent to one of the complementary pairs. For example, a red might be balanced by a blue and a green in place of the complementary blue-green.

Triadic Color Scheme

A **triadic** color scheme involves three hues equally spaced on the color wheel. Red, yellow, and blue would be the most common example. These hues form a triangle on the color wheel and suggest balance. This is true even when the red, yellow, and blue are subtle as in Vermeer's painting of the *Girl with a Pearl Earring* **(B).** Red, yellow, and blue often appear in composition with the simple contrast of black and white as they do in this picture.

Planning Color Schemes

These color schemes or harmonies are probably more common to such design areas as interiors, posters, and packaging than to painting. In painting, color often is used intuitively, and many artists would reject the idea that they work by formula. But knowing these harmonies can help designers consciously plan the visual effects they want a finished pattern to have. Moreover, color can easily provide a visual unity that might not be obvious in the initial pattern of shapes. Even though design aims vary, often the more complicated and busy the pattern of shapes is, the more useful will be a strict control of the color, and the reverse is also true.

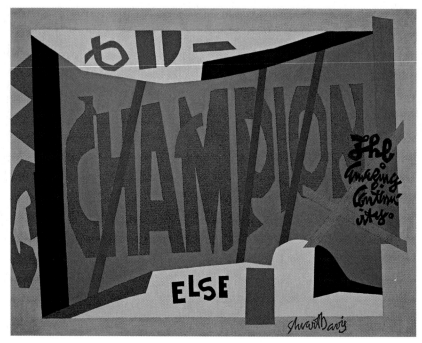

A
Stuart Davis. *Visa.* 1951. Oil on canvas, 40 × 52″. The Museum of Modern Art, New York (gift of Mrs. Gertrud A. Mellon, 9.1953).

B
Jan Vermeer. *Girl with a Pearl Earring.* c. 1665–1666. Oil on canvas, $17^1/_2 \times 15^3/_8''$
(44.5 × 39 cm). Royal Cabinet of Paintings, Mauritshuis, The Hague.

UNEXPECTED COMBINATIONS

Color discord is the opposite of color harmony. A combination of discordant colors can be visually disturbing. Discordant colors have no basic affinity for each other (as you would find with analogous colors), nor do they seem to balance each other (as with a complementary contrast).

The term "discord" conveys an immediate negative impression. Discord in life, in a personal relationship, may not be pleasant, but it often provides a stimulus or excitement. In the same manner, discord can be extremely useful in art and design.

Using Discord to Add Interest

Mild discord results in exciting, eye-catching color combinations. The world of fashion has exploited the idea to the point that mildly discordant combinations are almost commonplace. A discordant color note in a painting or design may contribute visual surprise and also may better express certain themes or ideas. A poster may better attract attention by its startling colors.

Once rules were taught about just which color combinations were harmonious and which were definitely to be avoided because the colors did not "go together." A combination of pink and orange was unthinkable; even blue and green patterns were suspect. Today these rules seem silly, and we approach color more freely, seeking unexpected combinations.

The color pair of orange and red-purple shown in **A** is one that has been called discordant. This is typical of color pairings that are widely separated on the color wheel but not complements. In **B** the effect is even more discordant when the red-purple is lightened to the same value as the orange.

A painting by Wolf Kahn **(C)** takes full advantage of this red-purple and orange color pairing to create a *Color/Tree Symphony*. The colors conjure the intense impact of autumn foliage and seem to create light.

Colors in Conflict

Certain color pairings are almost difficult to look at. In fact, our eye experiences a conflict in trying to perceive them simultaneously. Red and cyan literally have a vibrating edge when their values are equal and their intensities are high **(D)**. You will find this to be true for a range of colors when they are paired at equal value, but the **vibrating color** effect is strongest with reds opposed to blues and greens. Annie May Young exploits this almost electric effect in her quilt shown in **E**.

A
Pure orange and red-purple.

B
The same colors with closer values.

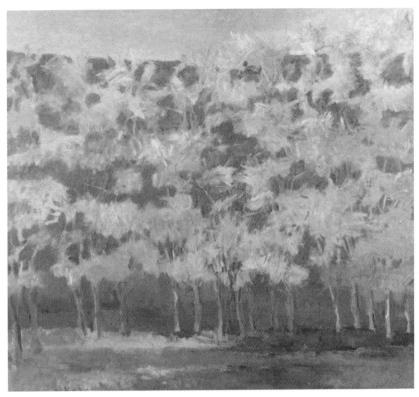

C
Wolf Kahn. *Color/Tree Symphony.* 1994. Oil on canvas, 51^1/$_2$ × 56^1/$_2$″.
Grace Borgenicht Gallery, New York.

D
Red and cyan will have a vibrating edge when values are
equal and intensities are high.

E
Annie May Young. *Quilt.* c. 1965. Cotton stiff material: corduroy
sheeting, polyester dress and pants material, wool, 91 × 81″.
Tinwood Media, Atlanta.

LOCAL, OPTICAL, ARBITRARY

There are three basic ways in which color can be used in painting. An artist may use what is called **local color.** This refers to identifying the color of an object under ordinary daylight. Local color is the **objective** color that we "know" objects are: Grass is green, bananas are yellow, apples are red. The use of local color reinforces, or takes advantage of, our preconceptions of an object's color.

Light Effects Color

Visually, the red of an apple can change radically, depending on the illumination. Because color is a property of light, the color of any object changes at sunset, under moonlight, or by different city lights **(A).** Even atmospheric effects can visually change the local color of distant objects, such as faraway mountains appearing blue. An artist reproducing these visual effects is using optical color.

Subjective Use of Color

In arbitrary color, the color choices are subjective, rather than based on the colors seen in nature. The artist's colors are selected for design, aesthetic, or emotional reasons. Large patches of color make up the composition of Milton Avery's *White Rooster* **(B).** The blue tree and salmon-colored sky are bold subjective color choices. Arbitrary color is sometimes difficult to pinpoint, because many painters take some artistic liberties in using color. Has the artist disregarded the colors he saw or has he merely intensified and exaggerated the visual reference? This latter use is termed "heightened color." Gauguin's painting in **C** intensifies the red earthen pathway bringing it close in saturation to the woman's dress.

Pure arbitrary (or subjective) color is often seen in twentieth-century and contemporary painting. Just as art in general has moved away from naturalism, so too has arbitrary color tended to become an important interest. Even color photographers—with filters, infrared film, and various darkroom techniques—have experimented widely in the area of unexpected color effects.

These categories of color use obviously apply to paintings with identifiable subject matter. In nonobjective art the forms have no apparent reference to natural objects, so that the color is also nonobjective. Purely aesthetic considerations determine the color choices.

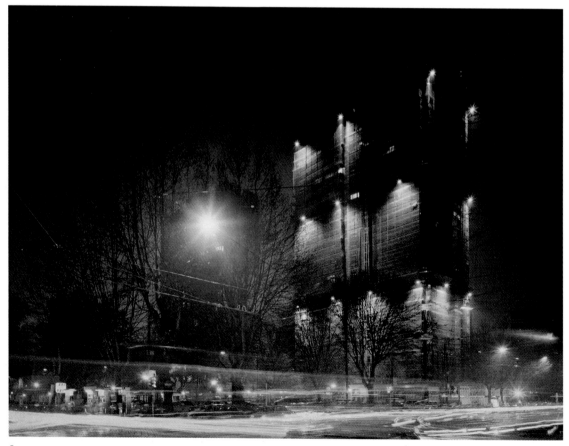

A
Lewis Baltz. *Rule Without Exception.* 1991. Photograph.

B
Milton Avery. *White Rooster.* 1947. Oil on canvas, $61^{1}/_{2} \times 50^{3}/_{4}''$. The Metropolitan Museum of Art (Gift of Joyce Blaffer von Bothmer, 1975, 1975.210).

C
Paul Gauguin. *Allées et Venues, Martinique (Coming and Going).* 1887. $28^{1}/_{2} \times 36^{1}/_{4}''$. (72.5 × 92 cm). Carmen Thyssen-Bornemisza Collection.

COLOR EVOKES A RESPONSE

"Ever since our argument, I've been blue."

"I saw red when she lied to me."

"You're certainly in a black mood today."

"I was green with envy when I saw their new house."

These statements are emotional. The speakers are expressing an emotional reaction, and somehow a color reference makes the meaning clearer, because color appeals to our emotions and feelings. For artists who wish to arouse an emotional response in the viewer, **emotional color** is the most effective device. Even before we "read" the subject matter or identify the forms, the color creates an atmosphere to which we respond.

Colors Evoke Emotions

In a very basic instance, we commonly recognize so-called warm and cool colors. Yellows, oranges, and reds give us an instinctive feeling of warmth and evoke warm, happy, cheerful reactions. Cooler blues and greens are automatically associated with quieter, less outgoing feelings and can express melancholy **(A)** or depression. These examples are generalities, of course, for the combination of colors is vital, and the artist can also influence our reactions by the values and intensities of the colors selected.

Theme and Context

Paintings in which color causes an emotional reaction and relates to the thematic subject matter are very common. The flat red background in Leon Golub's *Mercenaries IV* **(B)** is evocative of blood and impending violence associated with the threatening image of the mercenaries. The intense red seems to push these figures at us, heightening our emotional response to the subject matter. The "dirty" colors and complementary greens also contribute to the emphasis on conflict and violence.

With a change of context, the same hue can evoke a different response. Red is also a dominant color in Hans Hofmann's *The Golden Wall* **(C),** and once again the red seems to push the other shapes toward us. The nonobjective shapes of intense color and modulations in the red field create a vibrant, joyous quality in this painting quite different from Golub's *Mercenaries IV.*

The power of color to evoke an emotional response is undeniable. The context or situation the artist creates in a composition determines whether the effect is inventive or merely a cliché.

A

Pablo Picasso. *Crouching Woman.* 1902.
Oil on canvas, 35 × 28″ (90 × 71 cm).
Staatsgalerie, Stuttgart.

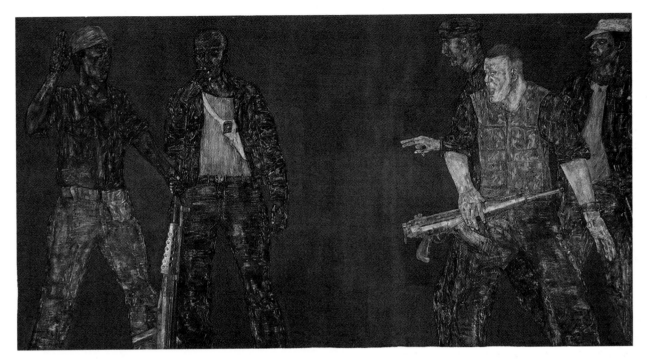

B
Leon Golub. *Mercenaries IV.* 1980. Acrylic on linen, 120 × 230^1/$_2''$ (3 × 6 m).
Private collection, courtesy of the artist.

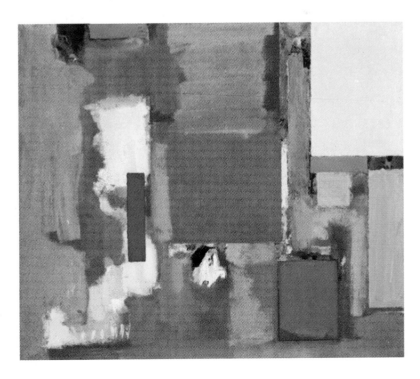

C
Hans Hofmann. *The Golden Wall.* 1961. Oil on
canvas, 5′ × 6′ 1/$_2''$ (1.51 × 1.82 m). Photograph
© 1993. The Art Institute of Chicago (Mr. and
Mrs. Frank G. Logan Prize Fund, 1962.775).

CONCEPTUAL QUALITIES OF COLOR

"Don't worry, he's true-blue."

"I caught him red-handed."

"So I told her a little white lie."

"Why not just admit you're too yellow to do it?"

We frequently utter statements that employ color references to describe character traits or human behavior. These color references are symbolic. The colors in the preceding statements symbolize abstract concepts or ideas: fidelity, sin, innocence, and cowardice. The colors do not stand for tangibles like fire, grass, water, or even sunlight. They represent mental, conceptual qualities. The colors chosen to symbolize various ideas are often arbitrary, or the initial reasons for their choice have become so deeply buried in history we no longer remember them. Can we really explain why green means "go" and red signifies "stop"?

Cultural Differences

A main point to remember is that symbolic color references are cultural: They are not worldwide but vary from one society to another. What is the color of mourning that one associates with a funeral? Our reply might be black, but the answer would be white in India, violet in Turkey, brown in Ethiopia, and yellow in Burma. What is the color of royalty? We think of purple (dating back to the Egyptians), but the royal color was yellow in dynastic China and red in ancient Rome (a custom continued today in the cardinals' robes of the Catholic church). What does a bride wear? White is our response, but yellow is the choice in Hindu India and red is the choice in China.

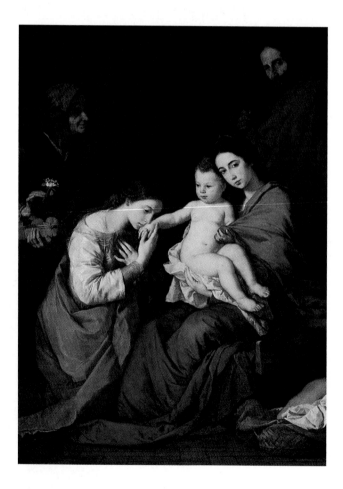

A
Jusepe de Ribera. *The Holy Family with Saints Anne and Catherine of Alexandria.* 1648. Oil on canvas, 82^1/$_2$ × 60^3/$_4$" (209.6 × 154.3 cm). The Metropolitan Museum of Art, New York (Samuel D. Lee Fund, 1934; 34.73).

Different eras and different cultures invent different color symbols. The symbolic use of color was very important in ancient art for identifying specific figures or deities to an illiterate public. Not only the ancients used color in this manner—in the countless pictures of the Virgin Mary throughout centuries of Western art, she is almost always shown in a blue robe over a red or white garment **(A)**.

Symbolic Color Today

Symbolic color designations are less important in art than they once were. Perhaps we are more conscious today of symbolic color as it is used in advertising, such as green to evoke an association with environmental responsibility or black to connote sophistication. Until recently black was a taboo for food packaging—now it may suggest a premium product.

Color symbolism can still be powerful to a large audience, however. The red and white stripes of the American flag shift to the black and white stripes of prison garb in David Hollenbach's indictment of the American justice system **(B)**.

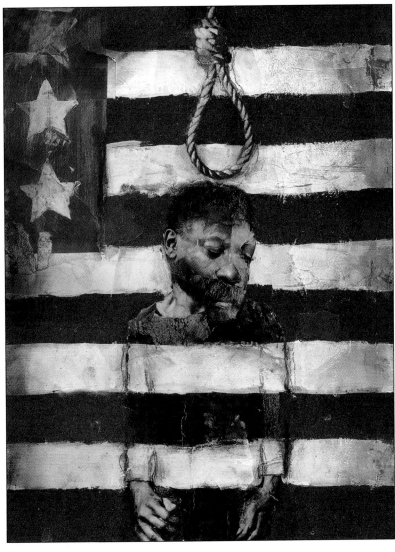

B
David Hollenbach. Client: *The American Prospect.* "The Judge as Lynch Mob," *Communication Arts Illustration Annual 43,* July 2002, pg. 51.

A CONTINUING DEBATE

We customarily think of an artist as working with color, but consider the vast area of drawings, prints, and photographs produced using pure value and no color. Also consider fields such as sculpture and architecture. Here, though color is present, the main design consideration has often been value because of the usual monotone of the materials involved. Texture, which is so important an element in these fields, is essentially a variation in light and dark visual patterns. It would seem that an artist in almost any field or specialization should be skillful in manipulating both color and value.

Artists Speak about Color

Do color and value work together or at cross-purposes? This question has been argued over the centuries. Some critics have maintained that the emphasis in a work should be on one or the other. Some artists of the past seem to have thought this way also. Leonardo da Vinci called color the "greatest enemy of art," and Titian supposedly said that an artist needs only three colors. Obviously, these artists emphasized value changes rather than contrast of pure color. The **Fauves** and **Expressionists** of the twentieth century would undoubtedly agree with van Gogh's statement, "Coloring is what makes a painter a painter."

Defining New Periods

Historically it seems that, for whatever reason, many artists have often chosen to put the emphasis on either color or value. Art historians outlining the stylistic changes in art have described shifts in this area as indicative of a new period.

This changing of color/value emphasis among different artists and different periods would explain why some works seem so inadequate when shown in a black-and-white illustration. While a Renaissance painting may be satisfactory, if not satisfying, shown only in value, a book on Impressionism would be impossible without any illustrations in color. The sparkle and brilliance of the original paintings would be lost.

Relationship between Color and Value

A comparison between a black-and-white reproduction and a color one can be useful in revealing the relationship between the value structure and the color structure of a composition. The value structure of the Ad Reinhardt painting **(A)** shows a fairly bland assortment of similar grays. (In fact, the camera, or rather black-and-white film, tends to read the colors as being more diverse in value than the human eye would see.) When we see the same painting reproduced in color **(B)**, a variety of intense hues is revealed. Some of these hues stand in contrast, such as the sea green and red, while others tend to melt, such as the warm red and magenta. This is due to the equal value relationships among the various hues.

A

Ad Reinhardt. *Abstract Painting.* 1948. Water- and oil-based paints on canvas, 6′ 4″ × 12′ (1.93 × 3.66 m). Allen Memorial Art Museum, Oberlin College, Ohio (gift of the artist and the Ruth C. Roush Fund for Contemporary Art).

B
Right half of painting **A.** Ad Reinhardt. *Abstract Painting,* detail. 1948. Oil on canvas,
40 × 80″. Allen Memorial Art Museum, Oberlin College, Ohio (Ruth C. Roush
Fund for Contemporary Art, 67.26).

GLOSSARY

Abstraction A visual representation that may have little resemblance to the real world. Abstraction can occur through a process of simplification or distortion in an attempt to communicate an essential aspect of a form or concept.

Achromatic Black, gray, or white with no distinctive hues.

Additive system A color mixing system in which combinations of different wavelengths of light create visual sensations of color.

Aerial perspective The perception of less distinct contours and value contrasts as forms recede into the background. Colors appear to be washed out in the distance or take on the color of the atmosphere. Also called atmospheric perspective.

Aesthetics A branch of philosophy concerned with the beautiful in art and how the viewer experiences it.

Afterimage Occurs after staring at an area of intense color for a certain amount of time and then quickly glancing away toward a white surface, where the complementary color seems to appear.

Allover pattern A composition that distributes emphasis uniformly throughout the two-dimensional surface by repetition of similar elements.

Alternating rhythm A rhythm that consists of successive patterns in which the same elements reappear in a regular order. The motifs alternate consistently with one another to produce a regular (and anticipated) sequence.

Ambiguity Obscurity of motif or meaning.

Amplified perspective A dynamic and dramatic illusionistic effect created when an object is pointed directly at the viewer.

Analogous colors A color scheme that combines several hues located next to each other on the color wheel.

Analysis A measure of the attributes and relationships of an artwork or design.

Anticipated movement The implication of movement on a static two-dimensional surface caused by the viewer's past experience with a similar situation.

Art deco A decorative style, popular in the 1920s, characterized by its geometric patterns and reflecting the rise of industry and mass production in the early twentieth century.

Art Nouveau A late nineteenth century style that emphasized organic shapes.

Assemblage An assembly of found objects composed as a piece of sculpture (see Collage).

Asymmetrical balance Balance achieved with dissimilar objects that have equal visual weight or equal eye attraction.

Axis A line of reference around which a form or composition is balanced.

Balance The equilibrium of opposing or interacting forces in a pictorial composition.

Bilateral symmetry Balance with respect to a vertical axis

Biomorphic Describes shapes derived from organic or natural forms.

Blurred outline A visual device in which most details and the edges of a form are lost in the rapidity of the implied movement.

Calligraphic Elegant, flowing lines suggestive of writing with an aesthetic value separate from its literal content.

Chiaroscuro The use of light and dark values to imply depth and volume in a two-dimensional work of art.

Chroma See Intensity.

Chromatic Relating to the hue or saturation of color.

Classical Suggestive of Greek and Roman ideals of beauty and purity of form, style, or technique.

Closed form The placement of objects by which a composition keeps the viewer's attention within the picture.

Collage An artwork created by assembling and pasting a variety of materials to a two-dimensional surface.

Color constancy A psychological compensation for changes in light when observing a color. A viewer interprets the color to be the same under various light conditions.

Color discord A perception of dissonance in a color relationship.

Color harmony Any one of a number of color relationships based on groupings within the color wheel (see Analogous Colors, Color Triad, and Complementary).

Color symbolism Employing color to signify human character traits or concepts.

Color triad Three colors equidistant on the color wheel.

Color wheel An arrangement of colors based on the sequence of hues in the visible spectrum.

Complementary A color scheme incorporating opposite hues on the color wheel. Complementary colors accentuate each other in juxtaposition and neutralize each other in mixture.

Composition The overall arrangement and organization of visual elements on the two-dimensional surface.

Conceptual Artwork based on an idea. An art movement in which the idea is more important than the two- or three-dimensional artwork.

Constancy effect An aspect of human perception that allows us to see size or color or form as consistent even if circumstances change appearances.

Content An idea conveyed through the artwork that implies the subject matter, story, or information the artist communicates to the viewer.

Continuation A line or edge that continues from one form to another, allowing the eye to move smoothly through a composition.

Continuity The visual relationship between two or more individual designs.

Contour A line used to follow the edges of forms and thus describe their outlines.

Cool color A color closer to blue on the color wheel.

Critique A process of criticism for the purpose of evaluating and improving art and design.

Cross-hatching A drawing technique in which a series of lines are layered over each other to build up value and to suggest form and volume.

Crystallographic balance Balance with equal emphasis over an entire two-dimensional surface so that there is always the same visual weight or attraction wherever you may look. Also called allover pattern.

Cubism A form of abstraction that emphasizes planes and multiple perspectives.

Curvilinear Rounded and curving forms that tend to imply flowing shapes and compositions.

Description A verbal account of the attributes of an artwork or design.

Design A planned arrangement of visual elements to construct an organized visual pattern.

Distortion A departure from an accepted perception of a form or object. Distortion often manipulates established proportional standards.

Draftsmanship The quality of drawing or rendering.

Earthworks Artworks created by altering a large area of land using natural and organic materials. Earthworks are usually large-scale projects that take formal advantage of the local topography.

Emotional color A subjective approach to color usage to elicit an emotional response in the viewer.

Enigmatic Puzzling or cryptic in appearance or meaning.

Equilibrium Visual balance between opposing compositional elements.

Equivocal space An ambiguous space in which it is hard to distinguish the foreground from the background. Your perception seems to alternate from one to the other.

Expressionism An artistic style in which an emotion is more important than adherence to any perceptual realism. It is characterized by the exaggeration and distortion of objects in order to evoke an emotional response from the viewer.

Eye level See Horizon line.

Facade The face or frontal aspect of a form.

Fauve A French term meaning "wild beast" and descriptive of an artistic style characterized by the use of bright and intense expressionistic color schemes.

Figure Any positive shape or form noticeably separated from the background, or the negative space.

Focal point A compositional device emphasizing a certain area or object to draw attention to the piece and to encourage closer scrutiny of the work.

Folk art Art and craft objects made by people who have not been formally trained as artists.

Form When referring to objects, it is the shape and structure of a thing. When referring to two-dimensional artworks, it is the visual aspect of composition, structure, and the work as a whole.

Formal Traditional and generally accepted visual solutions.

Fresco A mural painting technique in which pigments mixed in water are used to form the desired color. These pigments are then applied to wet lime plaster, thereby binding with and becoming an integral part of a wall.

Gestalt A unified configuration or pattern of visual elements whose properties cannot be derived from a simple summation of its parts.

Gesture A line that does not stay at the edges but moves freely within forms. These lines record movement of the eye as well as implying motion in the form.

Golden mean A mathematical ratio in which width is to length as length is to length plus width. This ratio has been employed in design since the time of the ancient Greeks. It can also be found in natural forms.

Golden rectangle The ancient Greek ideal of a perfectly proportioned rectangle using a mathematical ratio called the Golden mean.

Graphic Forms drawn or painted onto a two-dimensional surface. Any illustration or design.

Grid A network of horizontal and vertical intersecting lines that divide spaces and create a framework of areas.

Ground The surface of a two-dimensional design that acts as the background or surrounding space for the "figures" in the composition.

Harmony The pleasing combination of parts which make up a whole composition.

Hieratic scaling A composition in which the size of figures is determined by their thematic importance.

Horizon line The farthest point we can see where the delineation between the sky and ground becomes distinct. The line on the picture plane that indicates the extent of illusionistic space and on which are located the vanishing points.

Hue A property of color defined by distinctions within the visual spectrum or color wheel. "Red," "blue," "yellow," and "green" are examples of hue names.

Idealism An artistic theory in which the world is not reproduced as it is, but as it should be. All flaws, accidents, and incongruities of the visual world are corrected.

Illustration A picture created to clarify or accompany a text.

Imbalance Occurs when opposing or interacting forms are out of equilibrium in a pictorial composition.

Impasto A painting technique in which pigments are applied in thick layers or strokes to create a rough three-dimensional paint surface on the two-dimensional surface.

Implied line An invisible line created by positioning a series of points so that the eye will connect them and thus create movement across the picture plane.

Impressionism An artistic style that sought to recreate the artist's perception of the changing quality of light and color in nature.

Informal balance Synonymous with asymmetrical balance. It gives a less rigid, more casual impression.

Installation A mixed-media artwork that generally takes into account the environment in which it is arranged.

Intensity The saturation of hue perceived in a color.

Interpretation A subjective conclusion regarding the meaning, implication, or effect of an artwork or design.

Isometric projection A spatial illusion that occurs when lines receding on the diagonal remain parallel instead of converging toward a common vanishing point. Used commonly in Oriental and Far Eastern art.

Juxtaposition When one image or shape is placed next to or in comparison to another image or shape.

Kinesthetic empathy A mental process in which the viewer consciously or unconsciously recreates or feels an action or motion he or she only observes.

Kinetic Artworks that actually move or have moving parts.

Legato A connecting and flowing rhythm.

Line A visual element of length. It can be created by setting a point in motion.

Line quality Any one of a number of characteristics of line determined by its weight, direction, uniformity, or other features.

Linear perspective A spatial system used in two-dimensional artworks to create the illusion of space. It is based on the perception that if parallel lines are extended to the horizon line, they appear to converge and meet at a common point, called the vanishing point.

Lines of force Lines that show the pathway of movement and add strong visual emphasis to a suggestion of motion.

Local color The identifying color perceived in ordinary daylight.

Lost-and-found contour A description of a form in which an object is revealed by distinct contours in some areas whereas other edges simply vanish or dissolve into the ground.

Mandala A radial concentric organization of geometric shapes and images commonly used in Hindu and Buddhist art.

Medium The tools or materials used to create an artwork.

Minimalism An artistic style that stresses purity of form above subject matter, emotion, or other extraneous elements.

Mixed media The combination of two or more different media in a single work of art.

Module A specific measured area or standard unit.

Monochromatic A color scheme using only one hue with varying degrees of value or intensity.

Montage A recombination of images from different sources to form a new picture.

Multiple image A visual device used to suggest the movement that occurs when a figure is shown in a sequence of slightly overlapping poses in which each successive position suggests movement from the prior position.

Multiple perspective A depiction of an object that incorporates several points of view.

Multipoint perspective A system of spatial illusion with different vanishing points for different sets of parallel lines.

Naturalism The skillful representation of the visual image, forms, and proportions as seen in nature with an illusion of volume and three-dimensional space.

Negative space Unoccupied areas or empty space surrounding the objects or figures in a composition.

Nonobjective A type of artwork with absolutely no reference to, or representation of, the natural world. The artwork is the reality.

Objective Having to do with reality and fidelity to perception.

One-point perspective A system of spatial illusion in two-dimensional art based on the convergence of parallel lines to a common vanishing point usually on the horizon.

Op Art A style of art and design that emphasizes optical phenomena.

Opaque A surface impenetrable by light.

Open form The placement of elements in a composition so that they are cut off by the boundary of the design. This implies that the picture is a partial view of a larger scene.

Optical mixture Color mixture created by the eye as small bits of color are perceived to blend and form a mixture.

Overlapping A device for creating an illusion of depth in which some shapes are in front of and partially hide or obscure others.

Pattern The repetition of a visual element or module in a regular and anticipated sequence.

Picture plane The two-dimensional surface on which shapes are organized into a composition.

Plane The two-dimensional surface of a shape.

Pointillism A system of color mixing (used in painting and drawing) based on the juxtaposition of small bits of pure color. Also called divisionism (see Optical mixture).

Pop art An art movement originating in the 1960s that sought inspiration from everyday popular culture and the techniques of commercial art.

Positive shape Any shape or object distinguished from the background.

Primary colors The three colors from which all other colors theoretically can be mixed. The primaries of pigments are traditionally presented as red, yellow, and blue, whereas the primaries of light are red, blue, and green.

Progressive rhythm Repetition of shape that changes in a regular pattern.

Proportion Size measured against other elements or against a mental norm or standard.

Proximity The degree of closeness in the placement of elements.

Psychic line A mental connection between two points or elements. This occurs when a figure is pointing or looking in a certain direction, which causes the eye to follow toward the intended focus.

Radial balance A composition in which all visual elements are balanced around and radiate from a central point.

Realism An approach to artwork based on the faithful reproduction of surface appearances with a fidelity to visual perception.

Rectilinear Composed of straight lines.

Repeated figure A compositional device in which a recognizable figure appears within the same composition in different positions and situations so as to relate a narrative to the viewer.

Repetition Using the same visual element over again within the same composition.

Representational An image suggestive of the appearance of an object that actually exists.

Rhythm An element of design based on the repetition of recurrent motifs.

Saturation See Intensity.

Secondary color A mixture of any two primary colors.

Shade A hue mixed with black.

Shading Use of value in artwork.

Shape A visually perceived area created either by an enclosing line or by color and value changes defining the outer edges.

Silhouette The area between the contours of a shape.

Simultaneous contrast The effect created by two complementary colors seen in juxtaposition. Each color seems more intense in this context.

Site specific A work of art in which the content and aesthetic value is dependent on the artwork's location.

Spectrum The range of visible color created when white light is passed through a prism.

Staccato Abrupt changes and dynamic contrast within the visual rhythm.

Static Still, stable, or unchanging.

Subject The content of an artwork.

Subjective Reflecting a personal bias.

Subtractive system A color mixing system in which pigment (physical substance) is combined to create visual sensations of color. Wavelengths of light absorbed by the substance are subtracted, and the reflected wavelengths constitute the perceived color.

Suprematism A Russian art movement of the early 20th century that emphasized nonobjective form.

Surrealism An artistic style that stresses fantastic and subconscious approaches to art making and often results in images that cannot be rationally explained.

Symbol An element of design that communicates an idea or meaning beyond that of its literal form.

Symmetry A quality of a composition or form wherein there is a precise correspondence of elements on either side of a center axis or point.

Tactile texture The use of actual materials to create a surface that can actually be felt or touched.

Tertiary A mixture of a primary and an adjacent secondary color.

Texture The surface quality of objects that appeals to the tactile sense.

Tint A hue mixed with white.

Tonality A single color or hue that dominates the entire color structure despite the presence of other colors.

Tone A hue mixed with its complement.

Translucent A situation in which objects, forms, or planes transmit and diffuse light but have a degree of opacity that does not allow clear visibility through the form.

Transparency A situation in which an object or form allows light to pass through it. In two-dimensional art, two forms overlap, but they are both seen in their entirety.

Triadic A color scheme involving three equally spaced colors on the color wheel.

Trompe l'oeil A French term meaning "to fool the eye." The objects are in sharp focus and delineated with meticulous care to create an artwork that almost fools the viewer into believing that the images are the actual objects.

Two-point perspective A scene that is viewed through an angle, with no objects parallel to the picture plane and with edges receding on two points on the horizon line.

Unity The degree of agreement existing among the elements in a design.

Value A measure of relative lightness or darkness.

Value contrast The relationship between areas of dark and light.

Value emphasis When a light-and-dark contrast is used to create a focal point within a composition.

Value pattern The arrangement and amount of variation in light and dark values independent of any colors used.

Vanishing point In linear perspective, the point at which parallel lines appear to converge on the horizon line. Depending on the view there may be more than one vanishing point.

Vernacular A prevailing or commonplace style in a specific geographical location, group of people, or time period.

Vertical location A spatial device in which elevation on the page or format indicates a recession into depth. The higher an object, the farther back it is assumed to be.

Vibrating colors Colors that create a flickering effect at their border. This effect usually depends on an equal value relationship and strong hue contrast.

Visual color mixing The optical mixture of small units of color so that the eye perceives the mixture rather than the individual component colors.

Visual texture A two-dimensional illusion suggestive of a tactile quality.

Volume The appearance of height, width, and depth in a form.

Warm color A color that appears to be closer to the yellow-to-red side of the color wheel.

Wash drawing A technique of drawing in water-based media.

BIBLIOGRAPHY

General

Berger, John. *Ways of Seeing*. London: British Broadcast Corporation, 1987.

Canaday, John. *What Is Art?* New York: Alfred A. Knopf, 1980.

Dondis, Donis A. *A Primer of Visual Literacy*. Cambridge, MA: MIT Press, 1973.

Faulkner, Ray, Edwin Ziegfeld, and Howard Smagula. *Art Today: An Introduction to the Visual Arts*, 6th ed. Fort Worth, TX: Harcourt Brace College Publishers, 1987.

McCarter, R. William, and Rita Gilbert. *Living with Art*, 2nd ed. New York: McGraw-Hill, 1988.

Preble, Duane, and Sarah Preble. *Artforms: An Introduction to the Visual Arts*, 5th ed. New York: HarperCollins, 1993.

Roth, Richard, and Susan Roth. *Beauty Is Nowhere: Ethical Issues in Art and Design*. Amsterdam: Gordon and Breach, 1998.

Tufte, Edward R. *Visual Explanations: Images and Quantities, Evidence and Narrative*. New Haven, CT: Graphics Press, 1996.

Art History

Arnason, H. H. *History of Modern Art*, 3rd rev. ed. New York: Harry N. Abrams, 1986.

Gardner, Louise, et al, *Art through the Ages*, 11th ed. Fort Worth, TX: Harcourt Brace College Publishers, 2001.

Janson, H. W. *History of Art*, 4th rev. and enl. ed. New York: Harry N. Abrams, 1991.

Smagula, Howard. *Currents*, 2nd ed. Englewood Cliffs, NJ: Prentice-Hall, 1989.

General Design

Bevlin, Marjorie Elliot. *Design through Discovery*, 6th ed. Fort Worth, TX: Harcourt Brace College Publishers, 1994.

Bothwell, Dorr, and Marlys Frey. *Notan: DarkLight Principle of Design*. New York: Dover, 1991.

Collier, Graham. *Form, Space and Vision: An Introduction to Drawing and Design*, 4th ed. Englewood Cliffs, NJ: Prentice-Hall, 1985.

De Lucio-Meyer, J. *Visual Aesthetics*. New York: Harper & Row, 1974.

De Sausmarez, Maurice. *Basic Design: The Dynamics of Visual Form*. Blue Ridge Summit, PA: T A B Books, 1990.

Hoffman, Armin. *Graphic Design Manual*. New York: Van Nostrand Reinhold, 1977.

Hurlburt, Allen. *The Design Concept*. New York: Watson-Gupthill Publications, 1981.

Hurlburt, Allen. *The Grid*. New York: Van Nostrand Reinhold, 1982.

Hurlburt, Allen. *Layout: The Design of the Printed Page*. New York: Watson-Guptill Publications, 1989.

Itten, Johannes. *Design and Form: The Basic Course at the Bauhaus*, 2nd rev. ed. New York: Van Nostrand Reinhold, 1975.

Kepes, Gyorgy. *Language of Vision*. Chicago: Paul Theobald, 1969.

Kerlow, Isaac Victor, and Judson Rosebush. *Computer Graphics*. New York: Van Nostrand Reinhold, 1986.

Maier, Manfred. *Basic Principles of Design*. New York: Van Nostrand Reinhold, 1977.

Mante, Harald. *Photo Design: Picture Composition for Black and White Photography*. New York: Van Nostrand Reinhold, 1971.

Margolin, Victor. *Design Discourse*. Chicago, University of Chicago Press, 1989.

McKim, Robert H. *Thinking Visually*. New York: Van Nostrand Reinhold, 1980.

Murphy, Pat. *By Nature's Design*. San Francisco: Chronicle Books, 1993.

Myers, Jack Frederick. *The Language of Visual Art*. Orlando, FL: Holt, Rinehart and Winston, 1989.

Stoops, Jack, and Jerry Samuelson. *Design Dialogue*. Worcester, MA: Davis Publications, 1983.

Wilde, Richard. *Problems, Solutions: Visual Thinking for Graphic Communications*. New York: Van Nostrand Reinhold, 1989.

Wong, Wucius. *Principles of Three-Dimensional Design*. New York: Van Nostrand Reinhold, 1977.

Wong, Wucius. *Principles of Two-Dimensional Design*. New York: Van Nostrand Reinhold, 1972.

Visual Perception

Arnheim, Rudolf. *Art and Visual Perception: A Psychology of the Creative Eye, the New Version*, 2nd rev. and enl. ed. Berkeley: University of California Press, 1974.

Bloomer, Carolyn M. *Principles of Visual Perception*, 2nd ed. New York: Van Nostrand Reinhold, 1989.

Ehrenzweig, Anton. *The Hidden Order of Art: A Study in the Psychology of Artistic Imagination*. Berkeley: University of California Press, 1976.

Gombrich, E. H. *Art and Illusion: A Study in the Psychology of Pictorial Representation*. Princeton, NJ: Princeton University Press, 1961.

Space

Carraher, Ronald G., and Jacqueline B. Thurston. *Optical Illusions and the Visual Arts*. New York: Van Nostrand Reinhold, 1966.

Coulin, Claudius. *Step-by-Step Perspective Drawing: For Architects, Draftsmen and Designers*. New York: Van Nostrand Reinhold, 1971.

D'Amelio, Joseph. *Perspective Drawing Handbook*. New York: Leon Amiel, Publisher, 1964. Press, 1973.

Doblin, Jay. *Perspective: A New System for Designers*, 11th ed. New York: Whitney Library of Design, 1976.

Ivins, William M., Jr. *On the Rationalization of Sight: With an Examination of Three Renaissance Texts on Perspective to Which Is Appended "De Artificiali Perspectiva" by Viator (Pelerin)*. New York: Da Capo Press, 1973.

Luckiesh, M. *Visual Illusions: Their Causes, Characteristics and Applications*. New York: Dover Publications, 1965.

Montague, John. *Basic Perspective Drawing*, 2nd ed. New York: Van Nostrand Reinhold, 1993.

Mulvey, Frank. *Graphic Perception of Space*. New York: Van Nostrand Reinhold, 1969.

White, J. *The Birth and Rebirth of Pictorial Space*, 3rd ed. Cambridge, MA: Harvard University Press, 1987.

Texture

Battersby, Marton. *Trompe-l'Oeil: The Eye Deceived*. New York: St. Martin's Press, 1974.

O'Connor, Charles A., Jr. *Perspective Drawing and Applications*. Englewood Cliffs, NJ: Prentice-Hall, 1985.

Proctor, Richard M. *The Principles of Pattern: For Craftsmen and Designers*. New York: Van Nostrand Reinhold, 1969.

Wescher, Herta. *Collage*. New York: Harry N. Abrams, 1968.

Color

Albers, Josef. *Interaction of Color*, rev. ed. New Haven, CT: Yale University Press, 1975.

Birren, Faber. *Creative Color: A Dynamic Approach for Artists and Designers*. New York: Van Nostrand Reinhold, 1961.

Birren, Faber. *Ostwald: The Color Primer*. New York: Van Nostrand Reinhold, 1969.

Birren, Faber, ed. *Munsell: A Grammar of Color*. New York: Van Nostrand Reinhold, 1969.

Birren, Faber, ed. *Itten: The Elements of Color*. New York: Van Nostrand Reinhold, 1970.

Birren, Faber. *Principles of Color,* rev. ed. West Chester, PA: Schiffer Publishing, Limited, 1987.

De Grandis, Luigina. *Theory and Use of Color.* New York: Harry N. Abrams, 1987.

Fabri, Frank. *Color: A Complete Guide for Artists.* New York: Watson-Guptill, 1967.

Gerritsen, Frank J. *Theory and Practice of Color.* New York: Van Nostrand Reinhold, 1974.

Itten, Johannes. *The Art of Color,* rev. ed. New York: Van Nostrand Reinhold, 1984.

Kippers, Harald. *Color: Origin, Systems, Uses.* New York: Van Nostrand Reinhold, 1973.

Pentak, Stephen, and Roth, Richard. *Color Basics.* Belmont, CA: Wadsworth/Thomson, 2003

Rhode, Ogden N. *Modem Chromatics: The Student's Textbook of Color with Application to Art and Industry,* new ed. New York: Van Nostrand Reinhold, 1973.

Varley, Helen, ed. *Color.* Los Angeles: Knapp Press, 1980.

Verity, Enid. *Color Observed.* New York: Van Nostrand Reinhold, 1980.

Zelanski, Paul, and Mary Pat Fisher. *Color.* Englewood Cliffs, NJ: Prentice-Hall, 1989.

PHOTOGRAPHIC SOURCES

Part 1: **Opener** Karl Blossfeldt Archiv / Ann und Jürgen Wilde, Köln / Artists Rights Society (ARS), NY.

Chapter 1: **Opener** Frank Modell. 1956. © *The New Yorker* Collection from cartoonbank.com. All Rights Reserved. **4A** © 1983 John Kuchera. **7C** Paul Breitzmann. **9A** Copyright Claes Oldenburg and Coosje van Bruggen, 1993. **10A&B** Raymond Loewy, Industrial Design (Woodstock, NY: Overlook Press). Copyright © 1988 Raymond Loewy. **10C** © Edgar Heap of Birds, 1989. **11D** Jonathan Player, Hungerford, U.K. **11E** © Tim Mitchell / Survival International, London. **13C** Ken Fitzsimons. **15C** By permission of Aerospace Publishing Limited, London. **15D** By permission of Dorling Kindersley Ltd., London. **16A** D. James Dee. **17D&E** © James Rosenquist / Licensed by VAGA, New York. **18A** © The Estate of Eva Hesse. **19B&C** © Estate of David Smith / Licensed by VAGA, NY; photos Dan Budnik / Woodfin Camp & Associates. **19D&E** Raymond Loewy International Group Ltd., London. **20A&B** Courtesy of the author.

Chapter 2: **Opener** Peter Arno. 1970. © *The New Yorker* Collection from cartoonbank.com. All Rights Reserved. **24A** © Wayne Thiebaud / Licensed by VAGA, NY. **25B** Eduardo Fuss. **25C** © Alex Katz / Licensed by VAGA, NY; photo Des Moines Art Center. **26A** © National Geographic Society Image Collection. **27B** Karl Blossfeldt Archiv / Ann und Jürgen Wilde, Köln / Artists Rights Society (ARS), NY. **29F** Alex Bartel / SPL / Photo Researchers Inc. **31C** Purchased by the Friends of Art, Fort Worth Art Association, 1925; acquired by the Amon Carter Museum, 1990, from the Modern Art Museum of Fort Worth through grants and donations from the Amon G. Carter Foundation, the Sid W. Richardson Foundation, the Anne Burnett and Charles Tandy Foundation, Capital Cities / ABC Foundation, Fort Worth Star-Telegram, The R. D. and Joan Dale Hubbard Foundation, and the people of Fort Worth. **32A** © 2004 Artists Rights Society (ARS), NY / VG Bild-Kunst, Bonn. **33B** Courtesy of the artist and Feature Inc., New York; photo Oren Slor. **33C** Photograph © The Art Institute of Chicago. **35C** © 2004 Artists Rights Society (ARS), NY / ADAGP, Paris. **35E** © 2004 BMW of North America, LLC, used with permission; the BMW name and logo are registered trademarks. **39D** © Robert Rauschenberg / Licensed by VAGA, NY; photo © 1990 The Metropolitan Museum of Art. **39E** Smithsonian American Art Museum / Art Resource, NY. **41A** Copyright © Estate of Diane Arbus, 1971. **41C** © 1984 Kenneth A. Hannon. **43B** Nezu Art Museum, Tokyo / Bridgeman Art Library. **43C** © 2004 Artists Rights Society (ARS), NY / VG Bild-Kunst, Bonn; photo Axel Schneider, Frankfurt am Main. **44A** © 2003 Lucia Eames dba Eames Office (www.eamesoffice.com). **46A** Michael Dwyer / Stock Boston. **47B** © Tom McHugh / Photo Researchers Inc. **47C** Courtesy of Gehry Design, Santa Monica, CA.

Chapter 3: **Opener** Whitney Darrow, Jr. 1946. © *The New Yorker* Collection from cartoonbank.com. All Rights Reserved. **51B** © Estate of Stuart Davis / Licensed by VAGA, NY; photo © The Art Institute of Chicago. **52A** Bridgeman Art Library. **53B** © 2004 Artists Rights Society (ARS), NY / SABAM, Brussels; photo A.K.G., Berlin / Superstock. **53D** © 2004 Artists Rights Society (ARS), NY/ VG Bild-Kunst, Bonn; photo David Heald, © The Solomon R. Guggenheim Foundation, New York. **54A** Luca Vignelli. **55B** University of Pennsylvania Art Collection, Philadelphia. (1889.0001). **56B** The Royal Collection © 2004, Her Majesty Queen Elizabeth II. **57C** Courtauld Institute of Art Gallery, London, P.1947.LF.77. **58A** Courtesy Quickfish Media, Inc. **59B** Printed by Lawrence Hamlin; Publisher: Crown Point Press. **59C** © 2004 Artists Rights Society (ARS), NY / ADAGP, Paris; photo Tate Gallery, London / Art Resource, NY. **59D** © Artists Rights Society (ARS), NY / ADAGP, Paris; Kunstmuseum Basel, H1941.1; photo Martin Bühler / Oeffentliche Kunstsammlung Basel. **60A** © 2004 The Pollock-Krasner Foundation / Artists Rights Society (ARS), NY; photo © 2004 The Museum of Modern Art / Art Resource, NY. **61C** James Cohan Gallery, NY.

Chapter 4: **Opener** David Langdon © *The New Yorker Collection* from cartoonbank.com. All Rights Reserved. **64A** Fredrik Marsh. **65B** Glen Holland and Michelle Herman. **65C** © 1992 The Metropolitan Museum of Art. **66A** V&A Picture Library, London. **66B** Giraudon / Art Resource. **67C** © 1997 The Metropolitan Museum of Art. **67D** Claire Curran. **68A** Georg Ger-

ster / Photo Researchers Inc. **69B** Dennis Brack / Black Star. **71B** Nicolo Orsi Battaglini / Art Resource, NY. **71C** Statens Museum for Kunst, Copenhagen, KMS 6202; photo © and by permission of Stiftung Seebull Ada & Emil Nolde, Neukirchen, Germany. **73B** courtesy Gilbert Li. **74A** © 2004 Charly Herscovici, Brussels / Artists Rights Society (ARS), NY; photo Photothèque R. Magritte ADAGP / Art Resource, NY. **75B** Courtesy New York-New York Hotel & Casino LLC, Las Vegas. **75C** Courtesy Regen Projects, Los Angeles. **77B** Hervé Lewandowski / Réunion des Musées Nationaux / Art Resource, NY. **77C** © 2003 Board of Trustees, National Gallery of Art, Washington, DC **78A, 79B** Alinari / Art Resource. **79C** Timothy Remus.

Chapter 5: **Opener** David Lauer. **83B** Scala / Art Resource, NY. **84A** © Philip Guston; photo Smithsonian American Art Museum, Washington DC / Art Resource, NY. **85C** © 2004 Artists Rights Society (ARS), NY / VG Bild-Kunst, Bonn; photo © The Museum of Modern Art / Art Resource, NY. **87B** Ezra Stoller © Esto. All rights reserved. **87C** Wim Swaan / Getty Research Institute, Los Angeles, Wim Swaan Photograph Collection, 96.P.21. **90A** Copyright © Nan Goldin 1984. **91A** Tom Bonner. **93C** Isabella Stewart Gardner Museum / Bridgeman Art Library. **95C** © 1991 The Metropolitan Museum of Art. **95D** © The Art Institute of Chicago. **96B** The Granger Collection, NY. **97C** Museo di San Marco dell'Angelico, Florence / Bridgeman Art Library. **98A** © 1993 National Gallery of Art, Washington, DC, 1989.71.1. **100A** J. & L. Waldman / Bruce Coleman Inc. **101B** Nancy Crow, published in *Nancy Crow: Quilts and Influences* (American Quilters Society); used by permission. **101C** Whitney Museum of American Art, 95.170 © 2004 Estate of Jay DeFeo / Artists Rights Society (ARS), NY. Photograph: © Ben Blackwell. **102B** Photograph © 2004 The Museum of Modern Art. **102C** Timothy Hursley.

Chapter 6: **Opener** David Lauer. **107B** © 2004 Albert Renger-Patzsch Archiv / Ann und Jürgen Wilde, Zülpich / Artists Rights Society (ARS), NY. **107C** © Glasgow School of Art. **109C** © 2004 Mondrian / Holtzman Trust c/o Artists Rights Society (ARS), NY; photo © 2004 The Museum of Modern Art. **110A** Mansfield Bascom / Wharton Escherick Museum. **111B** Photograph © 2004 The Museum of Modern Art / Art Resource, NY. **113C** © Louise Bourgeois / Licensed by VAGA, NY; photo Peter Moore. **115B&C** Oeffentliche Kunstsammlung Basel, 1969.51.17. Photograph: Oeffentliche Kunstsammlung Basel, Martin Bühler.

Chapter 7: **Opener** Robert Gumpertz. 1986. © Robert Gumpertz, Mill Valley, CA. **120A** © Richard Long; photo courtesy New Art Centre Sculpture Park & Gallery, Roche Court, U.K. **121B** Jack Lenor Larsen / Cowtan & Tout, NY. **121C** Mark Newman / Bruce Coleman Inc., New York. **122A** Courtesy Ellsworth Kelly and Gemini G.E.L. © 1984. **123C** © 1998 Thomas Card. **123D** 2004 Artists Rights Society (ARS), NY / ADAGP, Paris; photo © 2000 The Museum of Modern Art. **125D** © 1982 The Metropolitan Museum of Art. **127C** © The Cleveland Museum of Art, 1133.1922. **128A** Courtesy of the Fogg Art Museum, Harvard University, 1943.843. Photograph © President and Fellows of Harvard College, Harvard University. **128B** © 2004 Artists Rights Society (ARS), NY / ADAGP, Paris. **130A** Philadephia Museum of Art / Art Resource, NY. **130B** © 2004 Susan Rothenberg / Artists Rights Society (ARS), NY. **131C** Printed by Lawrence Hamlin. Publisher: Crown Point Press. **131D** The Art Institute of Chicago (gift of Robert Allerton, 1923.944); photo © The Art Institute of Chicago. **132A** The Pierpont Morgan Library, purchased in 1919, I, 275d. **133C** Metropolitan Museum of Art, NY, 12.56.11. **133D** Harold Dorwin. **134A** © The Estate of Alice Neel. Courtesy Robert Miller Gallery, New York. **135B** Alinari / Art Resource, NY. **135D** © 2004 Artists Rights Society (ARS), NY / ADAGP, Paris; photo Art Resource, NY. **136B** © 1995 The Metropolitan Museum of Art. **137D** © 2004 Brice Marden / Artists Rights Society (ARS), NY. **138A** Nimatallah / Art Resource, NY. **138C & 139D** © 2004 Artists Rights Society (ARS), NY / VG Bild-Kunst, Bonn. **139E** By permission of Mark Feldstein and Dover Publications.

Chapter 8: **Opener** George Melly / J. R. Glaves-Smith. 1973. © *The New Yorker* Collection from cartoonbank.com. All Rights Reserved. **143B** Erich Lessing / Art Resource. **143C** © Estate of Roy Lichtenstein / Gemini G.E.L. **144A** © Estate of David Smith / Licensed by VAGA, NY. **145C** Fredrik

INDEX